HOW TO DRAW
ANIME & GAME CHARACTERS

Bishoujo Game Characters

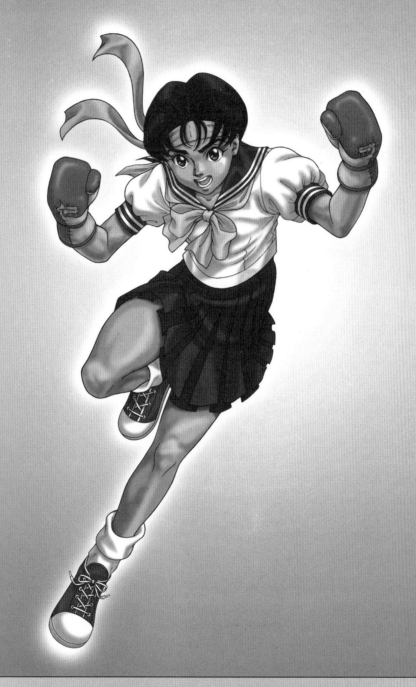

VOL. 5

FOREWORD

If one were to name something guaranteed to sell, it would have to be the genre composed mainly of *"gyaru ge"* (video games featuring female heroines) and *"bishoujo anime."* Representatives of this category are not normally epic or spectacular works, but they always sell. Moreover, it is not as if they are being supported by a hardcore fan base. There are many works with wide appeal, regularly attracting even female fans.

Yet, why does this genre sell so well? What I realized from participating in game production is that the entire foundations for character design seem to be laid down here, at the *bishoujo* game/anime production studio. While it goes without saying the girl leads are captivating, the very fact that the basics of character design is solidly in place in these works is the reason why they continue to sell in impressive volumes. I further noticed that the majority of works sold were not designed by male artists, but rather by their female colleagues. It is likely because these works reflect not just the interests of the boys, but the feelings and interests of the girls as well that they have been able to maintain audiences for such an extended time.

In this volume, I present specific *"bishoujo video game"* examples for you to use as reference in learning great character design techniques.

HOW TO DRAW ANIME & GAME CHARACTERS Vol. 5
Bishoujo Game Characters
by Tadashi Ozawa

Copyright © 2001 Tadashi Ozawa
Copyright © 2001 Graphic-sha Publishing Co., Ltd.

First designed and published in 2001 by Graphic-sha Publishing Co., Ltd.
This English edition was published in 2003 by Graphic-sha Publishing Co., Ltd.
1-14-17 Kudan-kita, Chiyoda-ku, Tokyo 102-0073 Japan

Contributions to illustrations:	Yoriko Mochizuki, Chika Majima, Tadahiro Kitamura
Contributions to text:	Chika Majima, Jet Inoue, Tomohiro Hasegawa
Design:	Kazuo Matsui
English edition layout:	Shinichi Ishioka
English translation management:	Língua fránca, Inc. (an3y-skmt@asahi-net.or.jp)
Planning editor:	Sahoko Hyakutake (Graphic-sha Publishing Co., Ltd.)
Foreign language edition project coordinator:	Kumiko Sakamoto (Graphic-sha Publishing Co., Ltd.)

Distributed by
NIPPAN
4-3 Kanda Surugadai,
Chiyoda-ku, Tokyo, Japan
Tel: +81-(0)3-3233-4083
Fax: +81-(0)3-3233-4106
E-mail: nippan@netlaputa.ne.jp

Distributed In North America by
Digital Manga Distribution
Carson, CA 90746, U.S.A.
Tel: (310) 604-9701
Fax: (310) 604-1134
E-mail: distribution@emanga.com
URL: http://www.emanga.com/dmd/

First printing: August 2003

ISBN: 4-7661-1276-8
Printed and bound in China

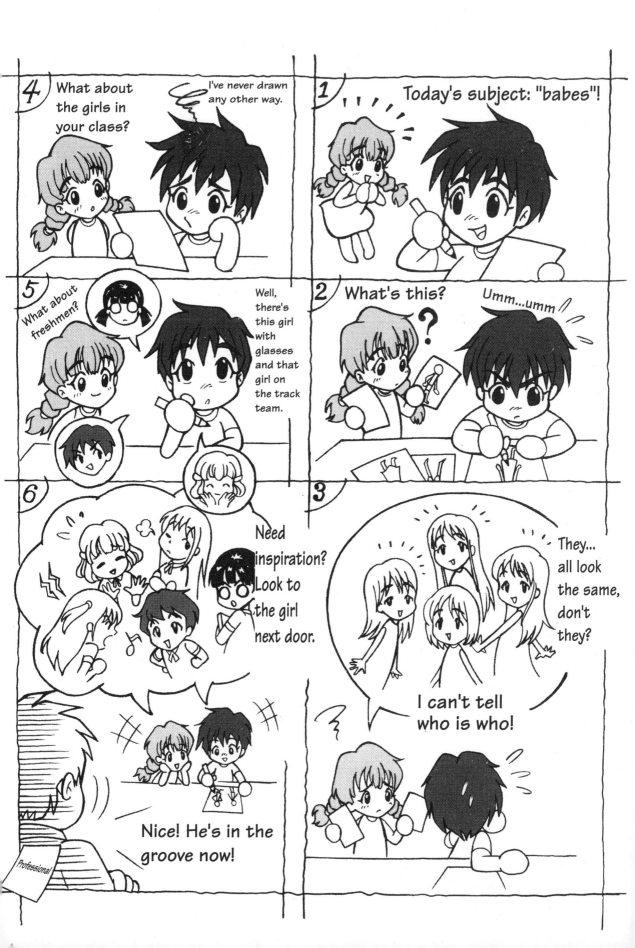

TABLE OF CONTENTS

What Are *Bishoujo* Games?

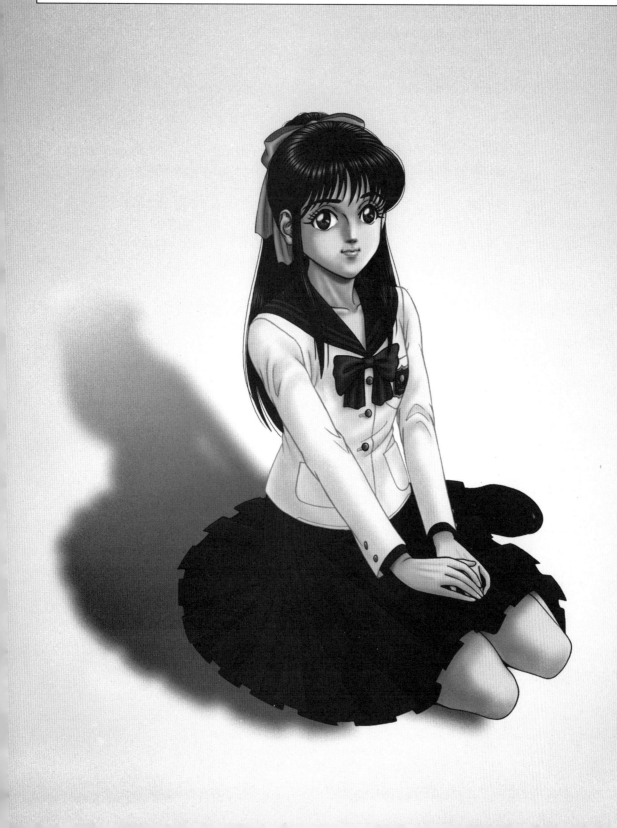

General Breakdown

We tend to watch *bishoujo* anime or play *gyaru ge* (translated in English as either "gal games" or "girls games" and meaning video games featuring female heroines) without giving the subject much thought. Naturally, we buy them, because they are fun. But what makes them fun? Because the girls are cute? Because they are sexy? Yet, if it were just that these games feature girls with pretty faces, we would soon tire of them. Although we refer to the category as *"gyaru ge"* or *"bishoujo"* games or anime, the individual products must be interesting and well developed, or they will just not capture the player's or audience's attention. In fact, the creators do not create these works simply for the purpose of "drawing girls." First, they perfect the game as an "artistic work" with carefully designed characteristics. Then the creators feature the *bishoujo* as that something extra (and to help the product sell). Well then, what sort of characteristics does an "interesting" game have?

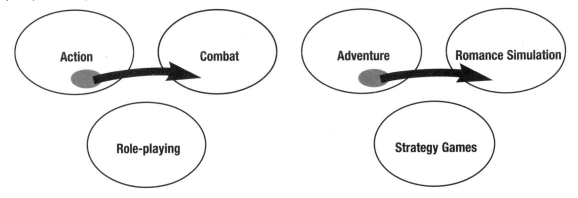

Characteristics of Action Games

These can trace their origins to alien invader-type games that made their appearance early on in video game history. The player moves the character and clears stages or levels to advance. The player **commands the heroine, while engaging the computer in combat**. This combat aspect expanded and evolved into "**combat games**."

Characteristics of Combat Games

Combat games evolved from action games. The player **chooses a character and then engages the character in combat with others**. Characters come in a wide array of forms and can be a kung fu fighter, vampire, or other bizarre creature. The character selection always includes **a pretty, yet powerful female character** of the sort not typically found in real life. Some players will use no other character than this. Elaborate costume designs, weapons, and other small effects also become important as props.

e.g.: Street Fighter Series *1
Darkstalkers Series *2

Characteristics of Role-playing Games (RPG)

Talking props, etc.

As the name indicates, these are games where the player plays a role, transformed in the game's world into the central character. The player finds entertainment in the story, which **develops** as the player resolves events, becomes involved with the game's heroine, and takes part in other activities. The relationships between characters and conclusions vary according to the choices made as the game is played. The image or **conception of the game's world** was emphasized in the design, resulting in a total, otherworldly atmosphere, perhaps with bizarre villainous creatures or set in the past or in

the future. The *bishoujo*, who is the game's heroine, often constitutes a key character.

Characteristics of Adventure Games

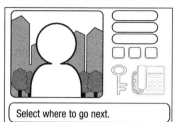

Select where to go next.

In adventure games, the story develops as **the player engages in a dialogue with the screen, which shows the game from the player's visual perspective**. "**Romance simulation games**" constitute a type of adventure game featuring only *bishoujo* characters. The player engages the characters in conversation or maneuvers and negotiates in order to invite the characters on dates or get them to declare their love to the player. Typically, this time of game advances through dialogue between the player and the game's characters.

e.g.: Tokimeki Memorial *4
True Love Story *5

Characteristics of Strategy Games

Chess and *shogi* (Japanese chess) are examples of strategy games, which consist of **the player manipulating all of the pieces on his or her side** to attack or capture the opponent's position. Games with historical settings typify this genre. Games where all of the "pieces" or characters composing the player's team are *bishoujo* would fall into the *bishoujo* game category; however, such games are still few. These games are extremely involving and require that the player become familiar with the statistics and attributes of all of the characters on his or her team. An example of a game not falling solely into the strategy game genre, but rather combining characteristics of multiple genres would be Sakura taisen ("Sakura Wars") *7.

A closer look

The above is a brief overview of the characteristics found in the various game genres. However, one specific characteristic cannot be neatly attributed to *bishoujo* games, of which there is a tremendous volume actually circulating in the market. They are a wonderful medley of characteristics, suited to the times or current fashion, or to the player's age, possibly following the player as he or she matures, adding a few extra spices, and recombining and recomposing the story to offer a unique flavor. Now then, let us take a closer look.

e.g. 1 An RPG with Strategy and Romance Simulation-game Development:

As an RPG, this game has a basic story, which then develops as the player acts in the role of the central character. However, this game has a combination of elements, transforming into a strategy game or into a romance simulation game at different stages as the game progresses. Needless to say, the characters making up the player's team during the strategy game stage typically comprise entirely *bishoujo*.

e.g. Sakura taisen *7

e.g. 2 An RPG with *Bishoujo* Action-game Development:

Again, this game develops along a storyline like an RPG game. Yet, the lead character is a *bishoujo*, and the game develops with the player overcoming challenges lying in wait at each scene. Typically, the lead character is a strong, lithe, beautiful young woman, who must surmount various dangers. e.g. *Warukyure no boken* (literally, "the Valkryies' Adventure") *8

e. g. 3 Animation *Bishoujo*:

Unlike in a video game, in an animated segment or film, the viewer has no control over the character's movements and cannot cause the character to react. Instead, the viewer enjoys anticipating how the story will develop and what sort of characters will appear. Since the creator did not need to keep in mind the player's participation, a seemingly limitless number of characters may appear. But the characters in "interesting animation" are designed to some extent according to a set framework, which are explained in detail on the following pages. Of these, animated films or segments falling under the *"bishoujo"* genre generally develop along a storyline in one of the settings described to the right. Animation is an important element of games, and often the presence of an animated segment can determine whether or not a game sells.

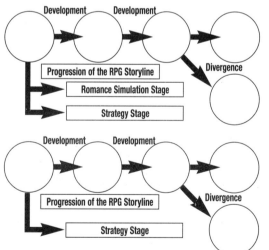

Development Development

Progression of the RPG Storyline
Romance Simulation Stage
Strategy Stage

Divergence

Development Development

Progression of the RPG Storyline
Strategy Stage

Divergence

1. A storyline develops within an everyday setting, such as school, etc..

2. A storyline develops within a setting in which a giant robot appears.

3. A storyline develops within a world inhabited by a magical girl(s).

4. A storyline develops within a sport-based context.

How many character types does a single game need?

If someone were to ask you what was your type, how would you answer? Nice? Pretty? Spunky? Calm? Everyone responds differently. The same holds true for *bishoujo* games. Each game features a variety of characters, requiring the player to try different strategies and attracting bystanders watching the game. Character design requires that the artist draw the characters so that their personality is apparent at first glance. So then, what is the minimum number of character types an artist should design?

The Standard: 6 Basic Character Types + 2 Extra

The first thing I was taught when I joined this industry was **to design at minimum 6 distinguishable character types**. Apparently, "6" is the number of personality groups that people can be roughly divided into as derived from the psychological traits they exhibit. Adding 2 extra practically ensures that there is at least one character the player will like. Now then, what exactly are these 8 character types?

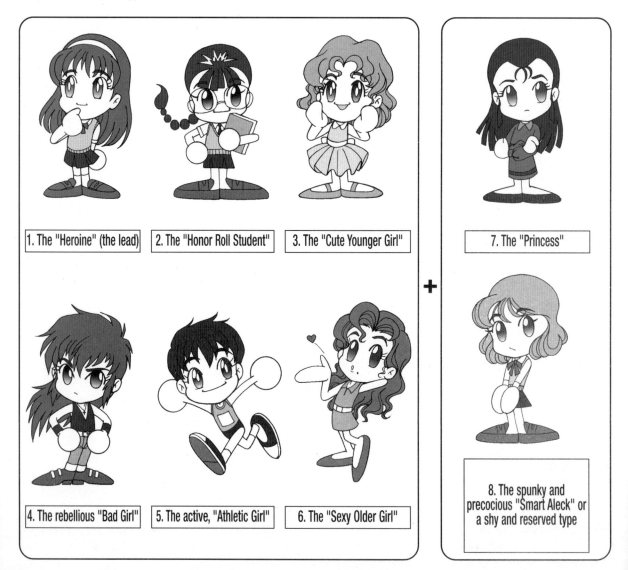

1. The "Heroine" (the lead)

2. The "Honor Roll Student"

3. The "Cute Younger Girl"

4. The rebellious "Bad Girl"

5. The active, "Athletic Girl"

6. The "Sexy Older Girl"

+

7. The "Princess"

8. The spunky and precocious "Smart Aleck" or a shy and reserved type

Designing Characters

How an artist should design a *bishoujo* character is greatly affected by the artist's conception of the game's world. First, make a list of the following conditions for your character. Then try drawing a character whose physical appearance most closely matches these conditions, based on the chart below. Once you have established the character's design, her relationship with the lead (the player in the case of romance simulation games) will fall into place.

1. Personality
2. Home environment (environment where the character was raised)
3. Weaknesses and strengths (character)
4. Degree of physical strength and intelligence
5. What makes the character happy (sad, angry, etc.)?
6. What is the character's *raison d'étre?* (What drives the character?)

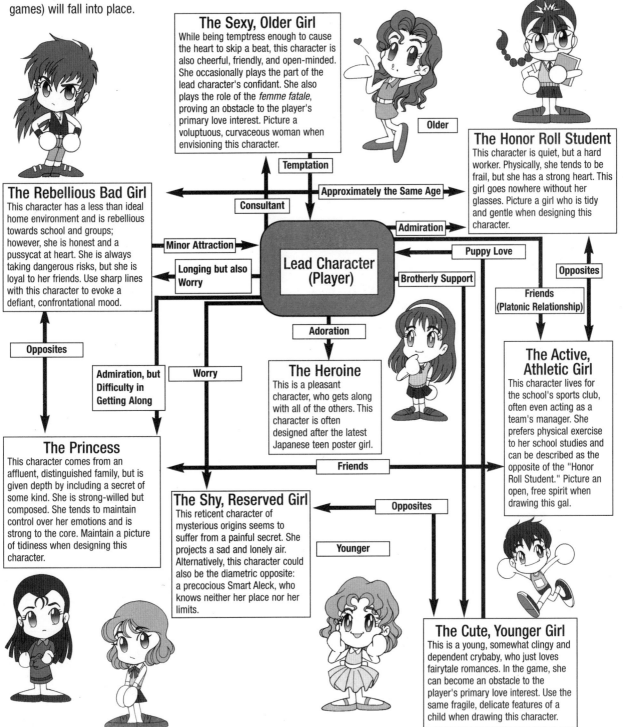

The Sexy, Older Girl
While being temptress enough to cause the heart to skip a beat, this character is also cheerful, friendly, and open-minded. She occasionally plays the part of the lead character's confidant. She also plays the role of the *femme fatale*, proving an obstacle to the player's primary love interest. Picture a voluptuous, curvaceous woman when envisioning this character.

Older

The Honor Roll Student
This character is quiet, but a hard worker. Physically, she tends to be frail, but she has a strong heart. This girl goes nowhere without her glasses. Picture a girl who is tidy and gentle when designing this character.

Temptation

Approximately the Same Age

Consultant

Admiration

The Rebellious Bad Girl
This character has a less than ideal home environment and is rebellious towards school and groups; however, she is honest and a pussycat at heart. She is always taking dangerous risks, but she is loyal to her friends. Use sharp lines with this character to evoke a defiant, confrontational mood.

Minor Attraction

Puppy Love

Longing but also Worry

Brotherly Support

Opposites

Lead Character (Player)

Friends (Platonic Relationship)

Opposites

Adoration

Admiration, but Difficulty in Getting Along

Worry

The Heroine
This is a pleasant character, who gets along with all of the others. This character is often designed after the latest Japanese teen poster girl.

The Active, Athletic Girl
This character lives for the school's sports club, often even acting as a team's manager. She prefers physical exercise to her school studies and can be described as the opposite of the "Honor Roll Student." Picture an open, free spirit when drawing this gal.

The Princess
This character comes from an affluent, distinguished family, but is given depth by including a secret of some kind. She is strong-willed but composed. She tends to maintain control over her emotions and is strong to the core. Maintain a picture of tidiness when designing this character.

Friends

The Shy, Reserved Girl
This reticent character of mysterious origins seems to suffer from a painful secret. She projects a sad and lonely air. Alternatively, this character could also be the diametric opposite: a precocious Smart Aleck, who knows neither her place nor her limits.

Opposites

Younger

The Cute, Younger Girl
This is a young, somewhat clingy and dependent crybaby, who just loves fairytale romances. In the game, she can become an obstacle to the player's primary love interest. Use the same fragile, delicate features of a child when drawing this character.

The Heroine

The conditions for creating a lead character are having **a physical appearance and personality with broad appeal**. Often, try to imagine the latest young poster girl who is loved by adults and teens alike in this role. Imagine who your ideal would be and design the heroine based on this image.

Romance Simulation Games

For romance simulation games, it is important that the character have a tidy, pure air to her. Draw her with her school uniform's bow properly tied and buttons fastened.

Early *Bishoujo* Games

This type of character originated from the creator's desire to make a game featuring a sailor suit-clad girl with a sword. Such games became the starting point of today's "*bishoujo* games." The genre gradually branched out from this point, evolving into "*bishoujo* games," which are characterized by having more involved contents than their antecedents.

Bishoujo Role-playing Games

I selected a character of European/Japanese mixed ancestry for this RPG heroine, who also has a diligent, industrious personality. As with the various "Ranger" series characters, various versions of a basic character are created using theme colors matched with personality types.

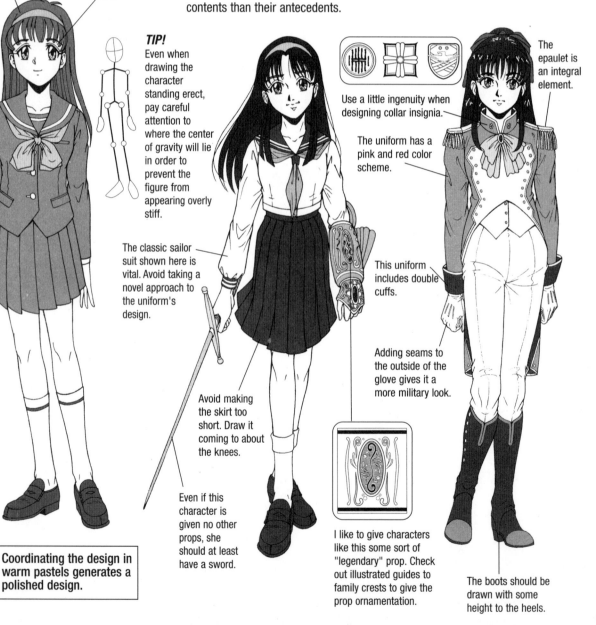

This character type usually has long, straight hair.

The character should have large, roundish eyes.

TIP!
Even when drawing the character standing erect, pay careful attention to where the center of gravity will lie in order to prevent the figure from appearing overly stiff.

Use a little ingenuity when designing collar insignia.

The epaulet is an integral element.

The uniform has a pink and red color scheme.

The classic sailor suit shown here is vital. Avoid taking a novel approach to the uniform's design.

This uniform includes double cuffs.

Adding seams to the outside of the glove gives it a more military look.

Avoid making the skirt too short. Draw it coming to about the knees.

Even if this character is given no other props, she should at least have a sword.

I like to give characters like this some sort of "legendary" prop. Check out illustrated guides to family crests to give the prop ornamentation.

The boots should be drawn with some height to the heels.

Coordinating the design in warm pastels generates a polished design.

The Honor Roll Student

This character, who comes next in line in importance after the heroine, can be best described as frail, gentle, and romantic. If nothing else, draw this character with **droopy eyes and glasses**.

Romance Games

The "brainy four-eyes" rendition of this type of character is the most common. Her 3 trademarks consist of a down turned, sullen mouth, sad, droopy eyes, and heavy-framed glasses. The cuff of her blouse, just peeking out of the jacket sleeve, should always be buttoned.

Combat Games

Although without glasses, this is the same character-type as the "brainy four-eyes" and is similarly positioned within the cast. Subtly mixing in elements of the Cute, Younger Girl gives this character extra charm. Years ago, this sort of character would be about 20 to 25 in age, but now she is usually designed to be somewhere in her teens.

Bishoujo Role-playing Games

More than necessarily being an "honor roll student," this particular character is academic and skilled in gathering information and solving dilemmas. She is often assigned green as her theme color. I designed this character to be British, in order to emphasize these personality traits.

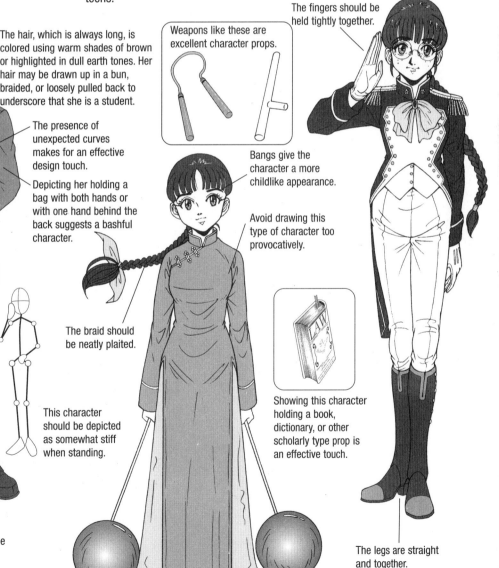

The hair, which is always long, is colored using warm shades of brown or highlighted in dull earth tones. Her hair may be drawn up in a bun, braided, or loosely pulled back to underscore that she is a student.

The presence of unexpected curves makes for an effective design touch.

Depicting her holding a bag with both hands or with one hand behind the back suggests a bashful character.

Weapons like these are excellent character props.

The fingers should be held tightly together.

Bangs give the character a more childlike appearance.

Avoid drawing this type of character too provocatively.

The braid should be neatly plaited.

This character should be depicted as somewhat stiff when standing.

Showing this character holding a book, dictionary, or other scholarly type prop is an effective touch.

The legs should be close together.

The legs are straight and together.

The Cute, Younger Girl

Clingy, dependent and usually younger than the Heroine, this character has a presence akin to that of a little sister. Use pastels for this character overall to suggest softness. If the Heroine is drawn at a 1:7 or 8 head to body ratio, this character should be drawn at a 1:6 head to body ratio.

Romance Simulation Games

She is an imp and a bit of a crybaby: try to draw her entire body expressing her emotional state. Give her freckles, frizzy hair and other elements to project her personality even more strongly.

Beauty and the Beast

The first of this kind could be Lum (from *Urusei Yatsura*). Here we see 4 key elements: cat ears, gloves with paw pads, a tail, and kitty cat boots. Curly hair works better than straight.

Bishoujo Role-playing Games

This character I designed is young but talented. Her parents are either well-off, are involved in politics, or some related organization. This character acts to cheer the others.

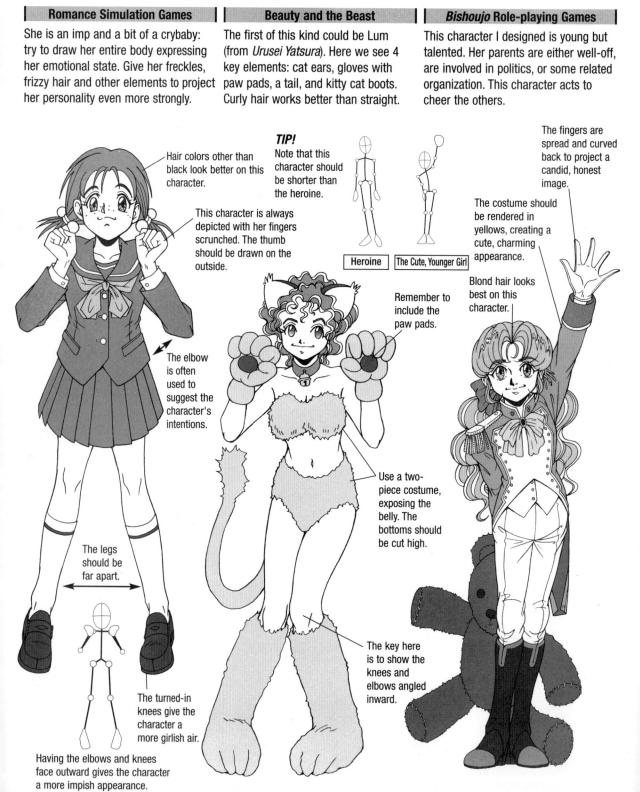

Hair colors other than black look better on this character.

This character is always depicted with her fingers scrunched. The thumb should be drawn on the outside.

The elbow is often used to suggest the character's intentions.

The legs should be far apart.

The turned-in knees give the character a more girlish air.

Having the elbows and knees face outward gives the character a more impish appearance.

TIP!
Note that this character should be shorter than the heroine.

Heroine | The Cute, Younger Girl

Remember to include the paw pads.

Use a two-piece costume, exposing the belly. The bottoms should be cut high.

The key here is to show the knees and elbows angled inward.

The fingers are spread and curved back to project a candid, honest image.

The costume should be rendered in yellows, creating a cute, charming appearance.

Blond hair looks best on this character.

The Bad Girl

This rebellious, strong-willed character is positioned within the cast as the diametric opposite of the Princess. She serves to bring new development to the storyline and to pull the story together. She tends to be taller than the heroine. Blue and other cool colors are often used in her hair and clothing.

Romance Simulation Games

A sure fire way to design a successful Bad Girl is to have the character be at first glance aloof but actually honest and true at heart. Draw her school uniform in slight disarray.

The Dominatrix

This character design accentuates the haughtiness of the Bad Girl. Since this character is intended to be older than the others, she should be drawn to appear voluptuous with lots of curves.

Bishoujo Role-playing Games

Far from the Bad Girl, this particular character, aloof and detached, is positioned next in importance from the Heroine as her opposite. The point to note here is that she is not the Heroine's enemy, but her rival within the group.

TIP!
Draw the Bad Girl's eyes somewhat more slanted than that of the heroine. Concealing the top of the iris with the eyelid will produce a strong impact.

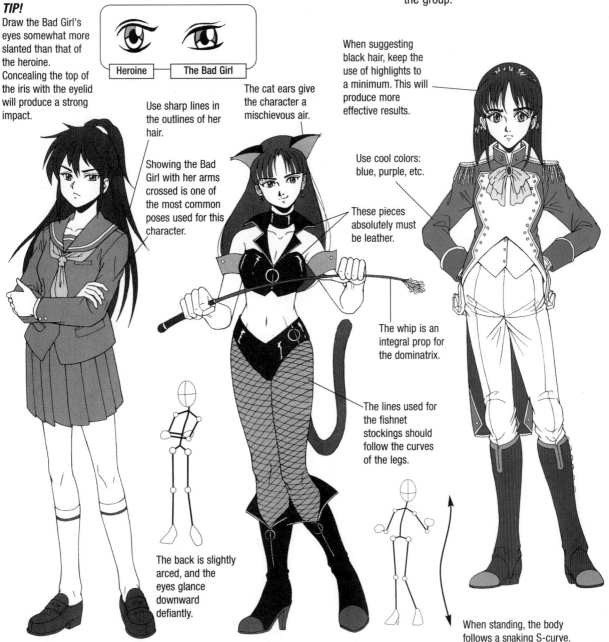

Heroine | The Bad Girl

Use sharp lines in the outlines of her hair.

Showing the Bad Girl with her arms crossed is one of the most common poses used for this character.

The cat ears give the character a mischievous air.

When suggesting black hair, keep the use of highlights to a minimum. This will produce more effective results.

Use cool colors: blue, purple, etc.

These pieces absolutely must be leather.

The whip is an integral prop for the dominatrix.

The lines used for the fishnet stockings should follow the curves of the legs.

The back is slightly arced, and the eyes glance downward defiantly.

When standing, the body follows a snaking S-curve.

The Athletic Girl

This character, who plays sports, hangs out and mixes it up with the boys, functions as an active figure. Of the cast, she is the most androgynous and has an almost boyish build.

Romance Simulation Game	Action/Combat Games	*Bishoujo* Role-playing Game
If nothing else, this gal is a spunky, cheerful tomboy. She is usually shown wearing a jersey or a jogging suit.	A female soldier is indispensable to any shoot-'em-up or other action game. Of the entire cast, The Athletic Girl is an obligatory character.	This character is designed to be feisty, optimistic, and not given to fretting over troubles. However, she also has a dark and tangled background, making her a complex character.

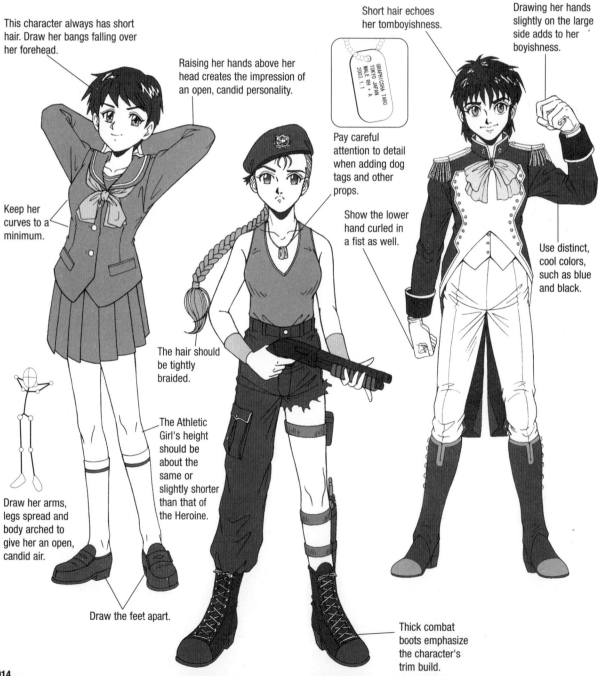

This character always has short hair. Draw her bangs falling over her forehead.

Raising her hands above her head creates the impression of an open, candid personality.

Short hair echoes her tomboyishness.

Drawing her hands slightly on the large side adds to her boyishness.

Keep her curves to a minimum.

GRAPH-SHA TARO
TOKYO JAPAN
MALE RH + A
2003. 1. 1

Pay careful attention to detail when adding dog tags and other props.

Show the lower hand curled in a fist as well.

Use distinct, cool colors, such as blue and black.

The hair should be tightly braided.

Draw her arms, legs spread and body arched to give her an open, candid air.

The Athletic Girl's height should be about the same or slightly shorter than that of the Heroine.

Draw the feet apart.

Thick combat boots emphasize the character's trim build.

The Princess

Broken down into 2 general personality types, The Princess is often added to the cast when it is designed to have about 4 characters, and one is the Honor Roll Student.

Romance Simulation Games

This character is well bred and comes from an affluent family, but has a sorrowful air. Give her slightly heavy-lidded eyes and gently turn up the corner of her mouth, which should be on the small side, to give her a sad, lonely appearance.

Combat Games

This is a kimono-clad aristocrat. Like the romance simulation game character, she too is well bred, but is confident and pulled together. Give her a dignified and well-groomed appearance.

Bishoujo Role-playing Games

This character is designed to have come from an affluent background (Russian nobility or the like) and of good breeding. She is versatile and adaptive. When the squad commander is not present, she serves to organize the other characters.

Her hair is worn either in a bob or pigtails. Keep the wave in her hair gentle.

Draw her mouth on the small-side to create a sad, lonely appearance.

TIP!
Reducing the distance between the eyebrows and eyes gives the character a more dignified appearance.

In contrast with the Athletic Girl, this character's pose is modest and pulled in.

Draw the locks of her hair curving from the scalp. The hair should usually be blond.

The hachimaki (headband) should be worn in a tidy manner.

Use an abundance of white and gold in her costume.

The hair is neatly trimmed.

This girl is from a good family: remember to include the family crest.

The knees are drawn close together.

When drawing her in a key pose, keep the hands lower than the shoulders.

This is generally drawn in the style of some distinguished family with a long tradition.

The *hakama* (long, pleated skirt worn over a kimono, designed with legs in the case of men) is key element.

The Sexy Older Girl

With her mature nature and sexy costumes, this character exudes seductive charm. It should be noted that this character has a cheerful, open personality, so she should not be presented in a bawdy or vulgar manner. Use a bright palette or keep the number of different colors to a minimum in order to project the impression of a mature character.

Romance Simulation Games

The appeal of the Sexy Older Girl lies in her cheerful yet seductive nature. She often functions as the heroine's. Emphasize curves in her chest and waist to suggest a voluptuous build.

Combat Games

Here, she is a martial arts expert retained by a casino or bar with an aloof personality and a dark background, such as having grown up in a rough, inner city neighborhood. It should be noted that drawing her in full tuxedo tails would have changed her overall image, so take care with the costume.

Bishoujo Role-playing Games

Here, she is the squad commander, and, as her title suggests, she functions as the leader. The story cannot progress without this character.

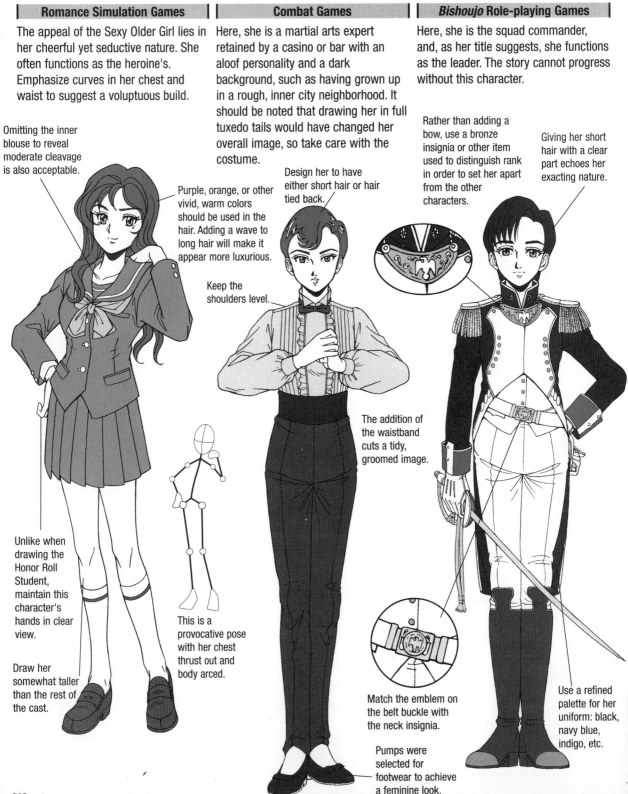

Omitting the inner blouse to reveal moderate cleavage is also acceptable.

Purple, orange, or other vivid, warm colors should be used in the hair. Adding a wave to long hair will make it appear more luxurious.

Design her to have either short hair or hair tied back.

Rather than adding a bow, use a bronze insignia or other item used to distinguish rank in order to set her apart from the other characters.

Giving her short hair with a clear part echoes her exacting nature.

Keep the shoulders level.

The addition of the waistband cuts a tidy, groomed image.

Unlike when drawing the Honor Roll Student, maintain this character's hands in clear view.

This is a provocative pose with her chest thrust out and body arced.

Draw her somewhat taller than the rest of the cast.

Match the emblem on the belt buckle with the neck insignia.

Use a refined palette for her uniform: black, navy blue, indigo, etc.

Pumps were selected for footwear to achieve a feminine look.

The Smart Aleck

When the cast calls for 6 core characters, often one is given smart-alecky traits as well. In contrast with the Cute, Younger Girl, render this character in sharp, crisp lines to draw out her cheeky nature.

Romance Simulation Games

This character is of an age where she is interested in fashion and has the desire to look more sophisticated than she really is. Consequently, she tends to dress herself in short skirts and curls her hair. Draw this character cute and trendy.

Combat Games

At max, this girl is no more than 16 years in age. Give her an air of adolescence yet with indications of developing into a woman.

Bishoujo Role-playing Games

This character is not a squad member, but she does play a support role, occasionally acting to balance out and add moderation to the cast. She can also be given a sultry air, like the Sexy Older Girl or serve any number of other functions.

Add movement to her hair to suggest a lively personality.

Take a in a folk dress book for sample designs to use in cords, braids, and other trimmings.

Keep the hair short.

Use red or some other vivid color.

Check out young women's magazines to get ideas for different poses.

Tilting her hand at this angle gives her the air of the precocious little-thing that she is.

Exposing the navel adds to her vivaciousness.

Adding movement to the trailing ends of her headband underscores her active nature.

Keep the knees apart.

As with the Cute, Younger Girl, give this character a smallish build.

Moderately stylize her build to slim her legs, making them androgynous.

The skirt should be long.

NOTE!
Exaggerate the hands and feet and draw them on the large side.

The Whole Cast

It is important not only to think carefully about character design when having the characters appear separately, but also when the entire cast appears together. Pose the characters so their personalities will be obvious at first glance. Adjust height according to the individual character's age and design.

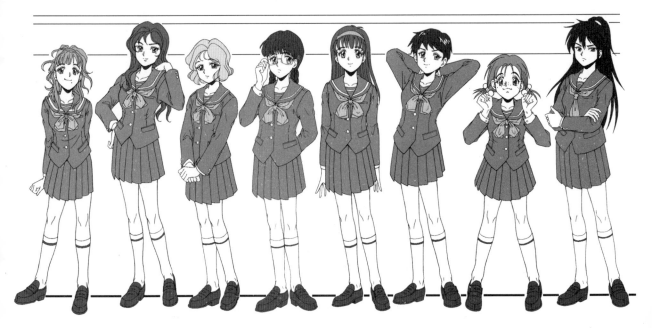

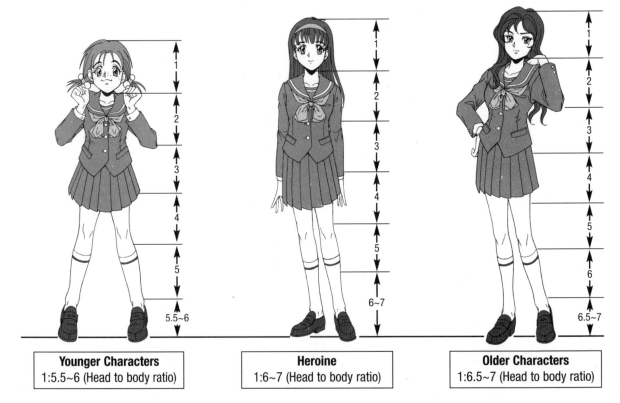

Younger Characters
1:5.5~6 (Head to body ratio)

Heroine
1:6~7 (Head to body ratio)

Older Characters
1:6.5~7 (Head to body ratio)

Planning the Character's Entrance and Game Screen Compositions

General patterns emerge according to the game type in how the character makes its appearance on the game screen. These patterns can be roughly broken down as follows:

1) The background remains visible, but the screen changes as the story unfolds.

2) The player engages in dialogue with the character, and the screen changes according to specific developments in the story.

Typically, 1) often consists of a dialogue between characters, while 2) usually consists of a dialogue between the player and a character.

Screen while manipulating the characters' movements

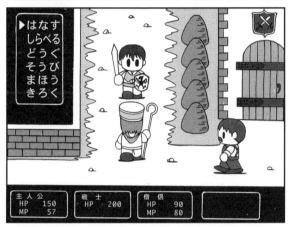

This is the basic screen for RPGs, combat, and action games. Often the graphics are 2-dimensional and not rendered in detail.

Character makes her entrance

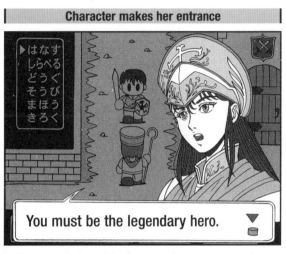

In the case of story-driven games, the game progresses by either the entire screen changing or the basic screen shifting to the background with the character making her entrance on top and speaking. The character is drawn in relative detail. Hand-drawn illustrations are often used as the basis for the artwork.

Screen when engaging in dialogue with the character

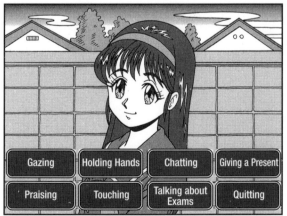

These games are set so that the player enjoys the game by engaging in conversation and maneuvers with the character. Adventure and romance simulation games are characteristic of this design. The character displays a multitude of facial expressions, such as laughing or becoming angry in response to the selections the player makes.

Animated sequence

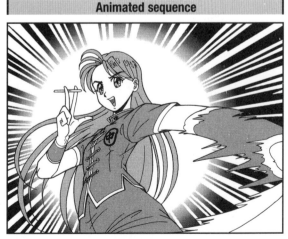

There are purely animated sequences that occur at the game's opening or at important developments in the game where the player merely watches without interacting. An animation company rather than a video game company usually produces the artwork for these sequences.

Crash Course in Editing I

Drawing by Teruno Otsu,
Odawara City, Kanagawa Prefecture

This is the fifth volume of the series containing editing tips for artwork sent by our readers. For this volume, we will start with this drawing by Teruno Otsu. The T-shirt design and jacket appliqu_ are successful in that they have the flavor of today's street wear. However, the overall composition is off balance. First, be sure that you are aware of the underlying skeletal structure and the positioning of the body's parts before adding your own stylistic touches such as showing the character slouching or shifting the weight to one foot, or adding design details. Here, I make a point of using this simple combination of a T-shirt and jacket to illustrate pointers in artwork editing.

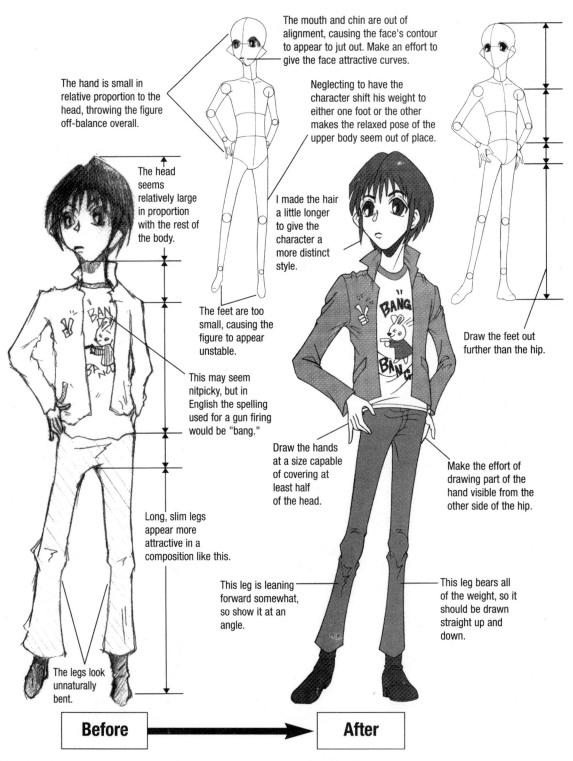

The hand is small in relative proportion to the head, throwing the figure off-balance overall.

The mouth and chin are out of alignment, causing the face's contour to appear to jut out. Make an effort to give the face attractive curves.

Neglecting to have the character shift his weight to either one foot or the other makes the relaxed pose of the upper body seem out of place.

The head seems relatively large in proportion with the rest of the body.

I made the hair a little longer to give the character a more distinct style.

The feet are too small, causing the figure to appear unstable.

This may seem nitpicky, but in English the spelling used for a gun firing would be "bang."

Draw the feet out further than the hip.

Draw the hands at a size capable of covering at least half of the head.

Make the effort of drawing part of the hand visible from the other side of the hip.

Long, slim legs appear more attractive in a composition like this.

This leg is leaning forward somewhat, so show it at an angle.

This leg bears all of the weight, so it should be drawn straight up and down.

The legs look unnaturally bent.

Before → **After**

CHAPTER 2

Bishoujo Video Game Character Expressions

How many different facial expressions are necessary?

Just because the cast of characters has been established does not necessarily mean a game or animated sequence can be quickly pounded out. While games do not require as much artwork as an animated sequence, a game cannot be played with just a single image used repeatedly for each character. In particular, in romance simulation, adventure, and other such dialogue-based games, having distinctive facial expressions where **the character reacts, smiling to show pleasure or frowning to show discontent**, is key toward driving the game and ensuring the player's enjoyment.

What is the minimum number of different facial expressions necessary?

Facial expressions were discussed in volume II of the *How to Draw Anime & Game Characters* series. I should note that my preference would be to draw about 60 different expressions per character in order to really bring that character to life. However, this would be unrealistic if you take into consideration the actual work involved. Consequently, here I will present just the basics.

In Japanese, there is the tendency to feel "pleasure," "anger," "sadness," and "delight" cover the basic emotions, but if you really think about it, this is much too vague.

So then, let us examine how these emotions would be represented graphically so that we may understand this more easily.

Impassive face: The standard expression

Pleasure:Includes laughing and smiling
("Delight" also falls under this emotion)
Anger:Includes feeling angry or indignant, etc.
Sadness:Includes crying and sad faces
Surprise:Includes surprise, fear, etc.

In addition to these, it is custom in video game design to add

anguish, dissatisfaction, arrogance (haughty attitude), and bashfulness

and have 6 to 8 facial expressions per character in order to make the individual personalities of the different characters distinct.

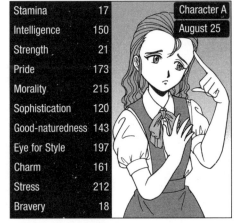

Stamina	17	Character A
Intelligence	150	August 25
Strength	21	
Pride	173	
Morality	215	
Sophistication	120	
Good-naturedness	143	
Eye for Style	197	
Charm	161	
Stress	212	
Bravery	18	

These are the personality settings for a simulation game where the player looks after a *bishoujo*.

The Eyebrows and Mouth

In the early days of video game production, in order to minimize the amount of memory to play the game, emotions were represented solely by manipulating the eyebrows and mouth. That is how key these two facial features are.

Impassive Face

Happy Face
The eyebrows are pointed upward and arced (slightly). The corners of the mouth are turned up.

Angry Face
The far ends of the eyebrows are raised and the corners of the mouth are turned down.

Stock Face

Happy Eyebrows and Mouth

Final Image

Angry Eyebrows and Mouth

Final Image

Suggesting the Degree of Emotion

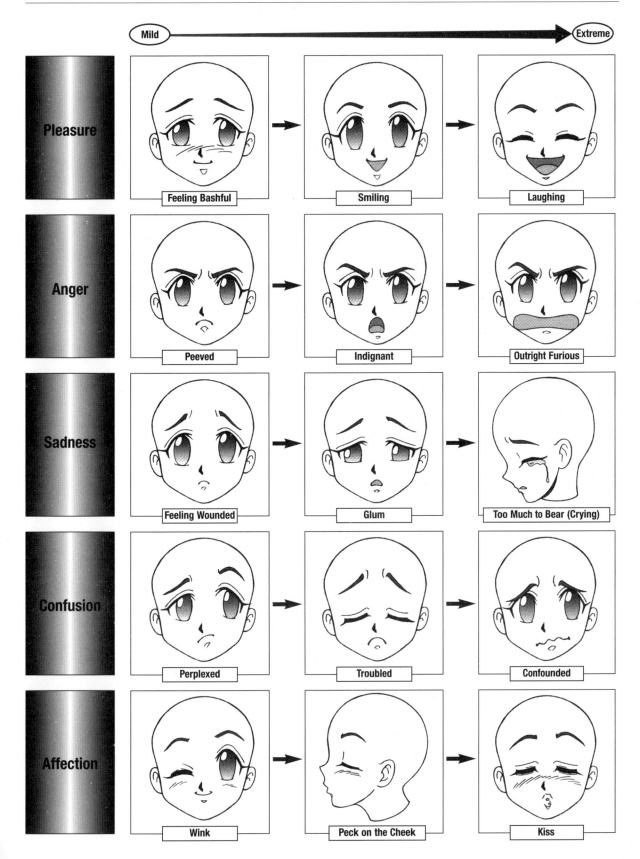

Pleasure
- Feeling Bashful
- Smiling
- Laughing

Anger
- Peeved
- Indignant
- Outright Furious

Sadness
- Feeling Wounded
- Glum
- Too Much to Bear (Crying)

Confusion
- Perplexed
- Troubled
- Confounded

Affection
- Wink
- Peck on the Cheek
- Kiss

The Heroine: Facial Expressions

This character is designed to be likeable, so she tends not to display openly negative emotions, such as anger or hatred. Quite the contrary, she should for the most part be shown laughing or looking happy. When drawing her sticking out her tongue, make the tongue exaggeratedly small and avoid showing the teeth.

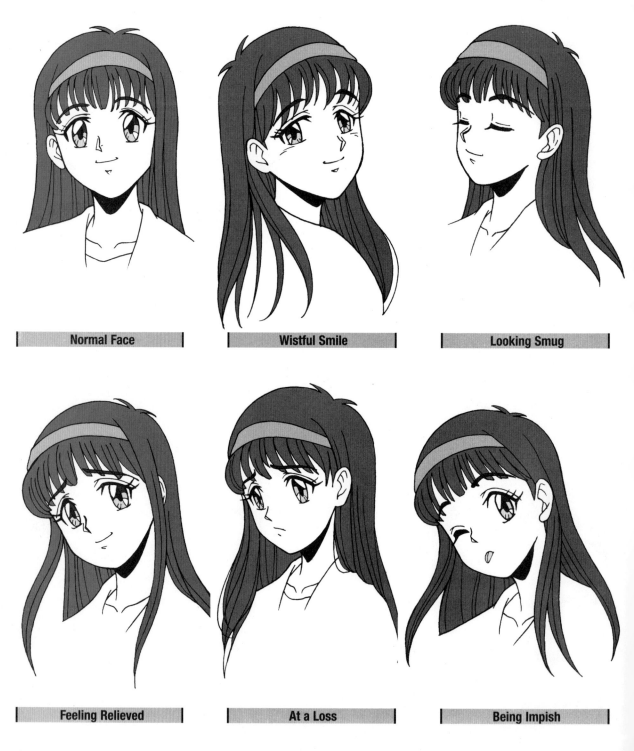

Normal Face	Wistful Smile	Looking Smug
Feeling Relieved	At a Loss	Being Impish

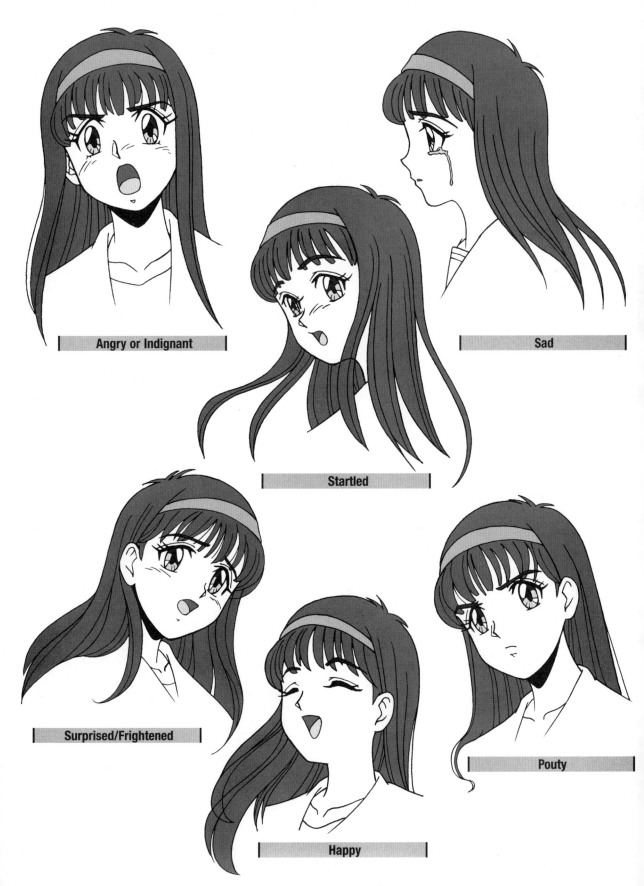

Angry or Indignant

Sad

Startled

Surprised/Frightened

Happy

Pouty

The Heroine: Body Language & Emotions

This character is most commonly posed standing with the knees together. Occasionally, when she is shown standing with her legs apart, their distance suggests her degree of emotion. Her hands are not normally shown raised above her shoulder or largely distanced from her body. Her toes are usually pointed inward. Give careful consideration to the placement of her hands when showing her with her mouth open in laughter or surprise.

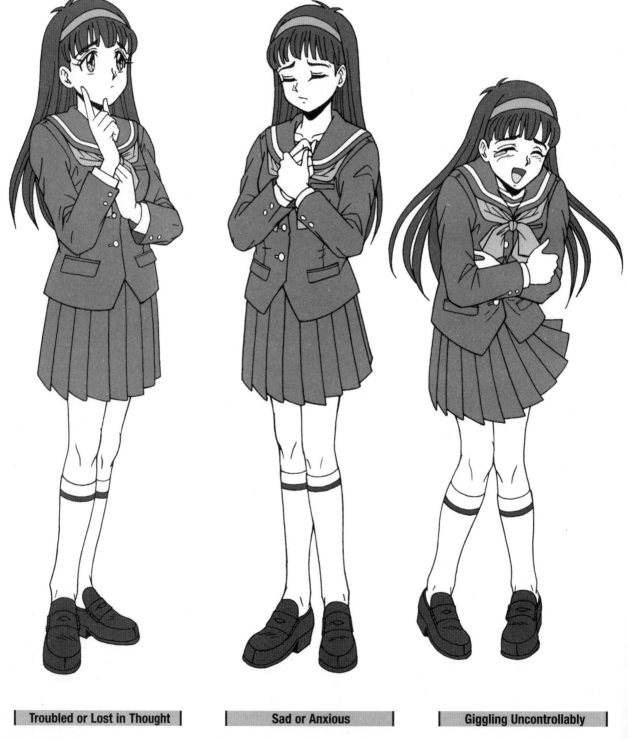

| Troubled or Lost in Thought | Sad or Anxious | Giggling Uncontrollably |

TIP!
An "open pose" (with the feet apart and hands raised above the shoulders) is used to suggest an outgoing, extroverted personality, and a "closed pose" (with the hands held lower than the shoulders, the arms either crossed or hands clasped or hidden, and the knees together) is used to suggest a reserved, introverted personality.

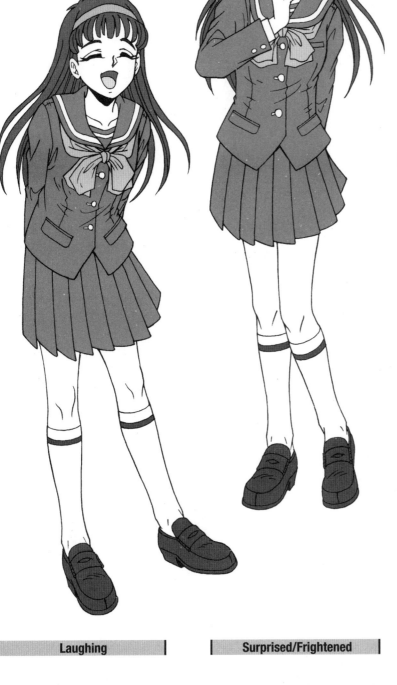

| Laughing | Surprised/Frightened | Angry |

The Honor Roll Student: Facial Expressions

The Honor Roll Student's calling card is her heavy-framed glasses, leading to her other nickname, "brainy four-eyes." Another trait of this character is her sullen mouth. She is supposed to be mild-mannered and a hard worker, so avoid drawing her with her mouth wide open when showing her laughing. Instead, showing her with her face tilted down but with her eyes cast up would be better suited to her personality. Showing her without her glasses is intended to be a powerful image, so avoid doing this too often or the impact will be lost on the viewer.

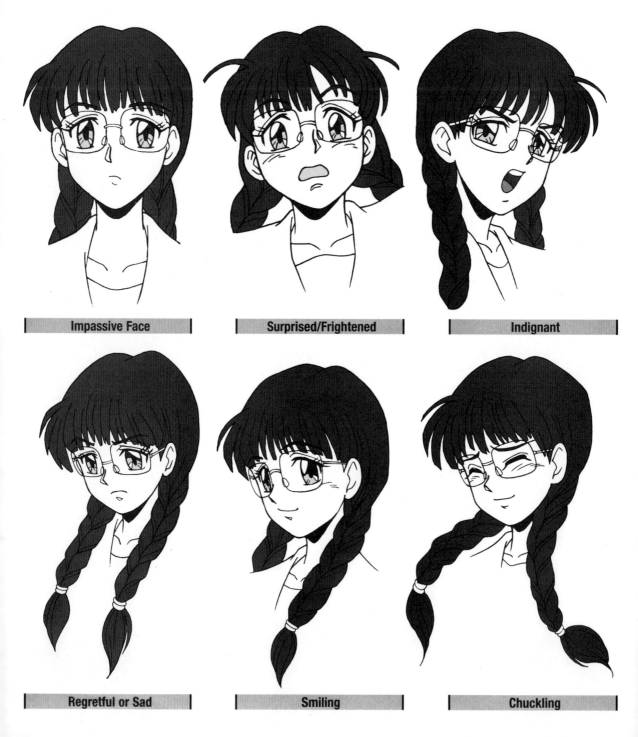

| Impassive Face | Surprised/Frightened | Indignant |

| Regretful or Sad | Smiling | Chuckling |

The Honor Roll Student: Body Language & Emotions

To illustrate the gentle nature of this character, show her with her hands hidden behind her back or elbows. She should most commonly be shown with her legs closely together. Please note that since she is perfect for designating as the class president, when showing her angry or scolding another character, her limbs should be drawn straight to give her a stern appearance.

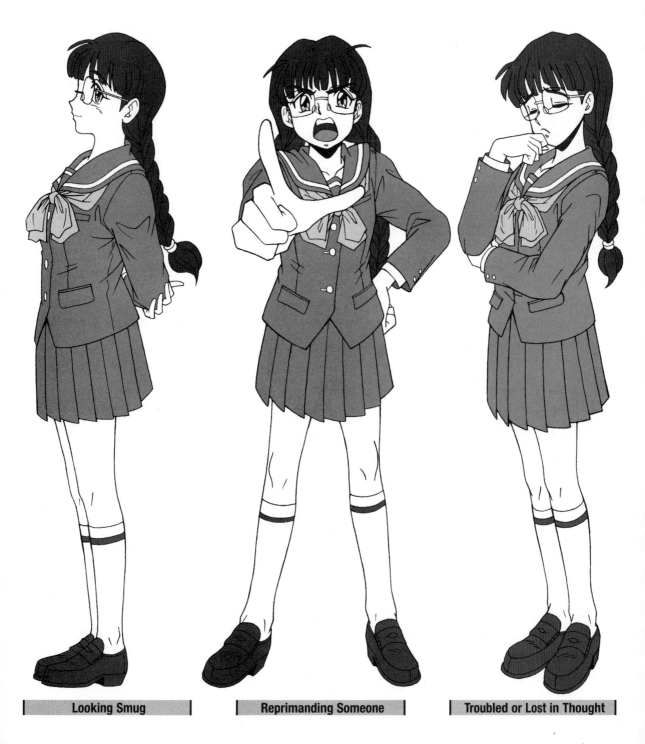

| Looking Smug | Reprimanding Someone | Troubled or Lost in Thought |

The Cute, Younger Girl: Facial Expressions

The charm of this character lies in her bouncy expressiveness. The secret to representing emotions is effective use of her eyebrows. Use such techniques as drawing her eyebrows in a check or V shape, adding furrows to her brow, or pushing the limits on raised eyebrows according to the emotion you are trying to express. Experiment with drawing her mouth exaggeratedly small or large to achieve different effects.

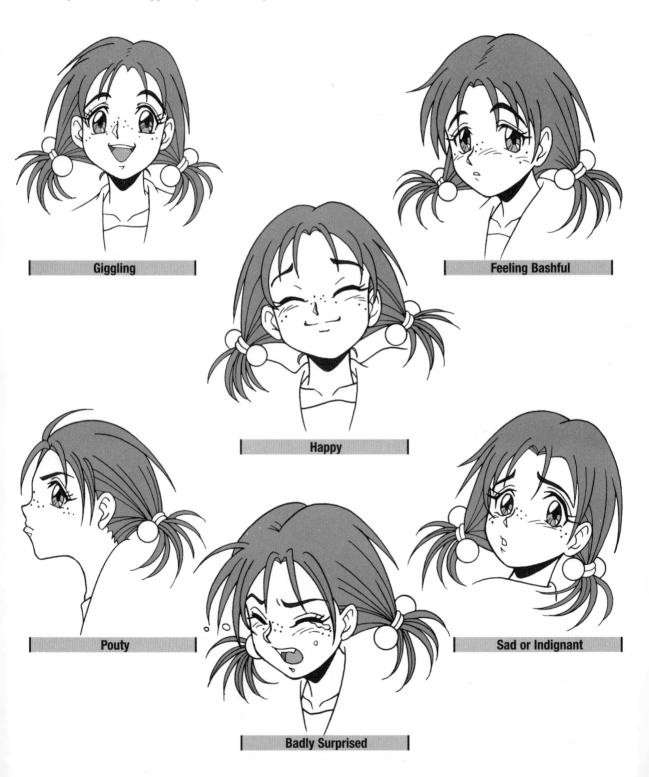

| Giggling | Feeling Bashful |

| Happy |

| Pouty | Sad or Indignant |

| Badly Surprised |

The Cute, Younger Girl: Body Language & Emotions

Since this is a younger character, showing her in somewhat babyish poses is highly effective. She usually stands with her feet apart to emphasize her candid innocence. When raising her elbows, bring them all the way up to her shoulders. Show her going almost overboard when feeling emotional: have her dance about or hug herself or those around her.

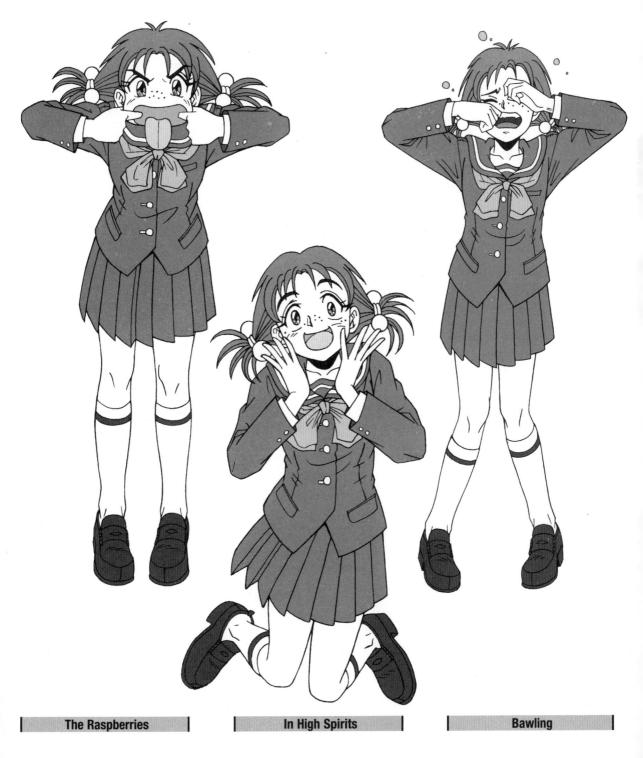

| The Raspberries | In High Spirits | Bawling |

The Bad Girl: Facial Expressions

Thickening the eyebrows suggests a more willful personality. The eyes are longer and narrower than those of the other characters. Shortening the distance between the eyebrows and the inside corners of the eyes produces a sharper, harsher face. Avoid showing the mouth open too widely and include a shadow somewhere on the face. This character type is typically drawn with long, straight hair.

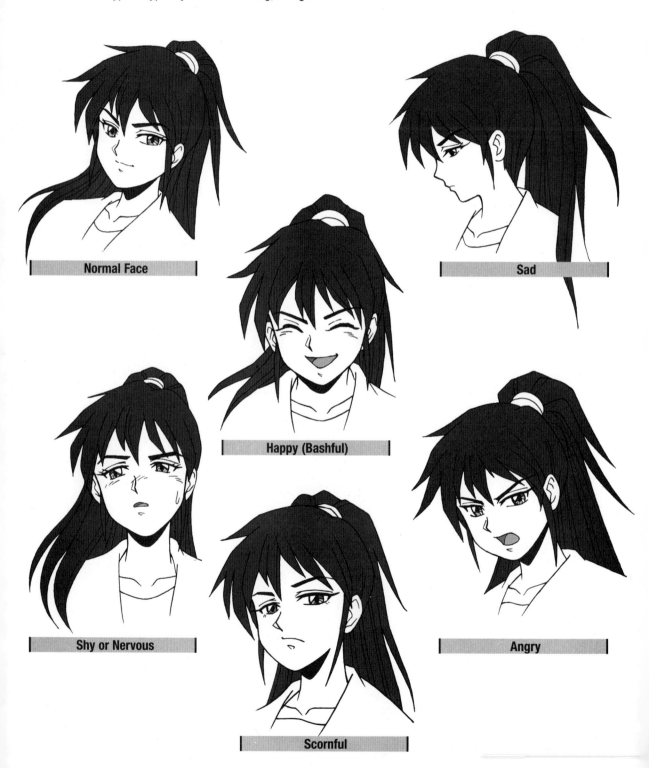

Normal Face

Sad

Happy (Bashful)

Shy or Nervous

Scornful

Angry

The Bad Girl: Body Language & Emotions

She often strikes rebellious or thuggish poses. Masculine movements and gestures also work well with this character. Showing her constantly with her hand thrust in a pocket suggests her guarded nature. Posing her with her knees and feet pointed inward would be out of character for this girl.

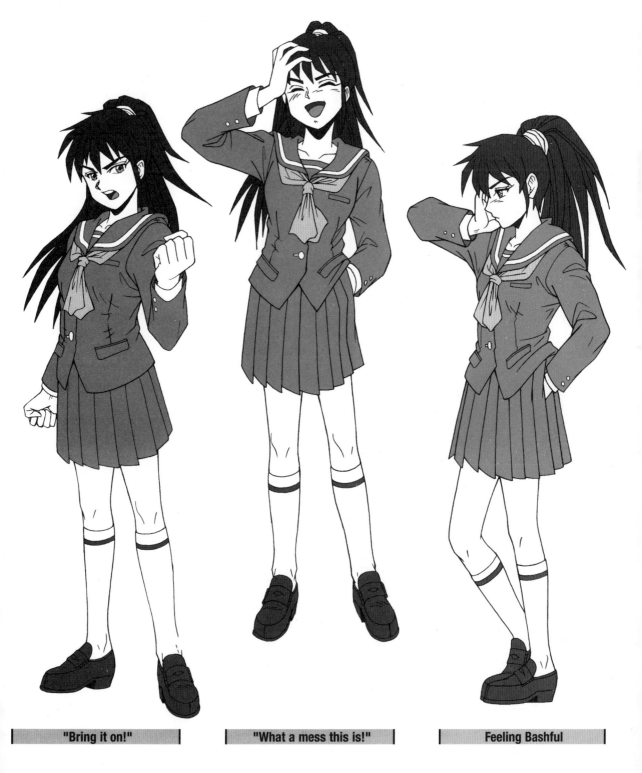

| "Bring it on!" | "What a mess this is!" | Feeling Bashful |

The Athletic Girl: Facial Expressions

The mouth of this character is drawn larger than that of the other characters to underscore her spunky, perky nature. The richness in her various facial expressions originate in her mouth, which opens widely when she laughs but becomes small when shut in sadness. Her eyes should be drawn large in height, with highlights added to make them look big and round. Showing the teeth emphasizes this character's boyishness. The hair is typically short. Long hair will detract from her androgynous nature.

Normal Face

Smiling

"Way to go!"

Surprised/Indignant

Happy/Delighted

Sad

The Athletic Girl: Body Language & Emotions

This girl is usually shown moving and gesturing in the same manner of a boy. In particular, when this character is angry, she is drawn in straight lines and with her feet planted far apart. For the most part, no matter how tomboyish a pose is used for her upper body, try to show her with her knees and feet pointed inward to illustrate that she is, after all, a girl.

| **Surprised/Frightened** | **Angry** | **Laughing Sheepishly** |

The Sexy Older Girl: Facial Expressions

Raising her eyes just slightly above the center will give this character a more mature face. Draw the eyes' contours to taper off to the sides, and use the lids to cover part of the tops and bottoms of the irises. Long, wavy hair and luxurious eyelashes add to her presence. A mole or beauty mark can make her appear seductive, and when strategically placed under an eye or lip, is all the more enticing.

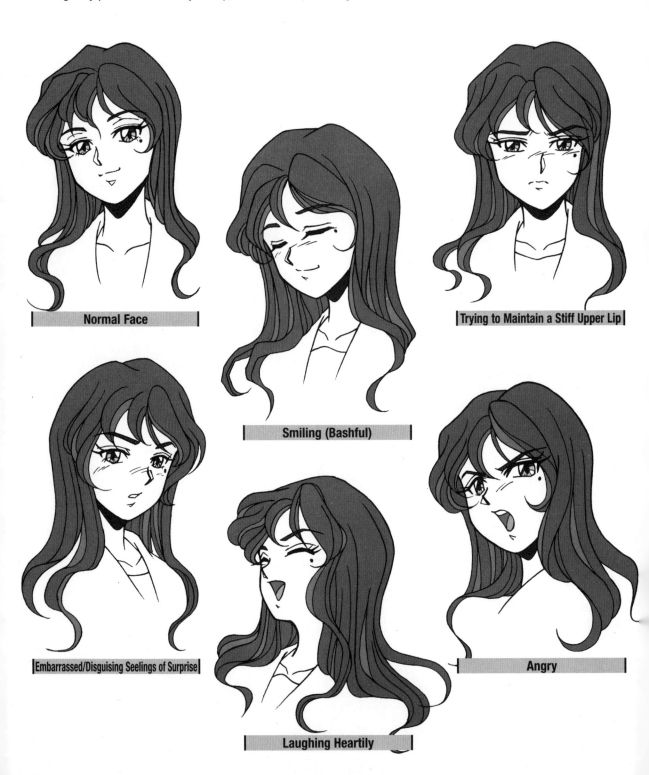

Normal Face

Smiling (Bashful)

Trying to Maintain a Stiff Upper Lip

|Embarrassed/Disguising Seelings of Surprise|

Laughing Heartily

Angry

The Sexy Older Girl: Body Language and Emotions

The Sexy Older Girl, who is a bit arrogant, is often drawn playing with her hair or with her chin raised, looking down at people. The movement of her fingers is another key point. Draw her long fingers arched back as if she were trying to show off them or her nails (giving her lacquered nails is an option for this character). Her hip is always thrust to either one side or the other.

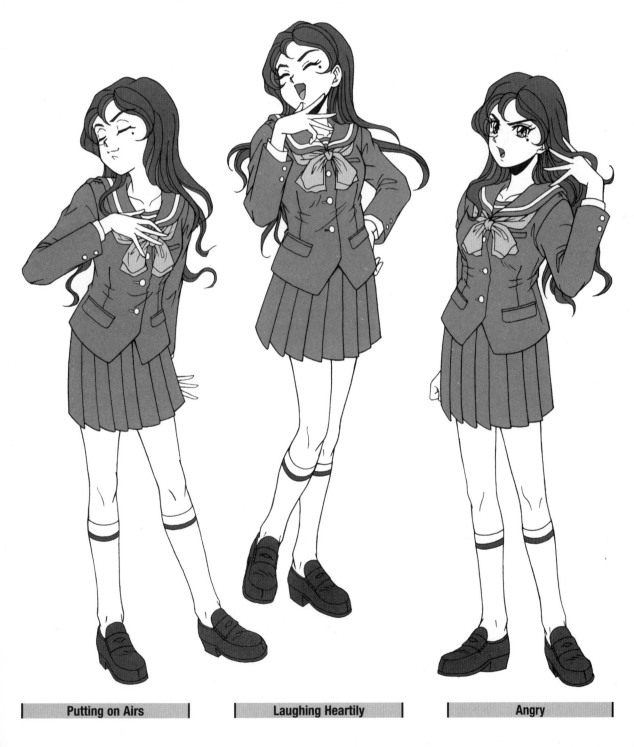

| **Putting on Airs** | **Laughing Heartily** | **Angry** |

The Princess: Facial Expressions

Since this character has breeding and poise, she should not be drawn exhibiting emotions openly. Keeping her mouth smaller than that of other characters will allow you to emphasize her introverted nature. Add blush to her face when showing surprise, fear, or happiness as well as when showing bashfulness to project a sensitive, delicate personality.

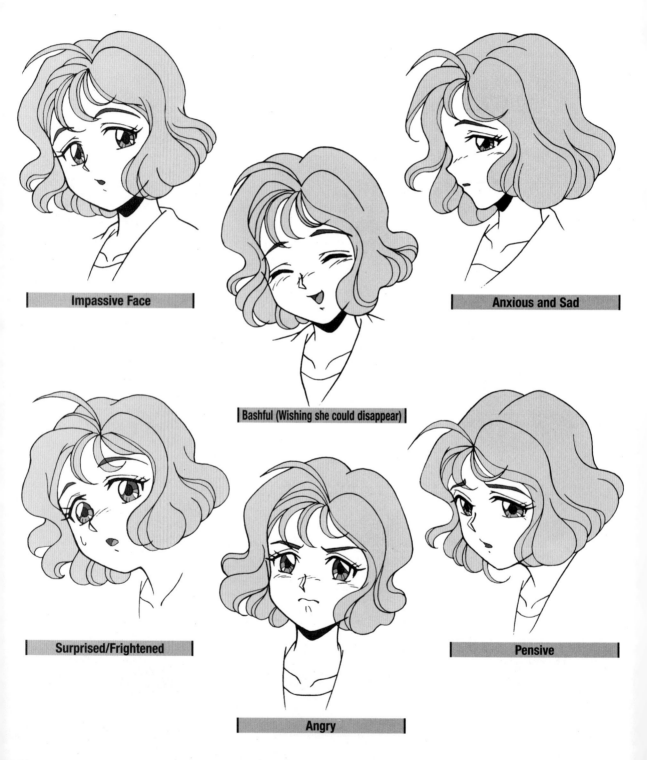

Impassive Face

Bashful (Wishing she could disappear)

Anxious and Sad

Surprised/Frightened

Angry

Pensive

The Princess: Body Language & Emotions

When drawing this character, picture a gentle, helpless soul. The hands should be clasped or hidden behind the back, the elbows are held close to the body, and the knees are together in order to underscore her introverted nature. When she cries, she does not want to be seen, so draw her with her hands completely covering her face.

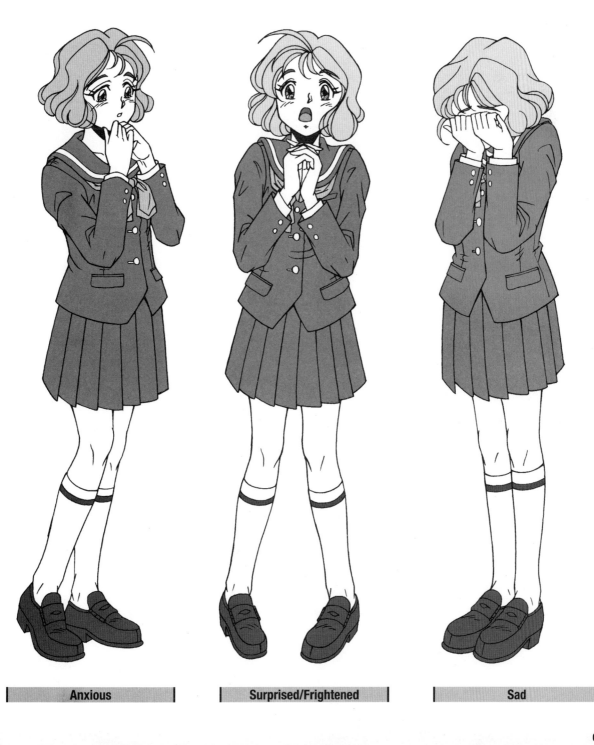

| Anxious | Surprised/Frightened | Sad |

The Smart Aleck: Facial Expressions

Even though this character is also a younger cast member, if the Cute, Younger Girl is a dreamy romantic, the smart aleck is a realist. Draw her with long, tapered eyebrows to evoke her sassy, cheeky nature. Contradictions created though combining childlike elements, such as a small face with a pointy chin and wide, round eyes with sensual elements, such as long, wavy hair or beauty marks, draws out the charm of this character.

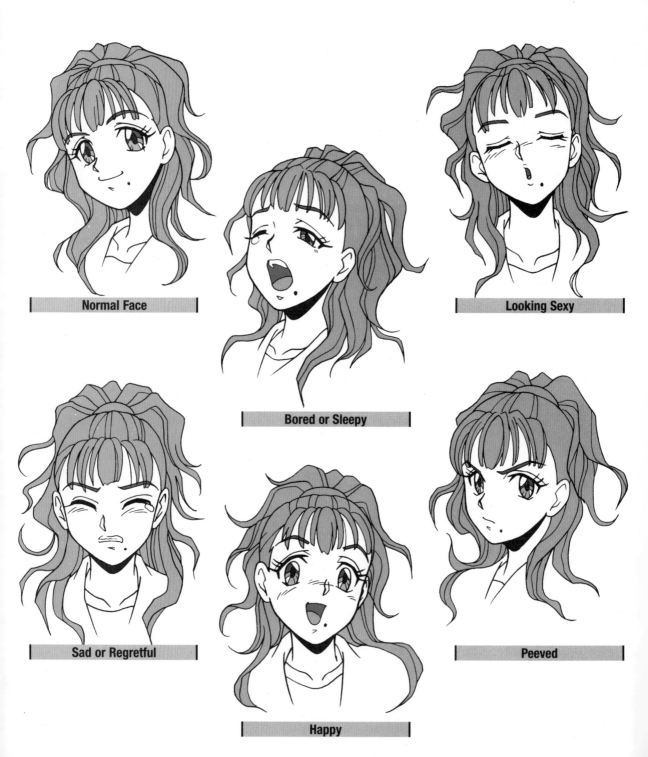

Normal Face

Looking Sexy

Bored or Sleepy

Sad or Regretful

Peeved

Happy

The Smart Aleck: Body Language & Emotions

This character will often assume real-life poses. An artist can get ideas just by flipping through magazines or observing young women around town. This character is given to both daring to show candid, unguarded views of herself as well as conversely displaying bravado and assuming a challenging stance. She is most commonly shown with her feet apart with her backside lowered. Experiment with different hand gestures: show her making the peace sign, with her fists clenched (boxer pose), or bringing her fingers to her eyes.

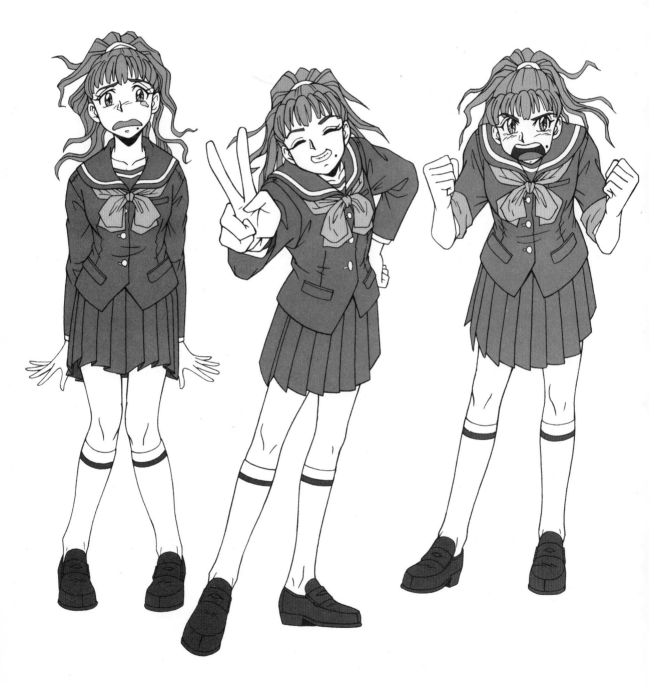

| **Suddenly Drained** | **Showing the Peace Sign (A key pose)** | **Angry and Indignant** |

The Heroine

The Heroine is overly innocent and trusting and tends toward gullible. Consequently, when reacting in astonishment, her facial expression and gestures should be exaggerated. Adding a touch of red to the cheeks suggests feelings of foolishness. Showing this character out of her uniform can create a scene with impact: dressing her in ultra-feminine clothes contrasts with the character's normal appearance, giving her extra appeal.

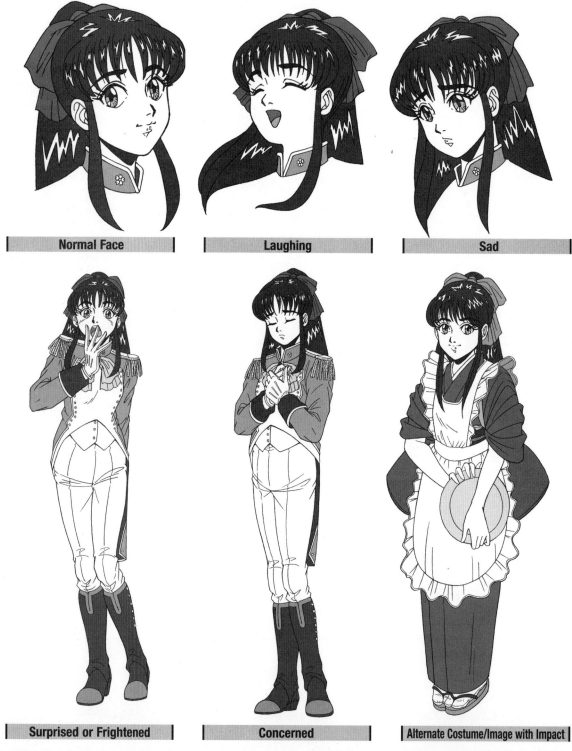

| Normal Face | Laughing | Sad |

| Surprised or Frightened | Concerned | Alternate Costume/Image with Impact |

The Honor Roll Student

This character is supposed to be academic and nerdy, so keep her movements and gestures understated and low key. She acts first on logic rather than emotion, so even snap reactions should be minimized. Her basic personality should be retained even when shown in maid's dress, an alternate costume to her standard uniform. When drawing her standing, use moderately stiff, straight lines.

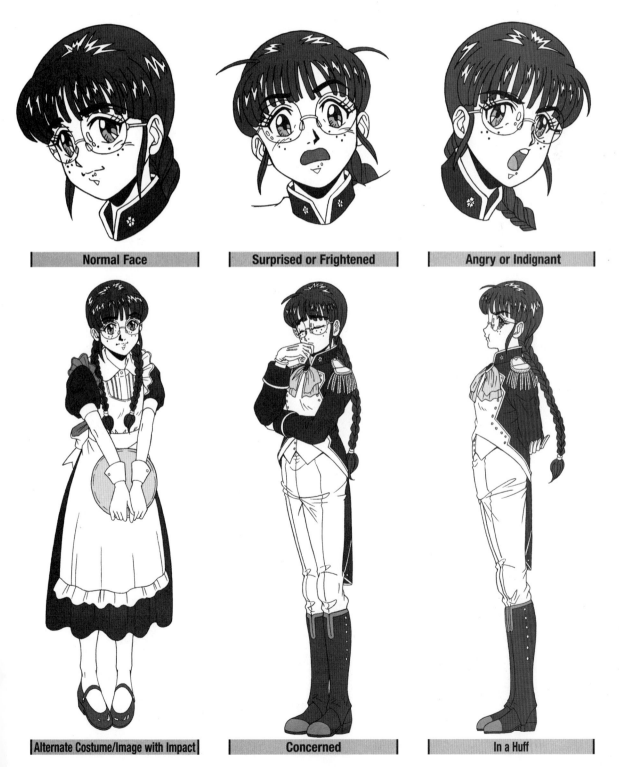

| **Normal Face** | **Surprised or Frightened** | **Angry or Indignant** |

| **Alternate Costume/Image with Impact** | **Concerned** | **In a Huff** |

The Cute, Younger Girl

Her innocence and childlike nature mean she wears her emotions on her sleeve. Draw her with both elbows and knees spread out, when showing her cry, have her bawl away in full view, draw her frequently with her mouth wide open and use other such effective techniques to illustrate her honest, unguarded nature. Draw her eyes and mouth proportionally large compared to the rest of her face to underscore her candid nature.

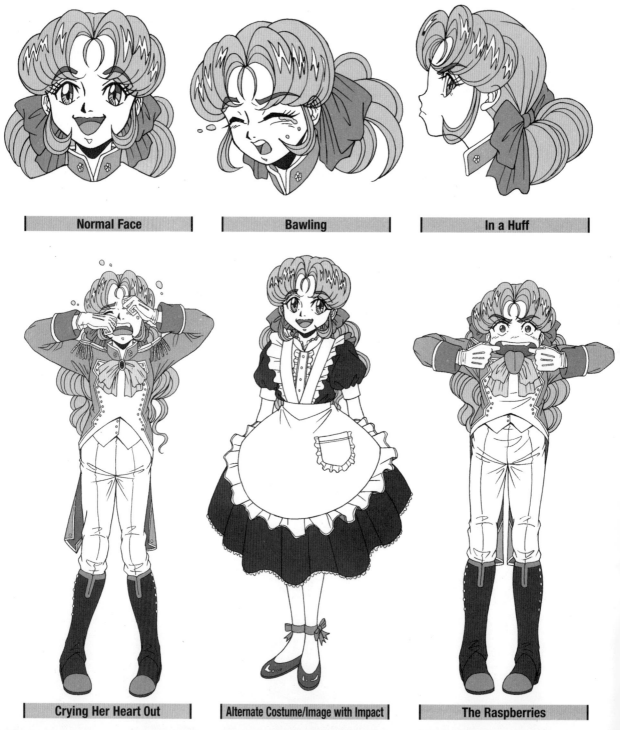

Normal Face

Bawling

In a Huff

Crying Her Heart Out

Alternate Costume/Image with Impact

The Raspberries

The Athletic Girl

This is a spunky, optimistic character; consequently, her movements and gesture tend toward boyish. The key to drawing her successfully is to show her with fists clenched, with both heels planted firmly on the ground, and with tension in the fingers. Maid dress is not suited to this character's personality. This is the sole character where using a waiter's uniform or other such masculine dress as an alternate costume would better reflect her personality.

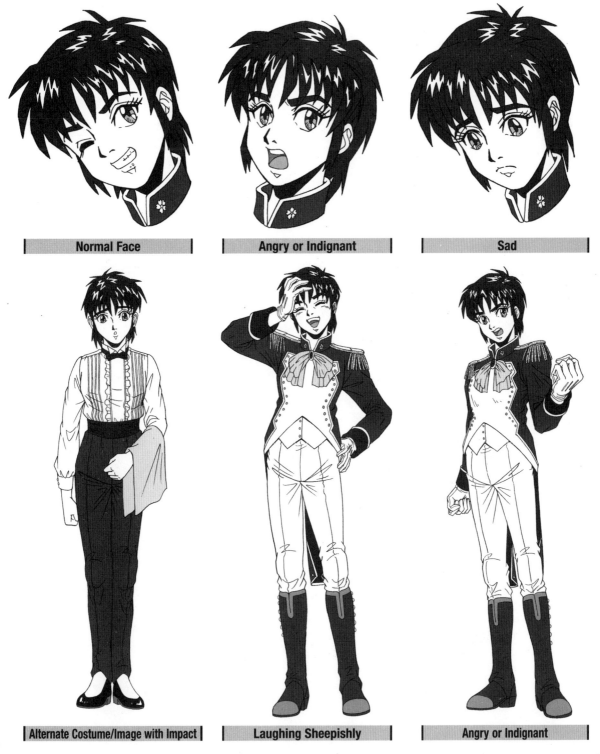

| Normal Face | Angry or Indignant | Sad |

| Alternate Costume/Image with Impact | Laughing Sheepishly | Angry or Indignant |

Action Games: The Heroine

The Heroine is capable of some really impressive moves, quite unexpected of such a slender figure. With a spunky, cheerful, and a fiery temperament, this character often appears in action games where the player progresses by clearing stages. While outspoken and having a strong sense of justice and aversion to unfairness, she is simultaneously tenderhearted and is unexpectedly moved to tears. Exaggerate the movements of the hands and feet to make her combat moves more visually obvious.

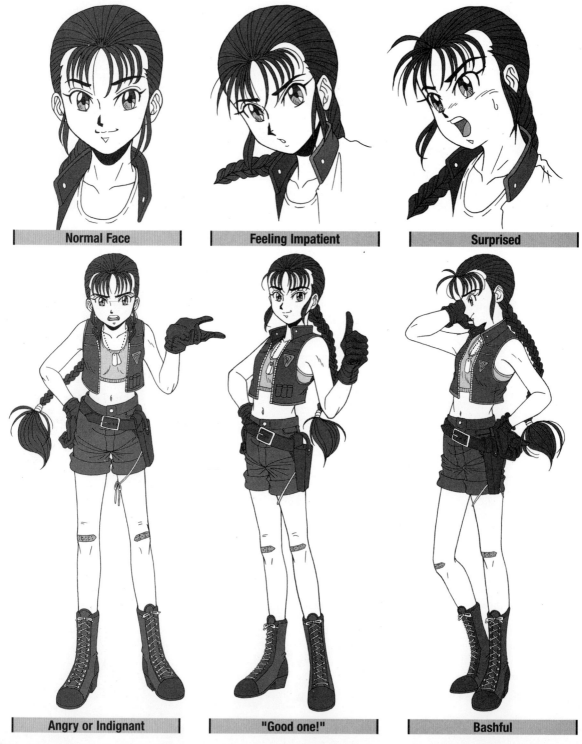

| Normal Face | Feeling Impatient | Surprised |

| Angry or Indignant | "Good one!" | Bashful |

The Heroine as a Magical Girl

The-girl-next-door-who-is-really-a-witch-type character, which now makes regular appearances in video games traces its origin to animated films. Images of this girl praying or casting a spell, as is indicative and likely obvious by the character design, appear with frequency. She is often an elementary school student, so try to picture a girl in her pre or early teens when drawing this character.

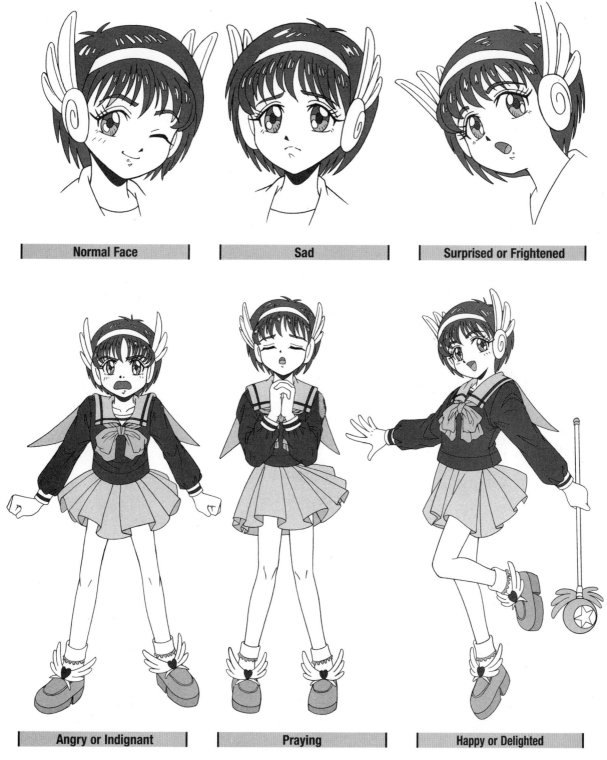

| Normal Face | Sad | Surprised or Frightened |

| Angry or Indignant | Praying | Happy or Delighted |

The Cute, Younger Girl: Half Animal

This character is likely to be dubbed "the Cat Girl," so make her mannerisms feline as well. While the teeth are not normally visible on the others, on this character, showing the upper teeth (only) is appropriate. The tail should be hung when the character feels sad or despondent and raised when happy or feeling playful. When the character jumps, exaggerate the height of her jump to make her appear more catlike.

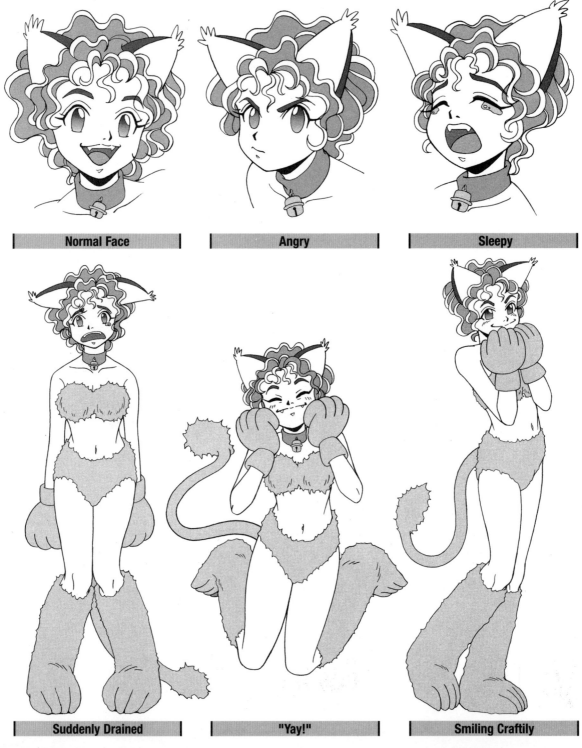

| **Normal Face** | **Angry** | **Sleepy** |

| **Suddenly Drained** | **"Yay!"** | **Smiling Craftily** |

Early Combat Games

In combat games today, there is a whole host of female characters to choose, but in early combat games, there was only one. On this page is presented what could be considered the first of all strong, yet lithe and graceful female combat characters. A head relatively smaller and legs longer than those seen on characters in regular games or animated films distinguish this character. Featuring furrowed eyebrows, the standard face displays a dignified countenance.

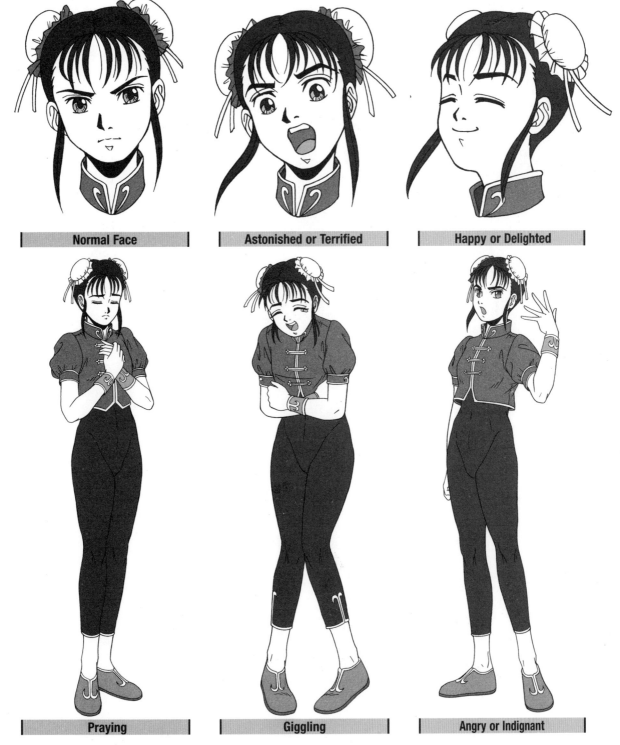

| Normal Face | Astonished or Terrified | Happy or Delighted |

| Praying | Giggling | Angry or Indignant |

No matter how skillfully you rendered the character, if she does not fit well into the background, there is no "story." The key here is **proper editing of the composition**. This may seem simple at first glance, but **it calls for a trained eye**. On the following pages, I present a few techniques in planning compositions, which effectively show off your character to her best advantage.

The Heroine

Here, we have 4 compositions that are the most successful in terms of the story. Just because the heroine is the lead character does not mean that she must always appear in the center of the screen.

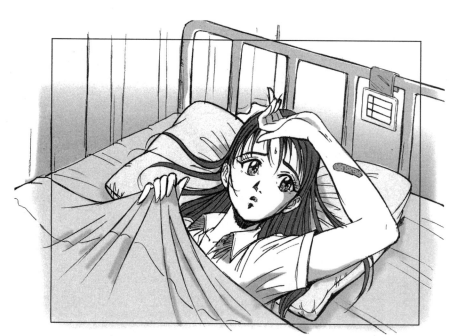

The Heroine and other characters with gentle dispositions have the tendency to fall ill or become injured. Scenes taking place in **the school nurse's office or hospital** constitute an important development in terms of the story's progression. The scene almost always features the character with **hair in disarray and a metal frame bed.** Try to draw the scene from a downward angle, picturing how another character might view the scene, rather than from directly above the bed. Opting for a bust shot rather than a drawing of the full figure will allow you to emphasize frailty in the character's face.

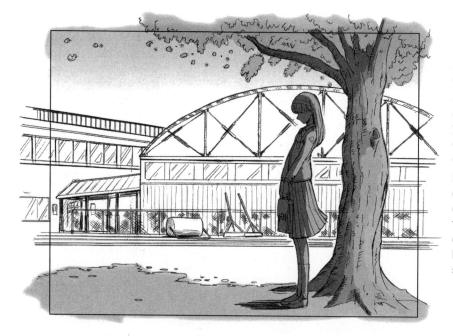

"**The tree in the corner of the schoolyard**" is an important prop, capable of effective use in a wide variety of scenes. Using **a cherry, a gingko**, or other seasonal tree allows suggestion of the time of year. Setting the scene in a famous or legendary venue is also effective.

In such scenes, long shots of the character are often used before dialogue begins. Positioning the tree to the right, and drawing the character closely to its side, **facing left** evokes a mood of waiting for something to happen.

The Heroine

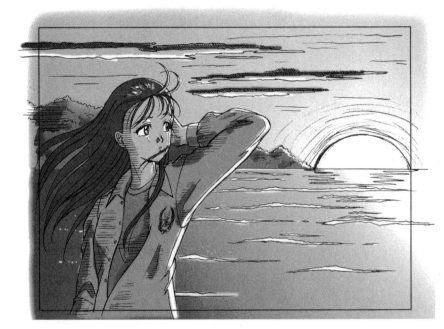

This sort of scene is often used when our hero, while at summer camp, takes a walk to the beach to see the ocean or the sunset and finds...her. What an opportunity! But, our hero is at a loss as to how he should strike up a conversation.

Suggest a dazzling sunset by positioning the character to the left and have backlighting reflect off her hair, **creating a glowing outline haloing her hair. A setting sun and a breeze gently blowing her hair** are essential elements to this scene. Moving the horizon line above center will add to the mood of scenes like this.

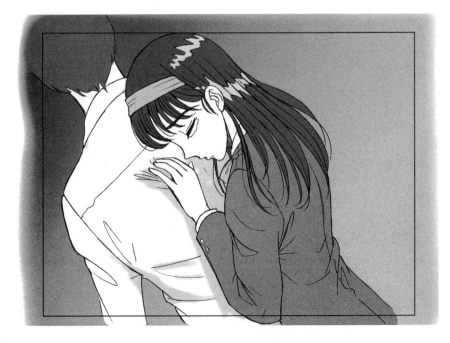

In this scene, after becoming intimate, the story takes a turn, and now we see the heroine, while weeping, nestle close to the hero. **Composing the scene from an angled perspective** generates a sense of unbalance, which in turn causes the game's player to wonder what has taken place. **Showing only the back views** of the male character, cropping the head of the character to hide it from the player's view are effective techniques. This sort of scene seems for the most part unique to Japanese games.

The Honor Roll Student

Since this character is an Honor Roll Student, more of her scenes take place at school than any of the other characters. Combining personality characteristics, by showing her as dour "hall monitor" who is really just a softy at heart, draws out the character's charm.

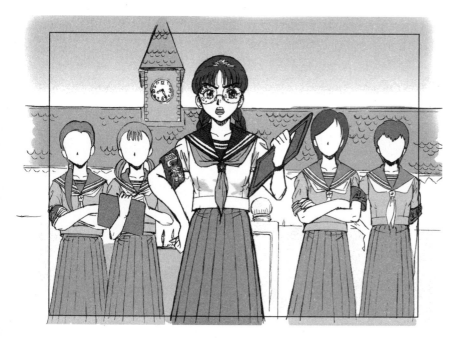

"So, tardy again, are we? Give us a look at your student handbook!" The scene is morning, at the school's front gate. School monitors stand in a row. The game player is usually not a school monitor, so he or she will inevitably butt heads with the Honor Roll Student in a scene like this. In order to make our glasses-sporting sweetie more prominent, have her stand not shoulder to shoulder with the rest, but in front, drawing her **about a head taller than the rest**. Also, to make her seem even more imperious, compose the scene **from a moderate, low angle**, elevating her head to almost the top of the screen. Cropping off her legs makes her appear even larger. Subtle placement of the school clock within the scene further illustrates that the player has been "tardy."

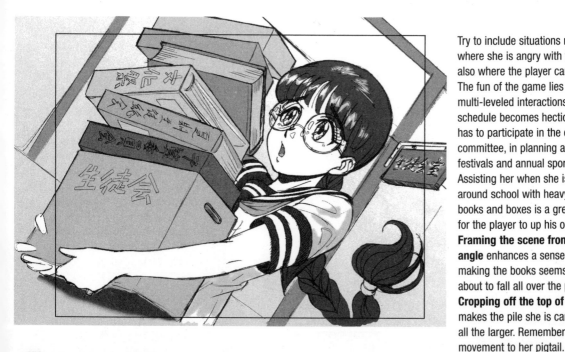

Try to include situations not only where she is angry with the player, but also where the player can assist her. The fun of the game lies in these multi-leveled interactions. This girl's schedule becomes hectic when she has to participate in the class budget committee, in planning annual school festivals and annual sport meets. Assisting her when she is running around school with heavy piles of books and boxes is a great opportunity for the player to up his or her points. **Framing the scene from a tilted angle** enhances a sense of unbalance, making the books seems as if they are about to fall all over the place. **Cropping off the top of the books** makes the pile she is carrying seem all the larger. Remember to give movement to her pigtail.

The Honor Roll Student

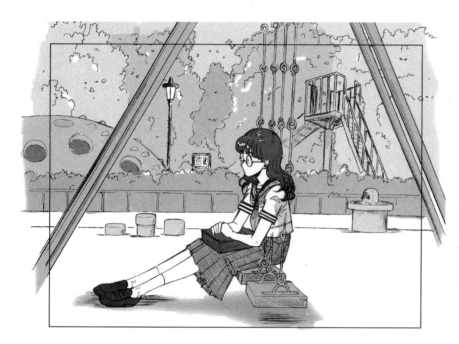

Here, she is shown seated on a swing, alone in a park on the way home. Showing an unexpected side to this character, who is usually oh-so sober and stern, makes her more appealing. Showing her **braids loose** makes the player wonder what has occurred, setting up for the next scene. Drawing her seated still on the swing, feet on the ground creates a wistful mood. **Crop off the top and sides of the swing set**, having it span beyond the screen's frame. Draw the background relatively uncluttered, leaving it void of people.

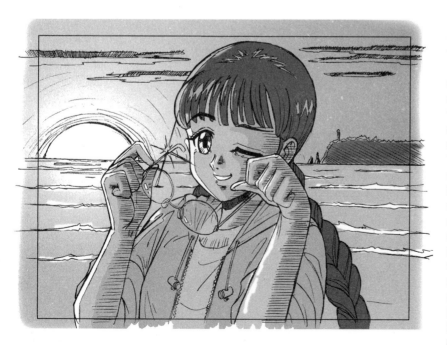

Showing this character, who is often dubbed, "brainy four-eyes," **without her glasses** is a way of impacting the viewer. An example setting is having our charming school monitor visit the beach while at summer camp, feel sentimental, and remove her glasses to swab at a few tears. This is a scene that can also be used for the other characters. However, being able to remove eyeglasses is the domain of this character alone. The horizon line should be placed about mid-screen. Show her eyes glistening with reflected backlight from the setting sun. Make a clear distinction between **areas touched by sunlight and areas swallowed in the shade of dusk**. This better conveys the scene's mood.

The Cute, Younger Girl

This character is childlike and in constant motion. Since she has an almost angelic face, make close-ups of this character as "close up" as possible. This character also tends to use her entire body to express herself, so make sure she fits entirely within the frame when using a long shot. This will allow her body language to be more effective.

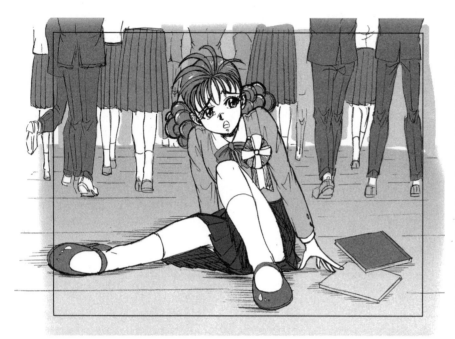

"Ouch!" In this scene, taking place at the new school term ceremony, she is knocked down by a student desperate to make the bell. The player has also fallen down, so **the perspective is drawn from a low angle**. The horizon line is just high of center. The characters standing in the background are also shown from an upward angle. **Draw them with their upper bodies cropped by the screen's frame. Having the floorboards gradually become smaller is an effective technique** for generating a sense of depth. Scattering notebooks and handouts about emphasizes the degree of impact when she was bumped.

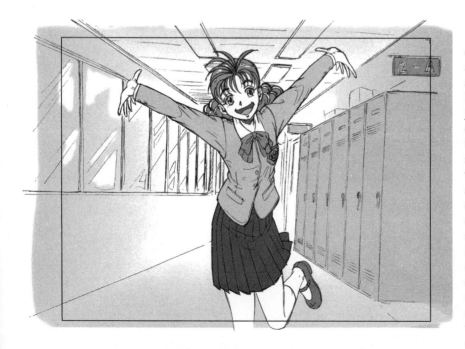

"Hi, you guys! What's up?" This character has the annoying habit of appearing just when the player is about to make his move on his love interest. In actuality, she is just a pest, but try to give her a cute, charming air and exaggerate her gestures and movements. The screen's frame crops the edges of the windows and lockers as they approach the picture plane. This composition creates the impression of the scene continuing past the screen's frame. Draw the hallway's line crossing at the center of the composition to **exaggerate a sense of depth. Positioning the character in the center with both arms spread** makes for a flamboyant, larger-than-life entrance.

The Cute, Younger Girl

This character pops up in all sorts of locations, giving nary a thought to propriety. Once on familiar terms, she will approach the player with the innocence of a child. **Close-ups reveal every flaw**, so take extra care with executing such scenes. Cropping off the top of her head creates the feeling of the character drawing all the nearer. Add highlights to the tops of her irises to illustrate that she is looking up at the player. Since this is a **downward perspective**, the neck is almost hidden from view. Such scenes are more effective without a background added.

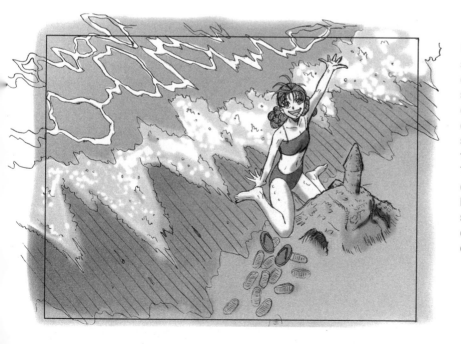

In this scene, our girl makes a surprise visit while at summer camp. In order to emphasize the sense of looking down and discovering her there, **omit drawing in the sky**. Show her seated, plunked down on the sand to emphasize her childlike nature. To emphasize a sense of depth, **draw the waves breaking on the beach at an angle**. Adding a sandcastle will make it easier to create the sense that she is seated on the sand.

The Bad Girl

The Bad Girl's personality comes out more in scenes of private life than at school. A motorcycle and guitar are typical props for this character. Use primarily long shots for the Bad Girl. Close-ups should be kept to a moderate length to maintain a sense of aloofness.

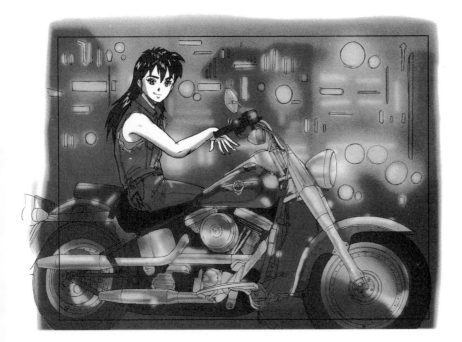

"Don't see you around here much," she tosses at the player in a street night scene. School scenes of her perpetually alone and displays of diametrically opposite emotions bring out this character's depth. **Any further cropping of the motorcycle will make it difficult to distinguish**, so try to show as much as possible. Adding intense highlights to metallic areas creates the illusion of reflecting downtown neon lights. **Avoid adding too much detail to the background**: simply drawing lights will give you more effective results. Leaving out the sky will better create the sense of actually being on the street with her.

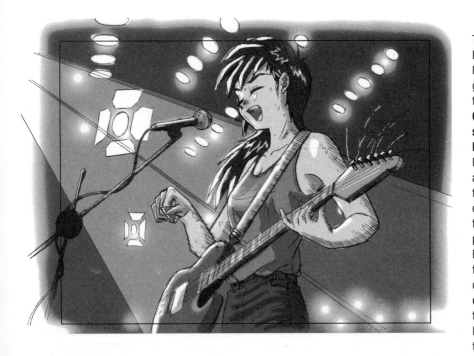

This scene shows our girl singing her heart out at a club downtown. If the character is right-handed, the guitar should be held with the neck to the left. A guitar has 6 strings. **Cropping the top of the head just slightly when drawing from a low angle** evokes the sense of looking up, making the character appear larger. Drawing all the way to her feet also requires that you draw the amp and cords, so framing from the waist up produces a cleaner composition. Rather than drawing the spotlight falling directly on her from overhead, draw it coming from **an oblique angle somewhere in front** of the character, with the light source somewhere outside of the frame. Avoid drawing a cluttered background.

The Bad Girl

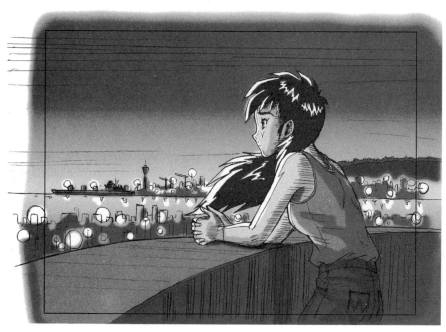

This is an evening scene of the character at a park, standing quietly gazing at the ocean. It is important to show other sides to this character other than just her "bad girl" image. Keep the direction of her gaze vague to make it more difficult for the player to make his or her approach. Drawing the handrail wider toward the picture plane and tapering toward the background generates a sense of depth. Vary the sizes of the town's lights on the opposite bank. Giving the composition an expansive sky and cropping off her legs will generate the mood desired. Make the uppermost portion of the sky the darkest, **gradually lightening as it moves down** toward the ground plane.

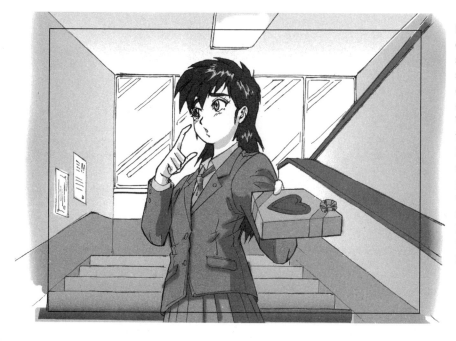

In this scene, after having assisted our girl with motorcycle repairs or saving her from unsavory ruffians, she passes the player in the corridor and unexpectedly calls out. This could also serve as a Valentine's Day scene. Drawing this character averting her gaze to hide her embarrassment more effectively brings out her true personality. Use oblique angles with the gift-wrapped box **to suggest volume and depth. Including the ceiling** evokes the feeling of looking up from the bottom of the stairs.

The Athletic Girl

This girl has been an athlete since childhood. Make an effort to give the composition a sense of speed or movement in order to bring out this aspect of her personality. Abstract backgrounds popular to manga, such as roaring flames or streak lines are an effective touch. I had been presenting this character solely with short hair. When showing her with long hair, have it tied back in a neat ponytail.

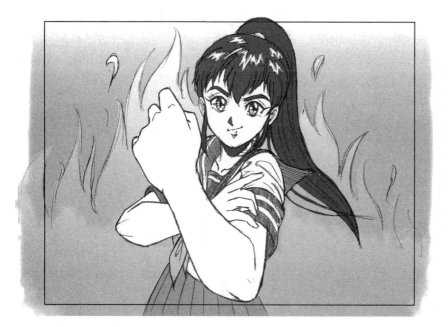

"Think you can take me?" In this scene she is challenging the player. Distort and exaggerate the size of the hand, which is thrust toward the viewer. Add flames to the background to suggest her fighting spirit. Showing **the left hand thrust forward** makes for a more composed image. **Center the character**, having the bottom of the frame crop off her lower body. This creates a stronger impact. Remember to give the hair movement.

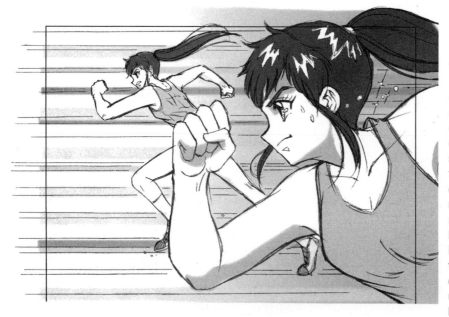

Here, we see our girl running with all her might. When you would like to show the full character running, but at the same time are looking to convey the magnetism of her determined expression, there is the option of drawing **a long shot and close-up simultaneously in the same scene**. The key is to show the character and her echo overlapping. Having the character **run from right to left** makes for a more effective composition. Backgrounds streaks are rendered in sets of 2 or 3 lines, drawn thinner than those used in the character's outline. For the close-up, including only the upper half of her body evokes a sense of speed.

The Athletic Girl

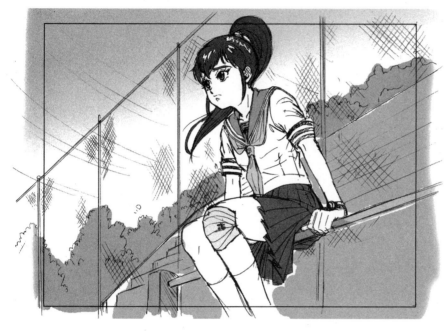

In this scene, our girl, injured, is unable to participate in a sports meet. **Characters in games do not normally sustain injuries**. Not only does this limit their movements, but it also means twice as many graphics must be drawn for the character. Still, significant injuries requiring that the character be hospitalized do constitute major story developments.

Drawing the character leaning forward illustrates her anxious emotional state. A high angle would have obscured her face from view, so a low angle was used here. Place her bandage somewhere in plain sight. Including all of the fence's links would clutter up the background, so instead only draw a few links here and there.

This is a dialogue scene where she, after being injured, is given a piggyback ride home. In order to show the situation properly, a long view showing the two in their entirety would also be necessary, but a close-up of this sort is more effective **when emphasizing their verbal interaction or facial expressions**. Extending the characters' heads and the elbow beyond the composition's frame concentrates the viewer's attention on the face. Since this is a scene of a piggyback ride, use an upward perspective.

The Sexy Older Girl

This is a more mature character, often in a position superior to that of the player. Consequently, she is usually drawn with a leisurely air. Scenes with a sexual tinge are this character's domain. When drawing such a scene, make her appear as if amused by the player.

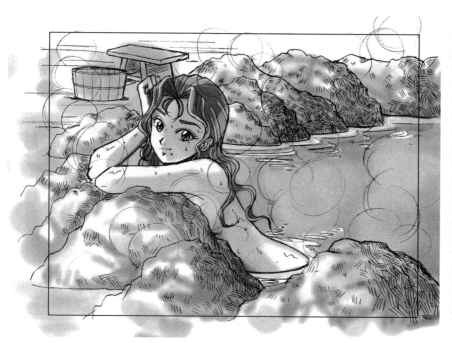

This is a provocative scene showing our girl in an outdoor hot spring. This sort of setting often consists of a chance encounter with the player when on a hot spring vacation. Since the scene is drawn from the player's perspective, **a high angle is used to give the illusion of looking downward. Cutting off the hot spring midway** gives a sense of depth. Draw the steam trailing off the edges of the frame as well. Darkening the overall composition will allow the whiteness of her skin to stand out. The wooden pail and bench are props designed to illustrate further that the scene takes place at a hot spring.

Here we see our girl at the shore. Although this is still the Sexy Older Girl, the sight of her barefoot, wearing a dress gives her **a gentle air**. Show a full view of the character, having her walk toward the picture plane. **Omitting the sky and including only the sea** in the background evokes a romantic mood. Add somewhat large reflections to the waves creates the sense of a sun-drenched beach. In contrast, leaving the character in shadow, keeping her facial expression indistinct will add impact to the next scene showing a close-up of the character.

The Sexy Older Girl

This popular pose for our girl shows **her looking down at the player, offering an alluring view**. The sight of her cleavage emphasizes her seductive appeal. **Distorted hexagons used to suggest the sun's rays** give the sense of a blazing sun. **Since this girl is in a position superior to that of the player, the scene is composed from an upward perspective**. Imagine that the player is laying down on the beach, looking up. Omit drawing her legs in full. She is mostly lit by backlight, but add a few white patches to where sunlight touches her body and face to give her a sense of volume.

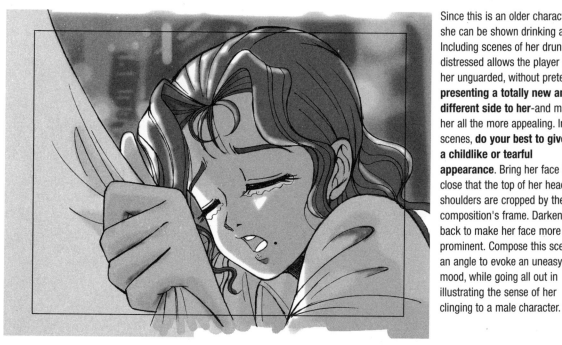

Since this is an older character, she can be shown drinking alcohol. Including scenes of her drunk or distressed allows the player to see her unguarded, without pretense, **presenting a totally new and different side to her**-and making her all the more appealing. In such scenes, **do your best to give her a childlike or tearful appearance**. Bring her face in so close that the top of her head and shoulders are cropped by the composition's frame. Darken her back to make her face more prominent. Compose this scene at an angle to evoke an uneasy mood, while going all out in illustrating the sense of her clinging to a male character.

Crash Course in Editing II

Drawing by Yoko Tagami
Kawasaki, Kanagawa Prefecture

In this drawing, we see the artist has added to her costume design a few fanciful, magical elements. The head to body ratio is well balanced; yet the figure lacks a sense of weight and volume. Unless you are working merely on a design sketch, take care to prevent your drawing from becoming too symmetrical: it can cause your artwork to lose a sense of movement.

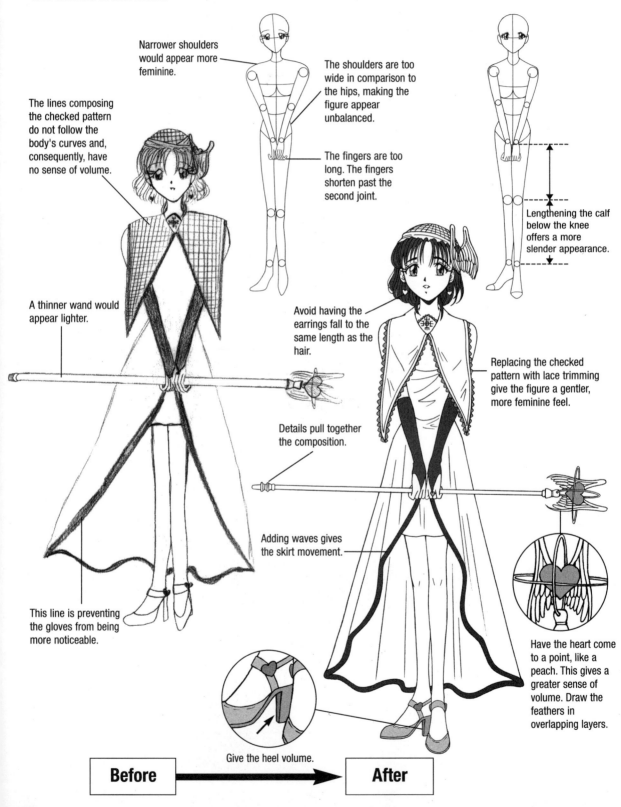

Narrower shoulders would appear more feminine.

The lines composing the checked pattern do not follow the body's curves and, consequently, have no sense of volume.

The shoulders are too wide in comparison to the hips, making the figure appear unbalanced.

The fingers are too long. The fingers shorten past the second joint.

Lengthening the calf below the knee offers a more slender appearance.

A thinner wand would appear lighter.

Avoid having the earrings fall to the same length as the hair.

Replacing the checked pattern with lace trimming give the figure a gentler, more feminine feel.

Details pull together the composition.

This line is preventing the gloves from being more noticeable.

Adding waves gives the skirt movement.

Have the heart come to a point, like a peach. This gives a greater sense of volume. Draw the feathers in overlapping layers.

Give the heel volume.

Before → **After**

062

Uniforms and Costumes

Recently, a variety of uniform designs, including those by brand names, have been making their appearance on the market, but you should make sure that you are at least able to draw a standard sailor suit and jacket. Once you become adept at drawing uniforms, do a study of the various articles composing a uniform and try your hand at creating your own original design. The following pages present a few variations based on uniforms actually available in stores.

Sailor Suits

The sailor suit is an eternal item and essential to animated scenes taking place at school or to romance simulation games. As the name implies, it was derived from those uniforms worn by sailors enlisted in the navy. Add idiosyncratic touches, like a short skirt just skimming past her bottom or thick, scrunched socks, when you are looking to emphasize the character's individuality.

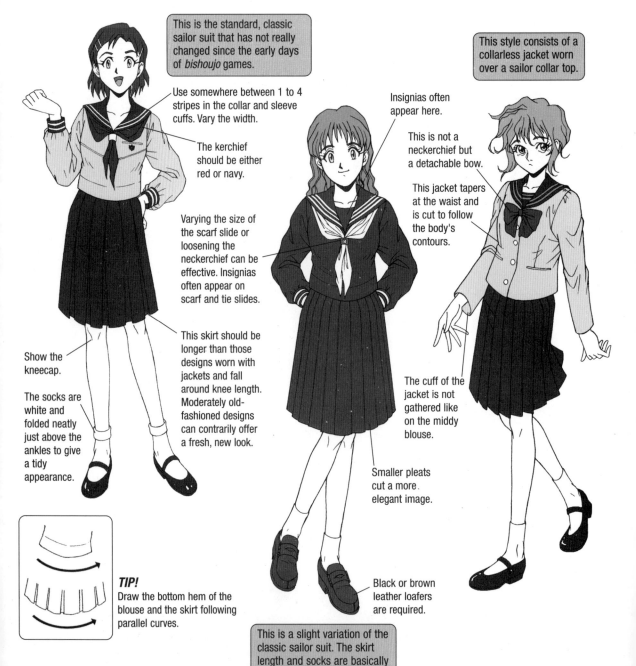

This is the standard, classic sailor suit that has not really changed since the early days of *bishoujo* games.

Use somewhere between 1 to 4 stripes in the collar and sleeve cuffs. Vary the width.

The kerchief should be either red or navy.

Varying the size of the scarf slide or loosening the neckerchief can be effective. Insignias often appear on scarf and tie slides.

Show the kneecap.

The socks are white and folded neatly just above the ankles to give a tidy appearance.

This skirt should be longer than those designs worn with jackets and fall around knee length. Moderately old-fashioned designs can contrarily offer a fresh, new look.

This style consists of a collarless jacket worn over a sailor collar top.

Insignias often appear here.

This is not a neckerchief but a detachable bow.

This jacket tapers at the waist and is cut to follow the body's contours.

The cuff of the jacket is not gathered like on the middy blouse.

Smaller pleats cut a more elegant image.

Black or brown leather loafers are required.

TIP!
Draw the bottom hem of the blouse and the skirt following parallel curves.

This is a slight variation of the classic sailor suit. The skirt length and socks are basically the same design.

Other Designs

Sailor suits have different looks, depending on whether it is summer or winter. Alter your sailor suits' designs to match the event or season. This will give a sense of the time of year.

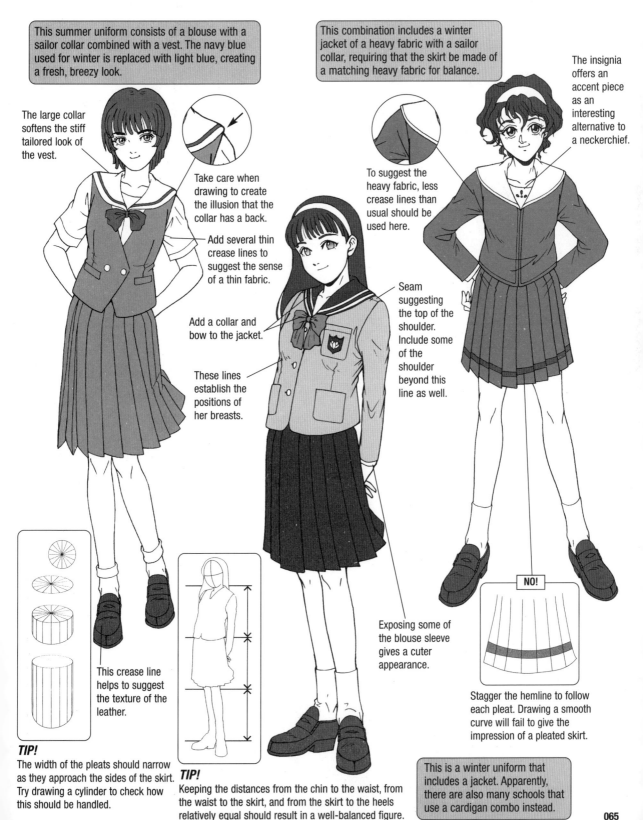

This summer uniform consists of a blouse with a sailor collar combined with a vest. The navy blue used for winter is replaced with light blue, creating a fresh, breezy look.

This combination includes a winter jacket of a heavy fabric with a sailor collar, requiring that the skirt be made of a matching heavy fabric for balance.

The insignia offers an accent piece as an interesting alternative to a neckerchief.

The large collar softens the stiff tailored look of the vest.

Take care when drawing to create the illusion that the collar has a back.

Add several thin crease lines to suggest the sense of a thin fabric.

To suggest the heavy fabric, less crease lines than usual should be used here.

Add a collar and bow to the jacket.

These lines establish the positions of her breasts.

Seam suggesting the top of the shoulder. Include some of the shoulder beyond this line as well.

This crease line helps to suggest the texture of the leather.

Exposing some of the blouse sleeve gives a cuter appearance.

NO!

Stagger the hemline to follow each pleat. Drawing a smooth curve will fail to give the impression of a pleated skirt.

TIP!
The width of the pleats should narrow as they approach the sides of the skirt. Try drawing a cylinder to check how this should be handled.

TIP!
Keeping the distances from the chin to the waist, from the waist to the skirt, and from the skirt to the heels relatively equal should result in a well-balanced figure.

This is a winter uniform that includes a jacket. Apparently, there are also many schools that use a cardigan combo instead.

Blazers and Jackets

Recently, the blazer/skirt combination has enjoyed more popularity than the sailor suit, and it should be easy to find models for reference on the train or around the neighborhood. The blazer has a highly tailored appearance, so couple it with a skirt shorter than that you would use with the sailor suit to give the character a cuter look.

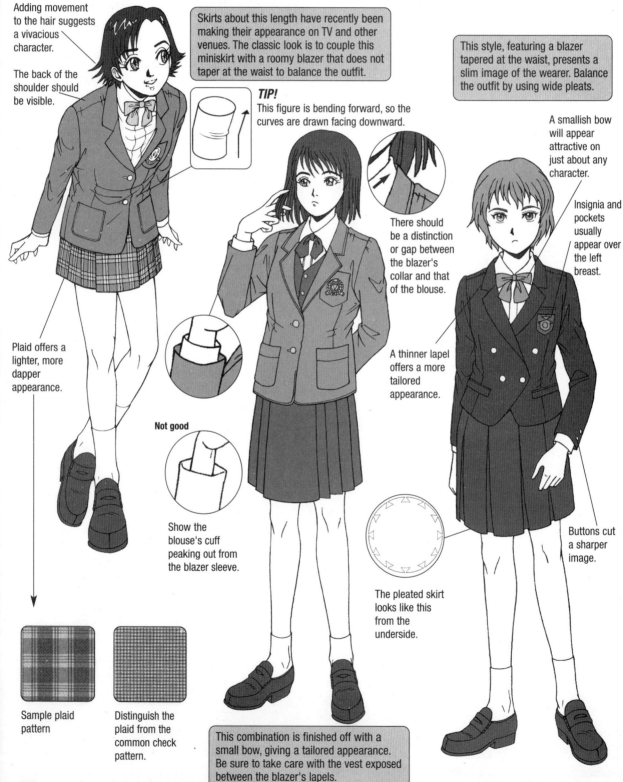

Adding movement to the hair suggests a vivacious character.

The back of the shoulder should be visible.

Skirts about this length have recently been making their appearance on TV and other venues. The classic look is to couple this miniskirt with a roomy blazer that does not taper at the waist to balance the outfit.

TIP!
This figure is bending forward, so the curves are drawn facing downward.

This style, featuring a blazer tapered at the waist, presents a slim image of the wearer. Balance the outfit by using wide pleats.

A smallish bow will appear attractive on just about any character.

Insignia and pockets usually appear over the left breast.

Plaid offers a lighter, more dapper appearance.

There should be a distinction or gap between the blazer's collar and that of the blouse.

A thinner lapel offers a more tailored appearance.

Not good

Show the blouse's cuff peaking out from the blazer sleeve.

The pleated skirt looks like this from the underside.

Buttons cut a sharper image.

Sample plaid pattern

Distinguish the plaid from the common check pattern.

This combination is finished off with a small bow, giving a tailored appearance. Be sure to take care with the vest exposed between the blazer's lapels.

Other Designs

A jacket is not just a jacket, and different designs are created by varying the cut of the collar or hemline. When using a jacket with an elaborate design, pair it with a skirt that is plain in color and design to balance the outfit.

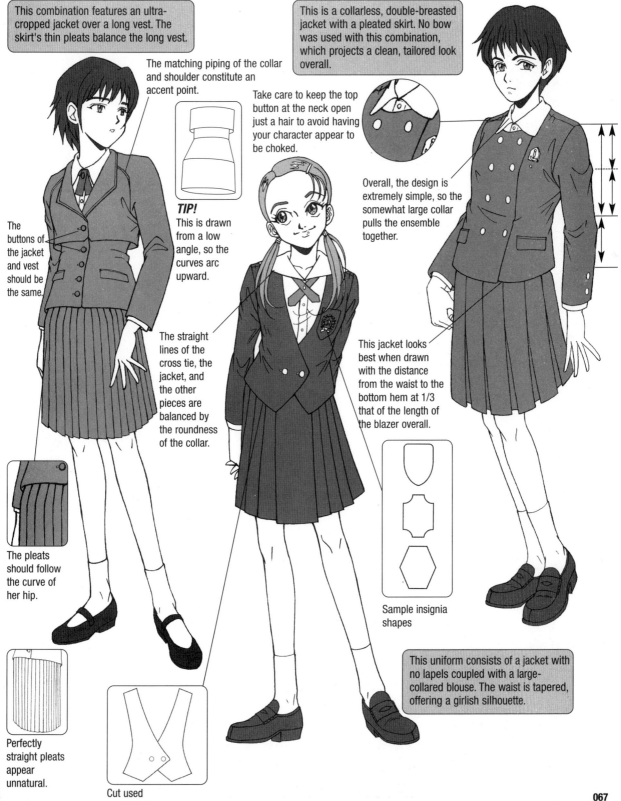

This combination features an ultra-cropped jacket over a long vest. The skirt's thin pleats balance the long vest.

The matching piping of the collar and shoulder constitute an accent point.

This is a collarless, double-breasted jacket with a pleated skirt. No bow was used with this combination, which projects a clean, tailored look overall.

Take care to keep the top button at the neck open just a hair to avoid having your character appear to be choked.

TIP!
This is drawn from a low angle, so the curves arc upward.

The buttons of the jacket and vest should be the same.

Overall, the design is extremely simple, so the somewhat large collar pulls the ensemble together.

The straight lines of the cross tie, the jacket, and the other pieces are balanced by the roundness of the collar.

This jacket looks best when drawn with the distance from the waist to the bottom hem at 1/3 that of the length of the blazer overall.

The pleats should follow the curve of her hip.

Sample insignia shapes

Perfectly straight pleats appear unnatural.

Cut used

This uniform consists of a jacket with no lapels coupled with a large-collared blouse. The waist is tapered, offering a girlish silhouette.

Summer Uniforms

Everyone in Japan has likely found him or herself riding the train after the Golden Week holidays have ended [*a series of holidays concentrated in the span of one week in the end of April/beginning of May*], and the atmosphere suddenly turned cheery by the presence of high school girls in their summer uniforms. Summer uniforms tend to be of white and blue fabrics, lighter than those used in winter uniforms. Crease lines in summer uniforms should be drawn in more detail than on winter uniforms.

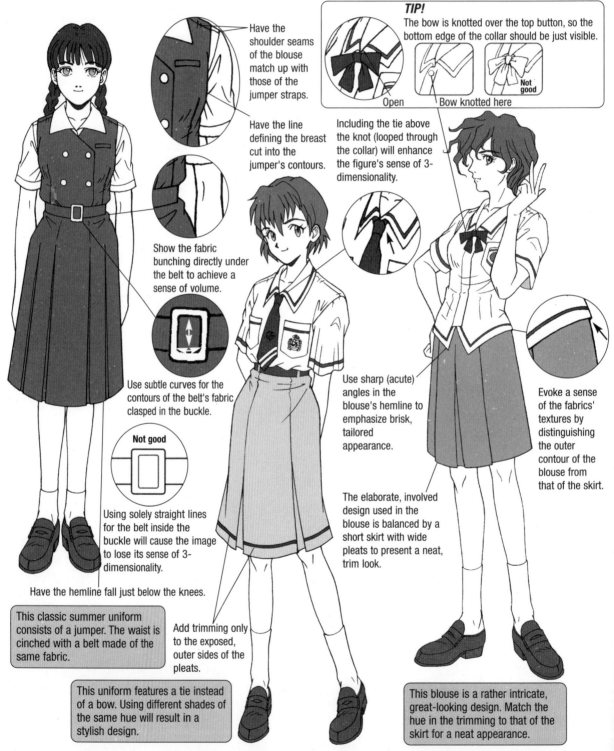

Have the shoulder seams of the blouse match up with those of the jumper straps.

Have the line defining the breast cut into the jumper's contours.

TIP!
The bow is knotted over the top button, so the bottom edge of the collar should be just visible.

Open
Bow knotted here
Not good

Including the tie above the knot (looped through the collar) will enhance the figure's sense of 3-dimensionality.

Show the fabric bunching directly under the belt to achieve a sense of volume.

Use subtle curves for the contours of the belt's fabric clasped in the buckle.

Not good

Using solely straight lines for the belt inside the buckle will cause the image to lose its sense of 3-dimensionality.

Have the hemline fall just below the knees.

This classic summer uniform consists of a jumper. The waist is cinched with a belt made of the same fabric.

Use sharp (acute) angles in the blouse's hemline to emphasize brisk, tailored appearance.

The elaborate, involved design used in the blouse is balanced by a short skirt with wide pleats to present a neat, trim look.

Add trimming only to the exposed, outer sides of the pleats.

This uniform features a tie instead of a bow. Using different shades of the same hue will result in a stylish design.

Evoke a sense of the fabrics' textures by distinguishing the outer contour of the blouse from that of the skirt.

This blouse is a rather intricate, great-looking design. Match the hue in the trimming to that of the skirt for a neat appearance.

Jumpers

The jumper offers a classic, girlish look, somewhat different from that of the sailor suit. Jumpers with long-sleeved blouses turn up during the transitional seasons, namely the spring and summer. In the winter, a jacket is usually worn as well.

A bolero jacket worn over a jumper in the winter creates a stylish look. When using a combination like this, avoid adding a belt or other accessory that will emphasize the waist.

TIP!
Be sure to stagger the height of contour lines used for the collar, the jumper straps, and the blouse.

You might adjust the character's appearance and give her a "European" flavor to match her clothes.

This is a full short skirt: match it with a fitted jacket to balance the outfit.

Remember to include the back of the shoulder and small creases around the waist.

Draw the collar worn on the outside of the jacket.

Use different lines for the contours of the arm and sleeve.

Make the sleeve roomy about the shoulder to give it a puffy look.

Making the collar smaller will help the bow stand out.

Having the buttons stop at the waist affords a "cuter" image than having them continue down.

Add decorative buttons instead of a belt as accent points.

Use arced lines for gathered creases.

This skirt length looks most attractive when drawn one fist length below the knee.

Use a gently undulating line for the hemline to accentuate softness. Caution: using ripples any wider than that shown here would make your character look like she just stepped out of Wonderland.

Narrow pleats offer a more girlish look. The skirt should be just below the knee to present a neat and tidy image.

This jumper is reminiscent of something an elementary school girl might wear and is better suited for less mature, "cute" characters.

This is a functional design, cut similar to an apron. Thin back straps work well with a design like this.

Cropped Jackets

These jackets, which come to just above the hips or shorter, include bolero jackets, which end at or above the waistline and are worn open in front. The cropped jacket affords a more feminine appearance than the typical blazer or jacket, and are perfect for use with the Princess-type characters. As far as school uniforms are concerned, cropped jackets are not as prevalent as sailor suits or blazer combinations, but they are still popular.

This is a bolero jacket/flared skirt combination. This design has an elegance, suggesting the wearer is from an affluent family. Long hair is more suited to this character.

NOTE!
The loops of bows tied by hand tend to droop.

Not good

This jacket has a somewhat complicated design, so it was paired with a simple skirt with minimal pleating for balance.

The forehead is exposed for a more mature hairstyle.

The colors used in the piping and the bow serve as accents. Matching the two presents a more polished appearance.

The fabric here is thick, so the surface is relatively even with little disruption.

This sophisticated design features front pleats.

Add buttons with insignia as a decorative accent. 4 to 6 should be effective.

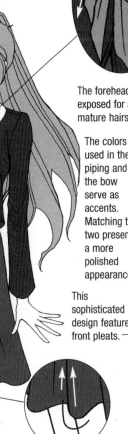

TIP!
To create the ripples in the flared skirt, draw each ripple separately, bringing the line from the hemline upward. Next, add thin vertical lines for detailed creases and ripples.

The pocket flap is attached above the tuck. Use two lines for the top and one for the bottom.

Knee-highs may be used instead of bobby socks when drawing a skirt with few pleats.

Wearing stockings instead of socks gives the character a more mature air.

Create a more sophisticated design with the same basic shoe by adding buckles and making the toe more pointed.

This genteel design features piping of a different material than that used for the rest of the jacket. The pre-tied bow is fastened with a pin to the collar, presenting a stylish image.

Collars and Pleats

Adding a collar, a bow, or pleats to a design no matter how simple, is an effective means for making the ensemble that much cuter. On this page are 3 sample designs. Use whatever points appeal to you in own, original designs.

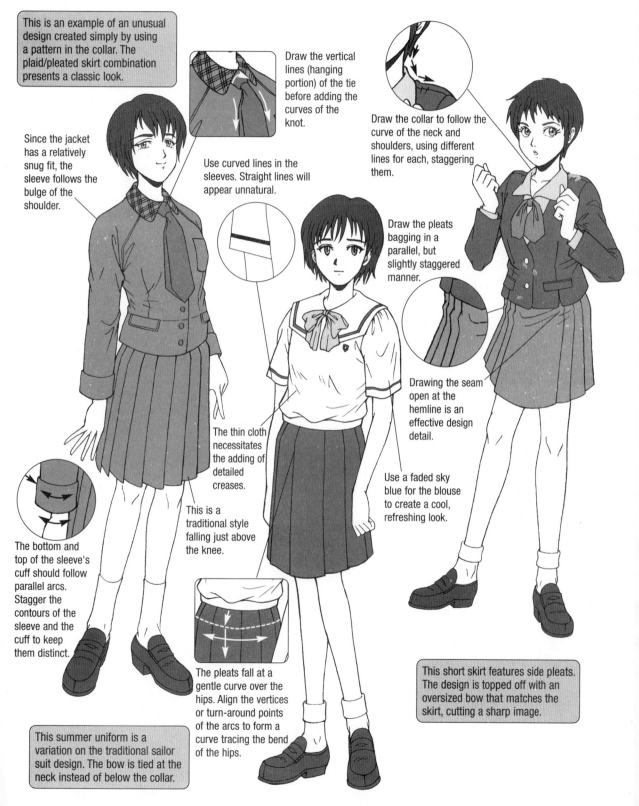

This is an example of an unusual design created simply by using a pattern in the collar. The plaid/pleated skirt combination presents a classic look.

Since the jacket has a relatively snug fit, the sleeve follows the bulge of the shoulder.

Draw the vertical lines (hanging portion) of the tie before adding the curves of the knot.

Use curved lines in the sleeves. Straight lines will appear unnatural.

Draw the collar to follow the curve of the neck and shoulders, using different lines for each, staggering them.

Draw the pleats bagging in a parallel, but slightly staggered manner.

Drawing the seam open at the hemline is an effective design detail.

The thin cloth necessitates the adding of detailed creases.

This is a traditional style falling just above the knee.

Use a faded sky blue for the blouse to create a cool, refreshing look.

The bottom and top of the sleeve's cuff should follow parallel arcs. Stagger the contours of the sleeve and the cuff to keep them distinct.

The pleats fall at a gentle curve over the hips. Align the vertices or turn-around points of the arcs to form a curve tracing the bend of the hips.

This short skirt features side pleats. The design is topped off with an oversized bow that matches the skirt, cutting a sharp image.

This summer uniform is a variation on the traditional sailor suit design. The bow is tied at the neck instead of below the collar.

Novel Uniform Designs

A flip through teen fashion magazines will leave you surprised at the number of cute uniform designs. On the following 2 pages are presented a few designs that received top rankings by high school girls.

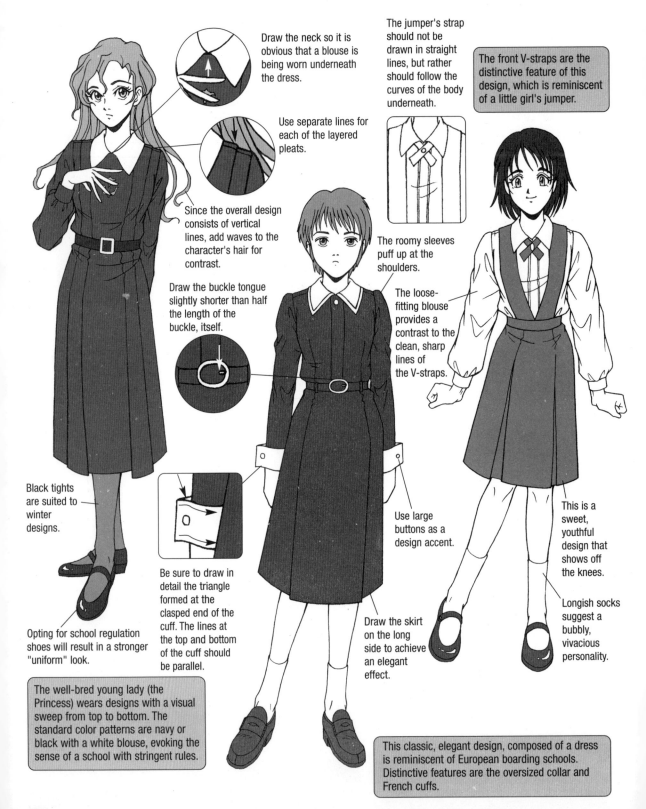

Draw the neck so it is obvious that a blouse is being worn underneath the dress.

Use separate lines for each of the layered pleats.

The jumper's strap should not be drawn in straight lines, but rather should follow the curves of the body underneath.

The front V-straps are the distinctive feature of this design, which is reminiscent of a little girl's jumper.

Since the overall design consists of vertical lines, add waves to the character's hair for contrast.

Draw the buckle tongue slightly shorter than half the length of the buckle, itself.

The roomy sleeves puff up at the shoulders.

The loose-fitting blouse provides a contrast to the clean, sharp lines of the V-straps.

Black tights are suited to winter designs.

Be sure to draw in detail the triangle formed at the clasped end of the cuff. The lines at the top and bottom of the cuff should be parallel.

Use large buttons as a design accent.

This is a sweet, youthful design that shows off the knees.

Opting for school regulation shoes will result in a stronger "uniform" look.

Draw the skirt on the long side to achieve an elegant effect.

Longish socks suggest a bubbly, vivacious personality.

The well-bred young lady (the Princess) wears designs with a visual sweep from top to bottom. The standard color patterns are navy or black with a white blouse, evoking the sense of a school with stringent rules.

This classic, elegant design, composed of a dress is reminiscent of European boarding schools. Distinctive features are the oversized collar and French cuffs.

Novel Uniform Designs

This design features a cropped jacket fitted snugly over a tiny, check print blouse. Small or fitted tops work well with large, voluminous bottoms.

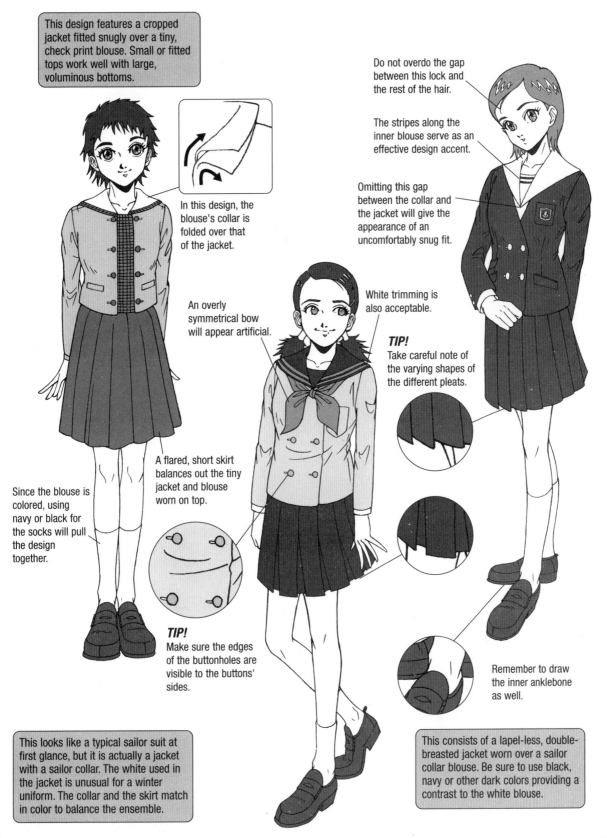

Do not overdo the gap between this lock and the rest of the hair.

The stripes along the inner blouse serve as an effective design accent.

Omitting this gap between the collar and the jacket will give the appearance of an uncomfortably snug fit.

In this design, the blouse's collar is folded over that of the jacket.

An overly symmetrical bow will appear artificial.

White trimming is also acceptable.

TIP!
Take careful note of the varying shapes of the different pleats.

Since the blouse is colored, using navy or black for the socks will pull the design together.

A flared, short skirt balances out the tiny jacket and blouse worn on top.

TIP!
Make sure the edges of the buttonholes are visible to the buttons' sides.

Remember to draw the inner anklebone as well.

This looks like a typical sailor suit at first glance, but it is actually a jacket with a sailor collar. The white used in the jacket is unusual for a winter uniform. The collar and the skirt match in color to balance the ensemble.

This consists of a lapel-less, double-breasted jacket worn over a sailor collar blouse. Be sure to use black, navy or other dark colors providing a contrast to the white blouse.

Gym Suits

Although the gym suit varies from school to school, a cotton shirt over a sports brief with laced athletic shoes seems to be the most common. It is often the case that different teams or clubs within the same school will also each have their own uniform. Track and basketball team uniforms often feature tank tops. Socks tend to be the same as those worn during class.

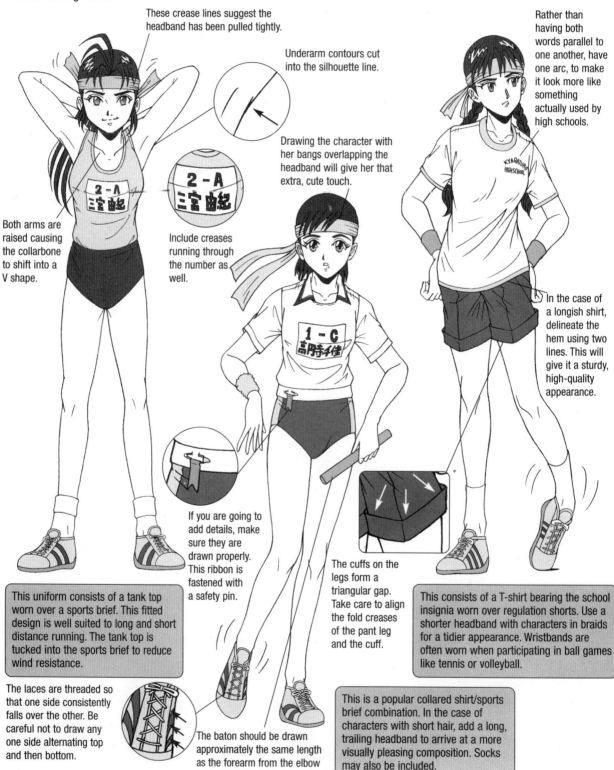

These crease lines suggest the headband has been pulled tightly.

Underarm contours cut into the silhouette line.

Drawing the character with her bangs overlapping the headband will give her that extra, cute touch.

Rather than having both words parallel to one another, have one arc, to make it look more like something actually used by high schools.

Both arms are raised causing the collarbone to shift into a V shape.

Include creases running through the number as well.

In the case of a longish shirt, delineate the hem using two lines. This will give it a sturdy, high-quality appearance.

If you are going to add details, make sure they are drawn properly. This ribbon is fastened with a safety pin.

The cuffs on the legs form a triangular gap. Take care to align the fold creases of the pant leg and the cuff.

This uniform consists of a tank top worn over a sports brief. This fitted design is well suited to long and short distance running. The tank top is tucked into the sports brief to reduce wind resistance.

This consists of a T-shirt bearing the school insignia worn over regulation shorts. Use a shorter headband with characters in braids for a tidier appearance. Wristbands are often worn when participating in ball games like tennis or volleyball.

The laces are threaded so that one side consistently falls over the other. Be careful not to draw any one side alternating top and then bottom.

The baton should be drawn approximately the same length as the forearm from the elbow to the fingertips.

This is a popular collared shirt/sports brief combination. In the case of characters with short hair, add a long, trailing headband to arrive at a more visually pleasing composition. Socks may also be included.

School Swimsuits

School swimsuits tend to cover more of the body than those sold in retail stores. Colors tend to be more conservative as well, with black and navy being popular. No other age group is capable of making these suits seem as delightfully charming as these nubile high school girls can. While there are various designs used by the swimming team and other extracurricular clubs, the most common swimsuit seems to be navy and worn with the legs bare.

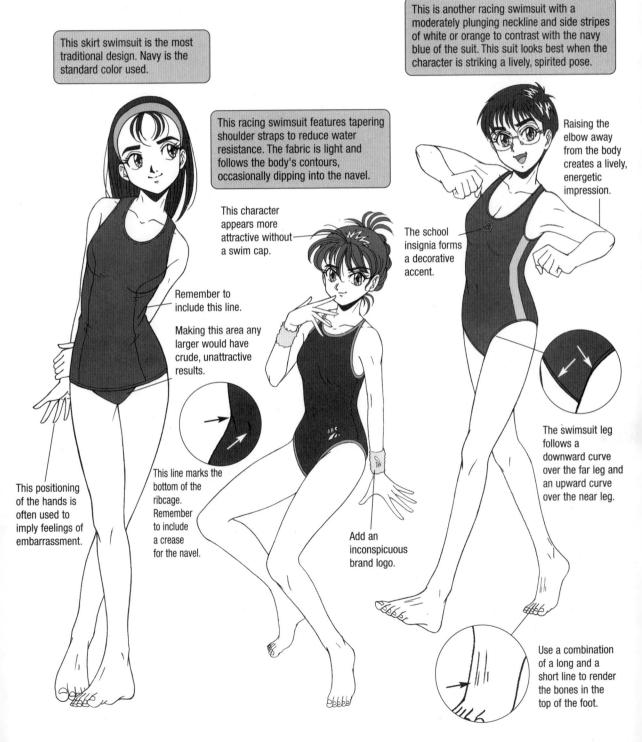

This skirt swimsuit is the most traditional design. Navy is the standard color used.

This is another racing swimsuit with a moderately plunging neckline and side stripes of white or orange to contrast with the navy blue of the suit. This suit looks best when the character is striking a lively, spirited pose.

This racing swimsuit features tapering shoulder straps to reduce water resistance. The fabric is light and follows the body's contours, occasionally dipping into the navel.

Raising the elbow away from the body creates a lively, energetic impression.

This character appears more attractive without a swim cap.

The school insignia forms a decorative accent.

Remember to include this line.

Making this area any larger would have crude, unattractive results.

This positioning of the hands is often used to imply feelings of embarrassment.

This line marks the bottom of the ribcage. Remember to include a crease for the navel.

Add an inconspicuous brand logo.

The swimsuit leg follows a downward curve over the far leg and an upward curve over the near leg.

Use a combination of a long and a short line to render the bones in the top of the foot.

While school uniforms can be used to bring out the character's personality, street clothes or clothes worn after school are particularly effective in defining the character. The following pages present popular costumes and outfits worn by characters for the various major events appearing in *bishoujo* games.

Christmas

Christmas is a major game event. Christmas Eve has a romance about it that suddenly brings the *bishoujo* character closer to the player. This is also an opportunity for the character to look all grown up in a fancy gown or dress, offering a wholly different view of our girl.

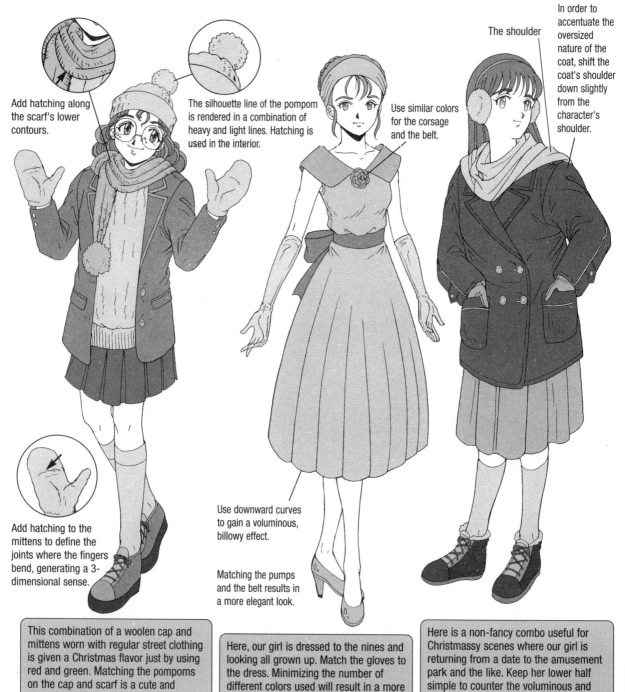

Add hatching along the scarf's lower contours.

The silhouette line of the pompom is rendered in a combination of heavy and light lines. Hatching is used in the interior.

Add hatching to the mittens to define the joints where the fingers bend, generating a 3-dimensional sense.

Use similar colors for the corsage and the belt.

The shoulder

In order to accentuate the oversized nature of the coat, shift the coat's shoulder down slightly from the character's shoulder.

Use downward curves to gain a voluminous, billowy effect.

Matching the pumps and the belt results in a more elegant look.

This combination of a woolen cap and mittens worn with regular street clothing is given a Christmas flavor just by using red and green. Matching the pompoms on the cap and scarf is a cute and effective touch.

Here, our girl is dressed to the nines and looking all grown up. Match the gloves to the dress. Minimizing the number of different colors used will result in a more elegant costume. Use of white, powder blue, cream, and other pastels will achieve a tasteful final image.

Here is a non-fancy combo useful for Christmassy scenes where our girl is returning from a date to the amusement park and the like. Keep her lower half simple to counter the voluminous and loose-fitting woolen coat on top.

Valentine's Day

Surprisingly enough, Valentine's Day does not play as large of a role in romance simulation games as one might expect. This is because a prominent Valentine's Day scene could give away the stories ending or development, essentially destroying the fun of the game. Below are a few poses the different characters strike when presenting Valentine's Day gifts. Each pose is indicative of the character's personality.

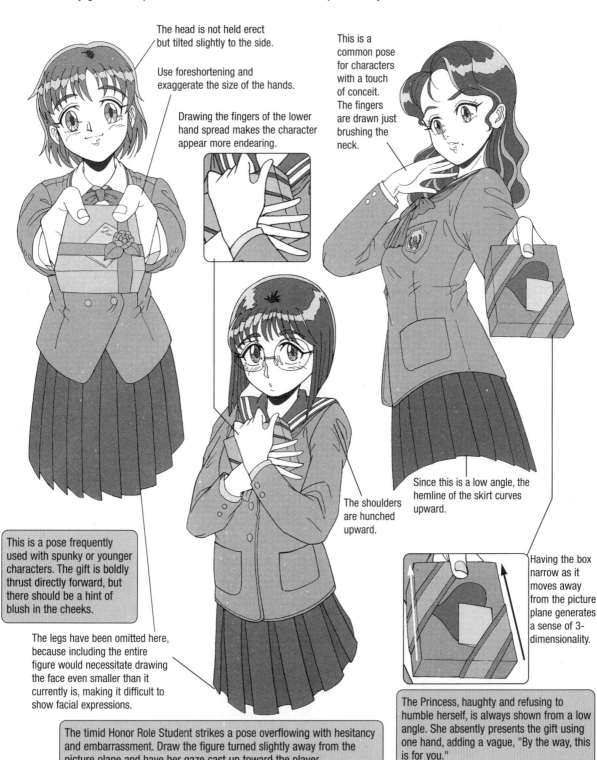

The head is not held erect but tilted slightly to the side.

Use foreshortening and exaggerate the size of the hands.

Drawing the fingers of the lower hand spread makes the character appear more endearing.

This is a common pose for characters with a touch of conceit. The fingers are drawn just brushing the neck.

The shoulders are hunched upward.

Since this is a low angle, the hemline of the skirt curves upward.

This is a pose frequently used with spunky or younger characters. The gift is boldly thrust directly forward, but there should be a hint of blush in the cheeks.

The legs have been omitted here, because including the entire figure would necessitate drawing the face even smaller than it currently is, making it difficult to show facial expressions.

Having the box narrow as it moves away from the picture plane generates a sense of 3-dimensionality.

The timid Honor Role Student strikes a pose overflowing with hesitancy and embarrassment. Draw the figure turned slightly away from the picture plane and have her gaze cast up toward the player.

The Princess, haughty and refusing to humble herself, is always shown from a low angle. She absently presents the gift using one hand, adding a vague, "By the way, this is for you."

Firework Displays

The *yukata* [*summer cotton kimono*] is the garment of choice to wear on dates to firework displays or festivals. While the *yukata* is a form of traditional Japanese dress, it tends to have less complicated decorative motifs and allows the artist more liberty with dynamic poses. Caution: the *yukata* [*and Japanese dress in general*] should always be worn with the left side over the right.

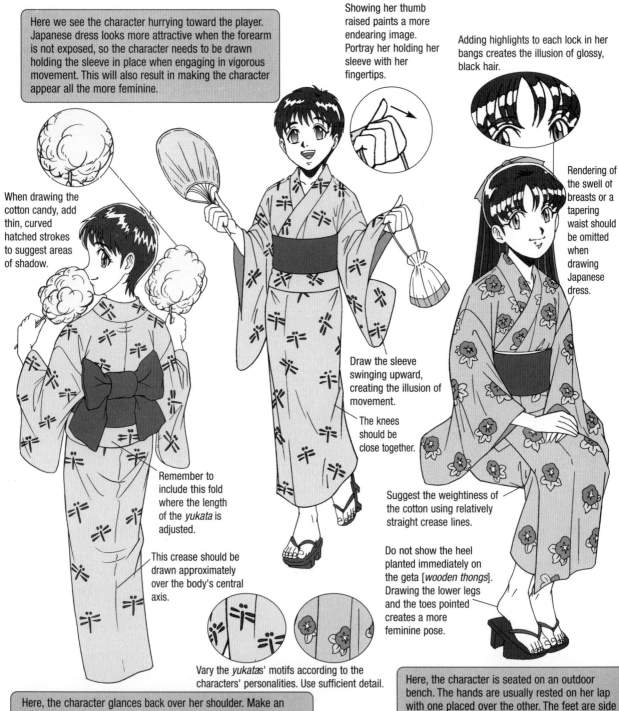

Here we see the character hurrying toward the player. Japanese dress looks more attractive when the forearm is not exposed, so the character needs to be drawn holding the sleeve in place when engaging in vigorous movement. This will also result in making the character appear all the more feminine.

Showing her thumb raised paints a more endearing image. Portray her holding her sleeve with her fingertips.

Adding highlights to each lock in her bangs creates the illusion of glossy, black hair.

Rendering of the swell of breasts or a tapering waist should be omitted when drawing Japanese dress.

When drawing the cotton candy, add thin, curved hatched strokes to suggest areas of shadow.

Draw the sleeve swinging upward, creating the illusion of movement.

The knees should be close together.

Remember to include this fold where the length of the *yukata* is adjusted.

This crease should be drawn approximately over the body's central axis.

Suggest the weightiness of the cotton using relatively straight crease lines.

Do not show the heel planted immediately on the geta [*wooden thongs*]. Drawing the lower legs and the toes pointed creates a more feminine pose.

Vary the *yukata*s' motifs according to the characters' personalities. Use sufficient detail.

Here, the character glances back over her shoulder. Make an effort to become adept at drawing cotton candy goldfish in plastic bags and other items commonly sold at night stalls. This will help evoke the proper mood. Note that the obi is not worn at the waist but just below the chest with the knot in back.

Here, the character is seated on an outdoor bench. The hands are usually rested on her lap with one placed over the other. The feet are side by side, and the figure leans to one side ever so slightly. The sleeves spread along the seat to show off the *yukata*'s beautiful pattern.

Aprons

The apron appears in scenes where a character is cooking. Include a school uniform underneath for Home Ec class scenes. Alter the apron's design to match the wearer's personality. To emphasize the sense of character at home, show her wearing slippers.

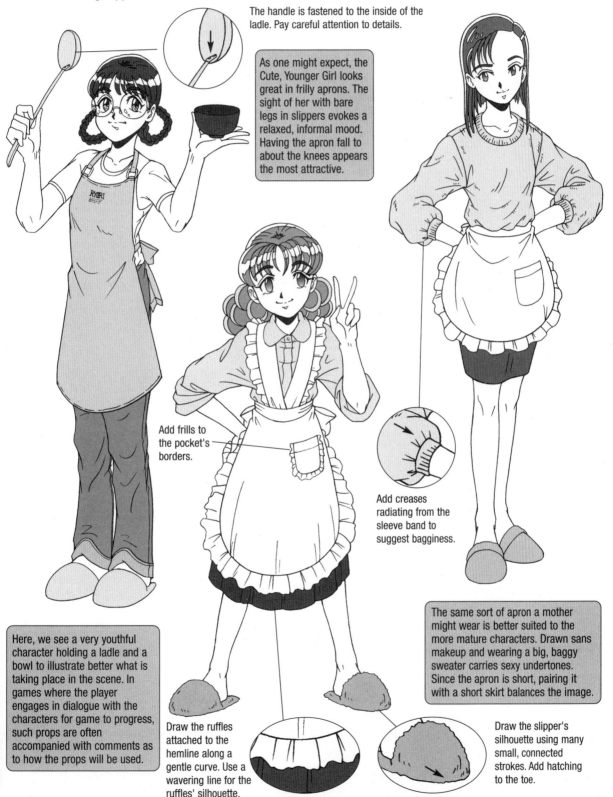

The handle is fastened to the inside of the ladle. Pay careful attention to details.

As one might expect, the Cute, Younger Girl looks great in frilly aprons. The sight of her with bare legs in slippers evokes a relaxed, informal mood. Having the apron fall to about the knees appears the most attractive.

Add frills to the pocket's borders.

Add creases radiating from the sleeve band to suggest bagginess.

Here, we see a very youthful character holding a ladle and a bowl to illustrate better what is taking place in the scene. In games where the player engages in dialogue with the characters for game to progress, such props are often accompanied with comments as to how the props will be used.

Draw the ruffles attached to the hemline along a gentle curve. Use a wavering line for the ruffles' silhouette.

The same sort of apron a mother might wear is better suited to the more mature characters. Drawn sans makeup and wearing a big, baggy sweater carries sexy undertones. Since the apron is short, pairing it with a short skirt balances the image.

Draw the slipper's silhouette using many small, connected strokes. Add hatching to the toe.

Nightwear

The sight of a character when she just wakes up offers the purest view possible of her true personality and is the best way to illustrate the differences in the characters' personalities. The nightwear worn also varies for each character. When drawing characters in their undergarments, go for an unstaged rather than erotic look.

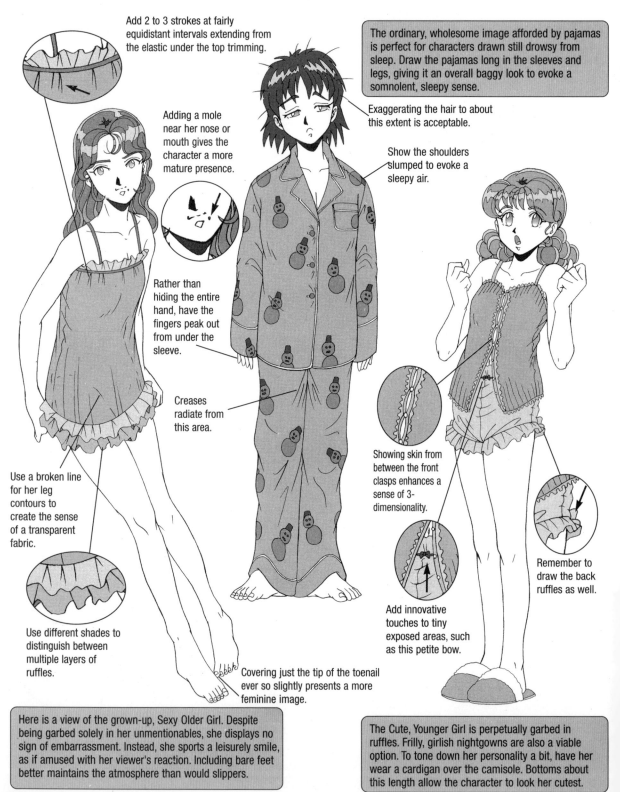

Add 2 to 3 strokes at fairly equidistant intervals extending from the elastic under the top trimming.

Adding a mole near her nose or mouth gives the character a more mature presence.

The ordinary, wholesome image afforded by pajamas is perfect for characters drawn still drowsy from sleep. Draw the pajamas long in the sleeves and legs, giving it an overall baggy look to evoke a somnolent, sleepy sense.

Exaggerating the hair to about this extent is acceptable.

Show the shoulders slumped to evoke a sleepy air.

Rather than hiding the entire hand, have the fingers peak out from under the sleeve.

Creases radiate from this area.

Use a broken line for her leg contours to create the sense of a transparent fabric.

Showing skin from between the front clasps enhances a sense of 3-dimensionality.

Remember to draw the back ruffles as well.

Use different shades to distinguish between multiple layers of ruffles.

Covering just the tip of the toenail ever so slightly presents a more feminine image.

Add innovative touches to tiny exposed areas, such as this petite bow.

Here is a view of the grown-up, Sexy Older Girl. Despite being garbed solely in her unmentionables, she displays no sign of embarrassment. Instead, she sports a leisurely smile, as if amused with her viewer's reaction. Including bare feet better maintains the atmosphere than would slippers.

The Cute, Younger Girl is perpetually garbed in ruffles. Frilly, girlish nightgowns are also a viable option. To tone down her personality a bit, have her wear a cardigan over the camisole. Bottoms about this length allow the character to look her cutest.

Part-Time Jobs

Uniforms worn for part-time jobs are charming in a different sense than school uniforms. Restaurants are the most common venues, but, depending on the character's personality, gasoline stations and baseball concession stands can pose effective alternatives. Mix and match. Below are presented standard fast food, café, and Japanese restaurant-style uniforms.

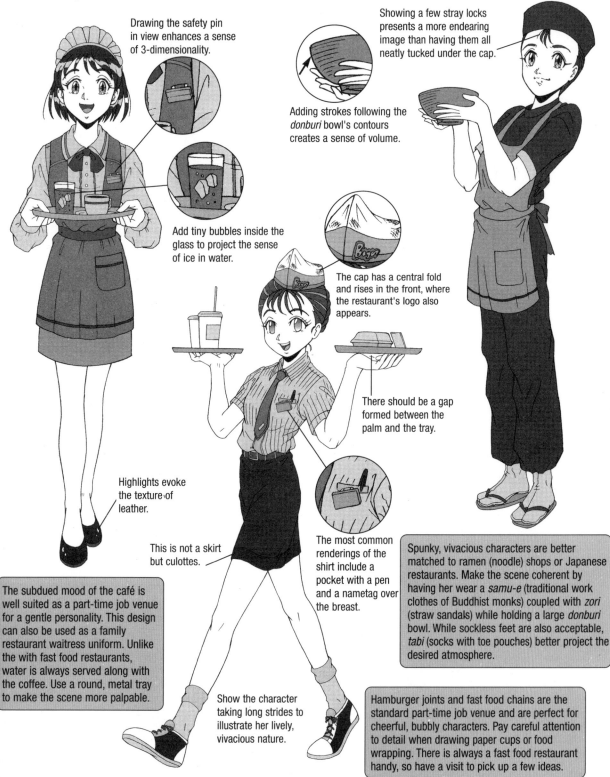

Drawing the safety pin in view enhances a sense of 3-dimensionality.

Showing a few stray locks presents a more endearing image than having them all neatly tucked under the cap.

Adding strokes following the *donburi* bowl's contours creates a sense of volume.

Add tiny bubbles inside the glass to project the sense of ice in water.

The cap has a central fold and rises in the front, where the restaurant's logo also appears.

There should be a gap formed between the palm and the tray.

Highlights evoke the texture of leather.

This is not a skirt but culottes.

The most common renderings of the shirt include a pocket with a pen and a nametag over the breast.

The subdued mood of the café is well suited as a part-time job venue for a gentle personality. This design can also be used as a family restaurant waitress uniform. Unlike the with fast food restaurants, water is always served along with the coffee. Use a round, metal tray to make the scene more palpable.

Show the character taking long strides to illustrate her lively, vivacious nature.

Spunky, vivacious characters are better matched to ramen (noodle) shops or Japanese restaurants. Make the scene coherent by having her wear a *samu-e* (traditional work clothes of Buddhist monks) coupled with *zori* (straw sandals) while holding a large *donburi* bowl. While sockless feet are also acceptable, *tabi* (socks with toe pouches) better project the desired atmosphere.

Hamburger joints and fast food chains are the standard part-time job venue and are perfect for cheerful, bubbly characters. Pay careful attention to detail when drawing paper cups or food wrapping. There is always a fast food restaurant handy, so have a visit to pick up a few ideas.

Hatsumode

New Year's Day scenes have the player going on *hatsumode* (the year's first visit to a Shinto shrine) with a character dressed in her finest kimono. In such scenes, her movements are more graceful than usual. When designing the kimono's motif, think of it as an overall composition rather than a repeated pattern. These scenes call for the long-sleeved *furisode* kimono. Take extra care to ensure the left side rests over the right.

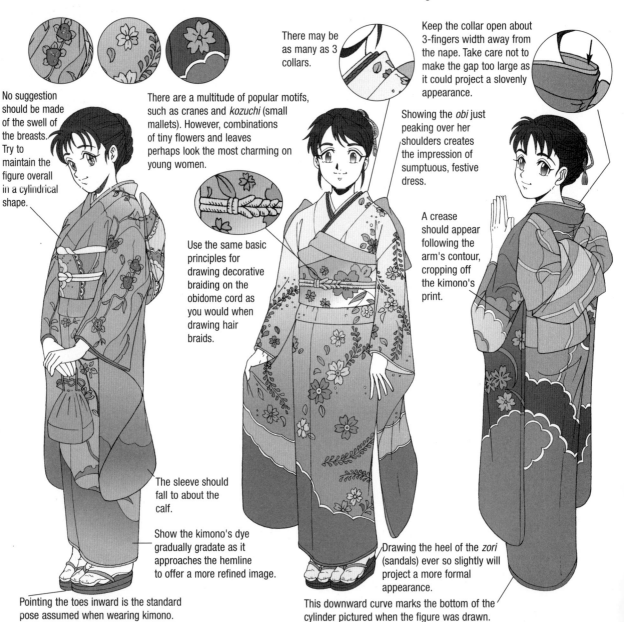

There may be as many as 3 collars.

Keep the collar open about 3-fingers width away from the nape. Take care not to make the gap too large as it could project a slovenly appearance.

No suggestion should be made of the swell of the breasts. Try to maintain the figure overall in a cylindrical shape.

There are a multitude of popular motifs, such as cranes and *kozuchi* (small mallets). However, combinations of tiny flowers and leaves perhaps look the most charming on young women.

Showing the *obi* just peaking over her shoulders creates the impression of sumptuous, festive dress.

A crease should appear following the arm's contour, cropping off the kimono's print.

Use the same basic principles for drawing decorative braiding on the obidome cord as you would when drawing hair braids.

The sleeve should fall to about the calf.

Show the kimono's dye gradually gradate as it approaches the hemline to offer a more refined image.

Drawing the heel of the *zori* (sandals) ever so slightly will project a more formal appearance.

Pointing the toes inward is the standard pose assumed when wearing kimono.

This downward curve marks the bottom of the cylinder pictured when the figure was drawn.

This formal pose is used when giving New Year's greetings. The drawstring purse is a traditional kimono accessory. A large *obi* knot, covering the entire back appears more attractive when wearing a *furisode* (long-sleeved kimono).

This is a prim and proper pose with the sleeve spread slightly with the hand. When the sleeves are opened out, they provide an expansive view of the motif. Give consideration to crease placement to accentuate this illusion. This combination shows a kimono and *obi* with matching motifs. A towel is wrapped around the waist before the kimono is donned, so avoid adding any suggestion of a curvaceous waist.

This is a moderately high angle of our girl glancing over her shoulder. She is drawn from a taller boy's perspective, so her gaze drifts upward. Kimono are made of heavy silk, and consequently, do not form much creasing. Use relatively straight line for creases. The hair can be pulled back or braided, but a chignon tends to be the most popular style.

Skiwear

Scenes requiring skiwear, including dates, spending the night at a ski lodge, or taking to the slopes with the player, are more prevalent in games than one might expect. Since the fabrics tend to be heavier than that used in regular clothing, extra care must be taken when drawing creases. In addition, rendering the footwear larger than usual will enhance the illusion of wearing "ski boots."

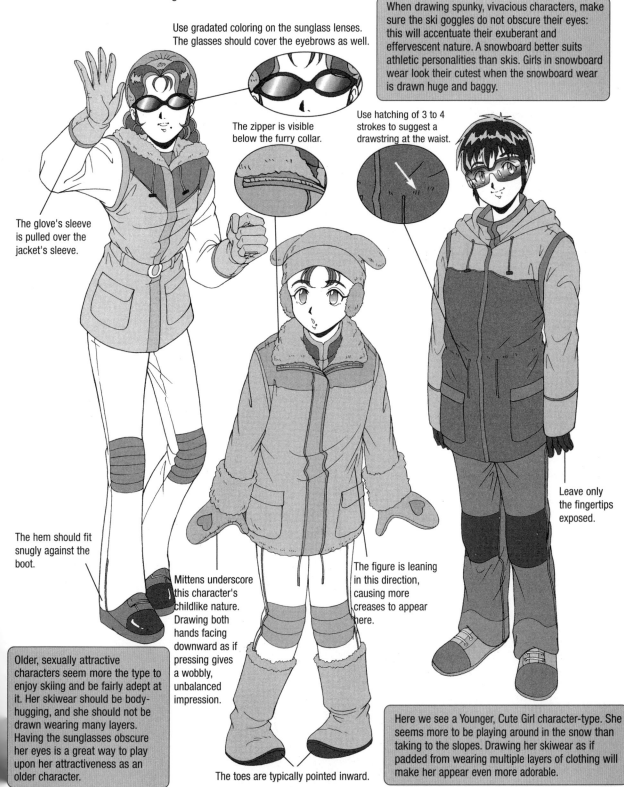

Use gradated coloring on the sunglass lenses. The glasses should cover the eyebrows as well.

When drawing spunky, vivacious characters, make sure the ski goggles do not obscure their eyes: this will accentuate their exuberant and effervescent nature. A snowboard better suits athletic personalities than skis. Girls in snowboard wear look their cutest when the snowboard wear is drawn huge and baggy.

The zipper is visible below the furry collar.

Use hatching of 3 to 4 strokes to suggest a drawstring at the waist.

The glove's sleeve is pulled over the jacket's sleeve.

The hem should fit snugly against the boot.

Mittens underscore this character's childlike nature. Drawing both hands facing downward as if pressing gives a wobbly, unbalanced impression.

The figure is leaning in this direction, causing more creases to appear here.

Leave only the fingertips exposed.

Older, sexually attractive characters seem more the type to enjoy skiing and be fairly adept at it. Her skiwear should be body-hugging, and she should not be drawn wearing many layers. Having the sunglasses obscure her eyes is a great way to play upon her attractiveness as an older character.

The toes are typically pointed inward.

Here we see a Younger, Cute Girl character-type. She seems more to be playing around in the snow than taking to the slopes. Drawing her skiwear as if padded from wearing multiple layers of clothing will make her appear even more adorable.

Beachwear

Unlike school regulation swimsuits, swimsuits worn at the beach come in a wide variety of colors and designs. Make scenes at the beach distinct from swimming class by including beach balls, inner tubes, tarps, and other props. Items such as watermelons and eyeshades serve as effective seasonal props.

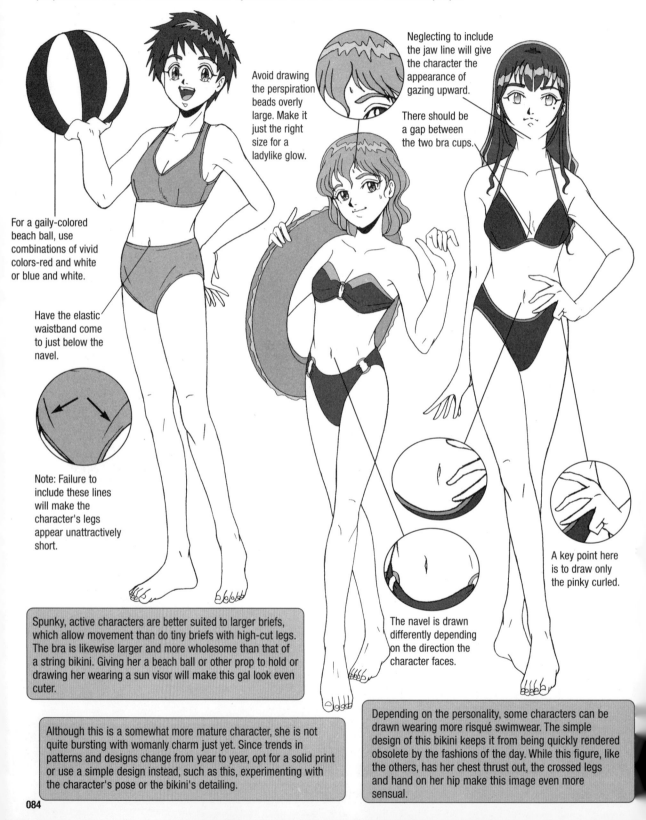

Avoid drawing the perspiration beads overly large. Make it just the right size for a ladylike glow.

Neglecting to include the jaw line will give the character the appearance of gazing upward.

There should be a gap between the two bra cups.

For a gaily-colored beach ball, use combinations of vivid colors-red and white or blue and white.

Have the elastic waistband come to just below the navel.

Note: Failure to include these lines will make the character's legs appear unattractively short.

The navel is drawn differently depending on the direction the character faces.

A key point here is to draw only the pinky curled.

Spunky, active characters are better suited to larger briefs, which allow movement than do tiny briefs with high-cut legs. The bra is likewise larger and more wholesome than that of a string bikini. Giving her a beach ball or other prop to hold or drawing her wearing a sun visor will make this gal look even cuter.

Although this is a somewhat more mature character, she is not quite bursting with womanly charm just yet. Since trends in patterns and designs change from year to year, opt for a solid print or use a simple design instead, such as this, experimenting with the character's pose or the bikini's detailing.

Depending on the personality, some characters can be drawn wearing more risqué swimwear. The simple design of this bikini keeps it from being quickly rendered obsolete by the fashions of the day. While this figure, like the others, has her chest thrust out, the crossed legs and hand on her hip make this image even more sensual.

Special Occasions

Successful romance simulation game characters necessitate idolized, poster-girl qualities. Consequently, the artist every once in awhile needs to draw her in a meaningless pose of the sort found in teen magazines, purely because it makes her look cute. Dressing her in costumes that are perhaps not something one would normally wear is acceptable, provided that it complements her personality.

Below we see a *hakama* (long, pleated skirt worn over a kimono)-a style of dress popular amongst girls and boys alike. Recently, sprinklings of high school girls wearing *hakama* have been making their appearance at commencement ceremonies. The *hakama* seems particularly suited to the Honor Roll Student. Leave out her usually primly tied ponytail, showing her wear her hair down instead to achieve a softer look.

The Sexy Older Girl and the Princess are usually designated to be from "affluent families." While typical households are not given to holding fancy parties, these characters call for scenes, such as a Christmas party, allowing them to dress in something glamorous. Try for a somewhat mature, slinky design.

Add a cap to the tube to ensure a diploma is housed inside.

Having the tip of her locks curl is a charming touch.

Use dark shading for the inside of her sleeve.

Be sure to include the contour line of the far arm as well.

Draw parallel, downward arcing creases to suggest drooping cloth.

Including the contours of the leg extended in front evokes the lustrous sense of silk.

Intersperse short, horizontal strokes along the vertical seam line.

Granny boots would work well as an alternative.

The end is not knotted, but draped over the rest of the sash.

Roll up the jean legs and draw them oversized and baggy. Use a different color for the cuff.

These overalls with nothing underneath are not the sort of getup one would expect the heroine or a shyer character to wear. However, this look is a viable option for characters such as the Cute, Younger Girl or the athletic girl, who are relatively unaware of their own sexuality. Use a boyish pose to prevent the image from becoming too risqué.

The crossed arms and placement of the feet are extremely popular for scenes such as this.

In combat and action games, the system only allows the character to be seen from set angles. This is because the fun of playing the game is given more emphasis than its look. For pizzazz, *manga*, animated films, or the original work from which the game is derived may use actions or poses not present in the game. This is because the artists have been creative in using foreshortening or angles to obtain a visually pleasing composition that can be enjoyed without participating in a game. On the next several pages are presented specific costume samples and how these costumes should appear on the game or in a panel.

School Costumes I

Here is a normally cute, girlish character, who is also the captain of the karate team. The appeal lies in this contrast. White is usually selected for the costume. However, red and pink are also possible options if a more flamboyant look is desired. When seeking an austere look, stick to white.

While sailor suits are charming, they do not allow much variation. A great technique is to give the character an unusual prop that draws out her true nature (background). Make the player wonder what is going on.

The formulaic sailor suit and gun-scenes in old movies showing high school girls and machine guns used to pack quite a punch. The key here is to draw the skirt longer than what is normally worn today. The uniform should follow traditional color patterns: white ground with blue or navy.

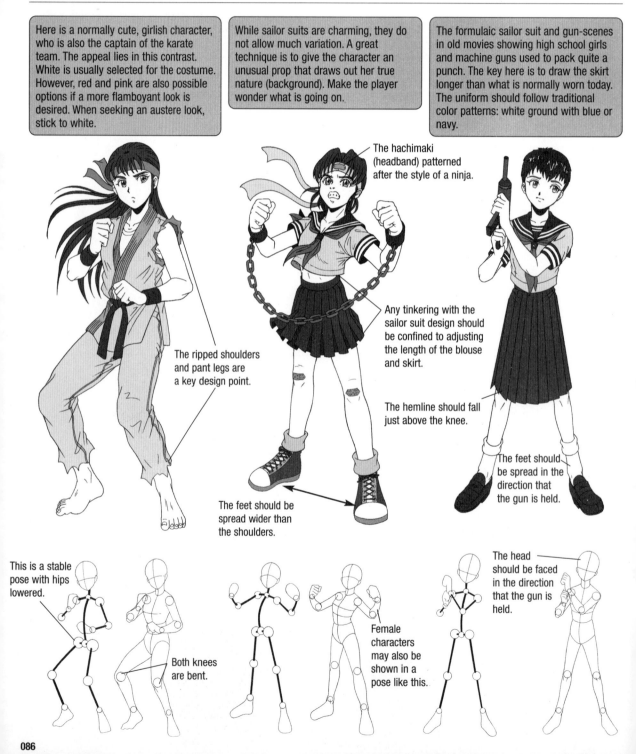

The hachimaki (headband) patterned after the style of a ninja.

The ripped shoulders and pant legs are a key design point.

Any tinkering with the sailor suit design should be confined to adjusting the length of the blouse and skirt.

The hemline should fall just above the knee.

The feet should be spread in the direction that the gun is held.

The feet should be spread wider than the shoulders.

This is a stable pose with hips lowered.

Both knees are bent.

Female characters may also be shown in a pose like this.

The head should be faced in the direction that the gun is held.

School Costumes: Sample Scenes I

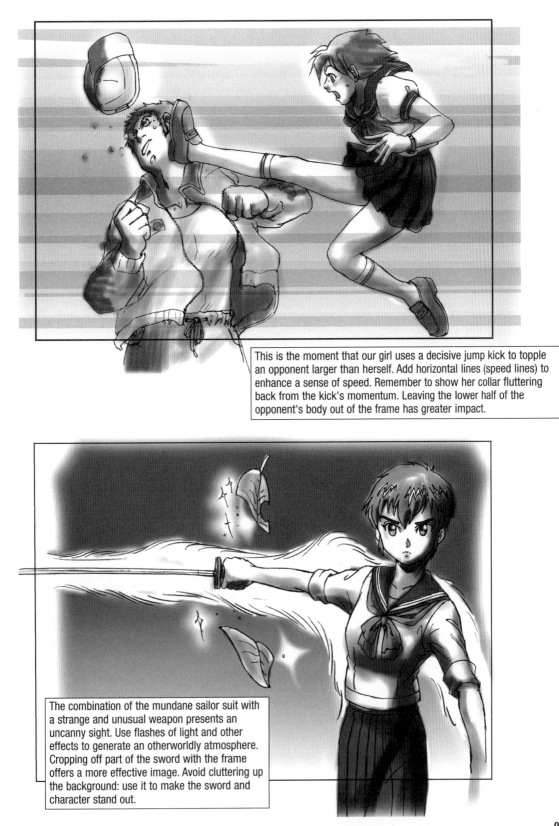

This is the moment that our girl uses a decisive jump kick to topple an opponent larger than herself. Add horizontal lines (speed lines) to enhance a sense of speed. Remember to show her collar fluttering back from the kick's momentum. Leaving the lower half of the opponent's body out of the frame has greater impact.

The combination of the mundane sailor suit with a strange and unusual weapon presents an uncanny sight. Use flashes of light and other effects to generate an otherworldly atmosphere. Cropping off part of the sword with the frame offers a more effective image. Avoid cluttering up the background: use it to make the sword and character stand out.

School Costumes II

Here, we have a character living her life disguised as a boy. She is seen wearing a short, modified school uniform jacket and projects an androgynous air. Since she has consciously opted to wear boy's clothing, all props associated with female characters have been removed. Garish color schemes such as red and white may be used; however, if you are striving for a "young tough" look, then stick with black. Incorporate gaudy elements such as red and gold embroidery.

Here we have the captain of the girls' wrestling team. Leotards seem to be the standard dress for women wrestlers. However, having the character wear some form of covering on top and then remove it when the situation calls is an effective alternative. The critical point to this character is that she is not a rough, violent personality, but rather has a soft spot. The top covering should be matched to the scene. Bright, vivid colors should be used in the leotard.

This combination consists of a full-length coat that is actually part of a boy's school uniform worn over a gym suit. Characters such as this, displaying a combination of intentionally combined incongruous elements, typically appear in parodies. As such, this character was drawn making full use of distortion and exaggeration to make the coat even more oversized and voluminous than normal. Project the sense that this character is the successor of a long line of athletes before her. The gym suit and sports brief are rendered in standard high school white and navy. The school uniform coat usually comes in black, but hot pink would enhance this sense of incongruity and pose an interesting alternative.

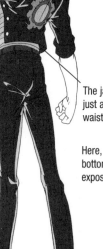

Opt for a pose that will allow view of the embroidery on the back of her jacket. If she is a member of the team, then using the team's insignia is another possibility.

The chest is wrapped with bleached white cloth. Be sure to show the swell of her breasts in the silhouette line.

The jacket ends just above the waist.

Here, we see the bottom of the leotard exposed.

The long headband underscores the impression of being a pep team member.

Remember to include the number.

Show the color of the lining.

Give her a large, authentic-looking champion belt.

Made of pliant materials, the boots are the kind used in fighting competitions. Consequently, they should show off the curves of her calves. Blue and red are the common colors of choice.

Use athletic shoes to match the gym suit.

The chest should be the most forward point.

Planting the feet at a distance wider than the shoulders gives a sense of balance.

School Costumes: Sample Scenes II

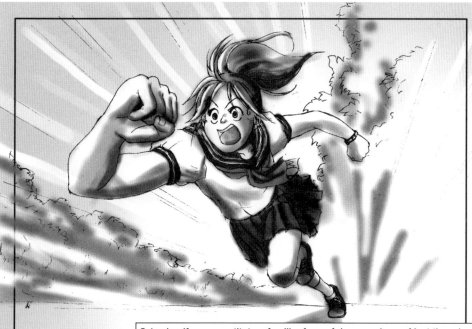

School uniforms constitute a familiar form of dress, and use of just the school uniform alone can evoke fixed ideas and associations. Having a "girl next door" type character display superhuman abilities can generate feelings of admiration or affection for the familiar. Exaggerated foreshortening was used in this artwork to enhance the idea of "extreme speed." Having lines radiate toward the picture plane from the point where her back foot touches the ground is an effective means of emphasizing this notion. Pay close attention to the sizes of the clouds.

For this image, a phantasmal effect was created by setting a girl dressed in a modern uniform assuming a key attack pose next to another girl in ninja dress, overlapping the two images so that one is visible through the other. Setting the two characters side by side with both wearing completely different dress in this manner projects an impression of mystery. Having the swords cropped by the frame at the top and bottom creates an effective composition.

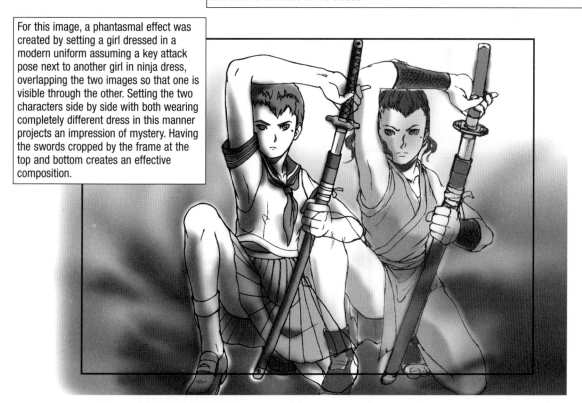

Special Units Costumes I

This gal is an infiltration and assassination special forces commando. The gun belt is essential to clearly define what this character's function is. Add strategic rips and tears to her clothing to enhance her ruggedness. Many game players are knowledgeable in firearms, requiring that the artist do proper homework before drawing. Using red and yellow in places to bring out her femininity is acceptable, but the composition should be coordinated using an overall color palette of subdued khaki and moss green.

The beret and dog tags (ID), indicate her to be a member of a military unit. Out of the ordinary clothing, such as this body suit, suggest she is a special forces commando. Since this is an organization's uniform, embroidery or other gaudy decorations should be avoided. Coordinate the beret with the body suit to enhance the "uniform" concept. Use of camouflage print will add to the costume's authenticity.

This character is a special forces undercover agent. Given the scenario, the most popular colors for her costume are subdued, dark shades. Since the tight-fitted cat suit covers her entire figure, many of her body's contours appear in the costume. Be sure to draw creases forming around the body's joints. While short hair would be more practical, too much realism will cause the image to lose its zing, plus the illusion of speed enhanced by the flowing hair would also become more difficult to render.

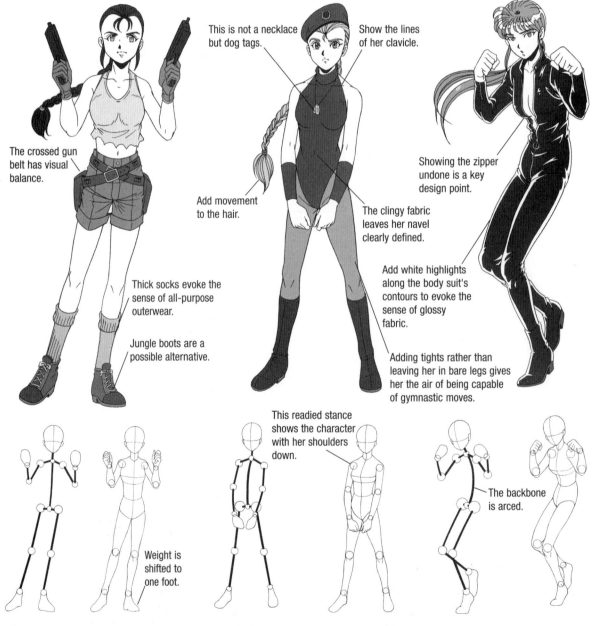

The crossed gun belt has visual balance.

Thick socks evoke the sense of all-purpose outerwear.

Jungle boots are a possible alternative.

Weight is shifted to one foot.

This is not a necklace but dog tags.

Show the lines of her clavicle.

Add movement to the hair.

The clingy fabric leaves her navel clearly defined.

This readied stance shows the character with her shoulders down.

Showing the zipper undone is a key design point.

Add white highlights along the body suit's contours to evoke the sense of glossy fabric.

Adding tights rather than leaving her in bare legs gives her the air of being capable of gymnastic moves.

The backbone is arced.

Special Units Costumes: Sample Scenes I

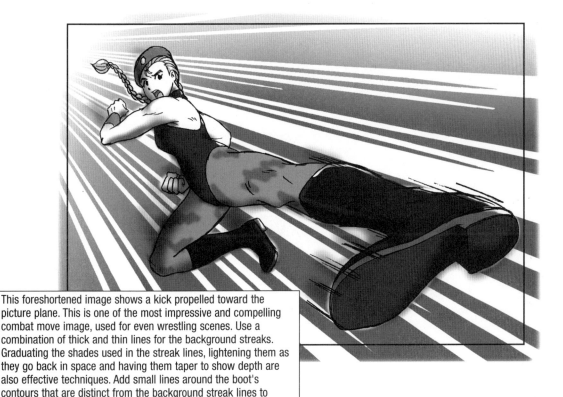

This foreshortened image shows a kick propelled toward the picture plane. This is one of the most impressive and compelling combat move image, used for even wrestling scenes. Use a combination of thick and thin lines for the background streaks. Graduating the shades used in the streak lines, lightening them as they go back in space and having them taper to show depth are also effective techniques. Add small lines around the boot's contours that are distinct from the background streak lines to accentuate the force of the kick.

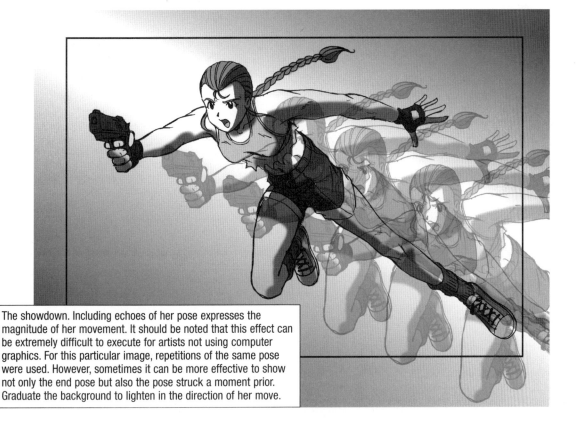

The showdown. Including echoes of her pose expresses the magnitude of her movement. It should be noted that this effect can be extremely difficult to execute for artists not using computer graphics. For this particular image, repetitions of the same pose were used. However, sometimes it can be more effective to show not only the end pose but also the pose struck a moment prior. Graduate the background to lighten in the direction of her move.

Special Units Costumes II

Here we have a policewoman one might expect to see walking down the street. The rolled-up sleeves and gloves are a standard combination. The rolled-up sleeves suggest "movement." The gloves suggest she belongs to a special police unit. In order to maintain the idea that she is a "cop," the gloves are worn with a necktie in place. This contrast constitutes a key design point. The color palette should follow the blues typical to real police uniforms; however, a bright color may be used in the necktie to add flourish to the image.

Here, we have a member of the SWAT team. Her helmet and uniform sport the SWAT team insignia, helping to generate the air of a SWAT team member. The key here is the props. Drawing unconvincing props will cause the character to lose her authenticity. Research actual firearms and gun belts. Since she is a member of the SWAT team, her uniform should be subdued in color. In order to create a more cheerful air, the use of neat and clean shades-white, light blue, and grey-is also acceptable to project a more feminine image.

Here is a spunky policewoman. Comic elements have been incorporated into the character. It is unforgivable to be noncommittal when working in a comical framework. Don't hold back! Have the police badge-which is typically metal-stand out. The miniskirt, not something likely to appear on a real policewoman, is a key design point. This character is more likely to be a member of "The Perfume Posse" or other such group with a campy name than to have a serious title.

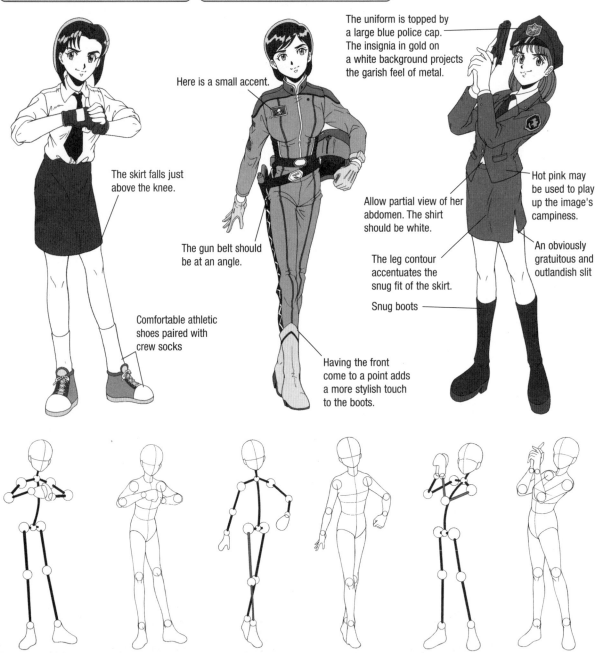

The skirt falls just above the knee.

Comfortable athletic shoes paired with crew socks

Here is a small accent.

The gun belt should be at an angle.

Having the front come to a point adds a more stylish touch to the boots.

The uniform is topped by a large blue police cap. The insignia in gold on a white background projects the garish feel of metal.

Allow partial view of her abdomen. The shirt should be white.

The leg contour accentuates the snug fit of the skirt.

Snug boots

Hot pink may be used to play up the image's campiness.

An obviously gratuitous and outlandish slit

Special Units Costumes: Sample Scenes II

Here is a rousing scene showing a woman in common street dress making mincemeat of a hefty opponent. Combat games do not tend to include close-ups of this sort, nor is the expression of the opponent normally shown; however, the pain on this guy's face is a key point to the scene. Add exaggerated lines to enhance the feel of speed.

In this scene, our girl undauntedly shoots a gun within a crowd. The uniform indicates that the character is a policewoman. The key point here is that her target has intentionally been removed from the composition, leading the game player to wonder who she is shooting at. Use the expressions of surprise and fear on the onlookers to communicate the weightiness of the scene. Showing smoke trail from the gun barrel projects the impression that the gun has just been fired.

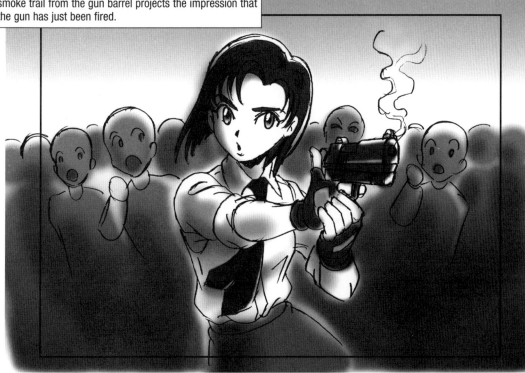

Street Fighting

Part of the appeal of the street-smart girl is that she constantly goes around in a miniskirt. There used to be games that would have a character like this, who without batting an eyelash would throw out a kick, giving the player a peak at her white undies-an act somehow plausible with this character. Her basic dress should be appropriate for a young woman and should not be ridiculously audacious. Try giving her eye-catching items, such as a bright red jacket, to help her stand out over the rest of the cast.

This character has special training or experience, sparking the player's imagination with respect to her background. Since this character has a penchant for practical wear, dress her in browns and other darkish earth tones and camouflage patterns. Here, we see her wearing a leather bomber jacket, fatigues, and army boots.

This biker chick is sporting biker boots and carrying a helmet to establish her part. The blond, cropped hair underscores her mannish personality. The leather shirt is a heavy material, and consequently requires care when adding creases. Black and dark brown tend to be the most popular colors.

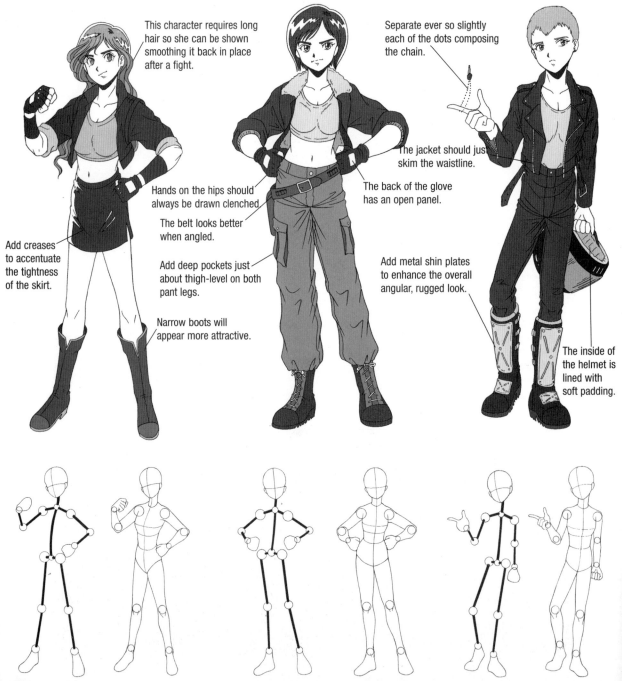

This character requires long hair so she can be shown smoothing it back in place after a fight.

Hands on the hips should always be drawn clenched.

The belt looks better when angled.

Add deep pockets just about thigh-level on both pant legs.

Add creases to accentuate the tightness of the skirt.

Narrow boots will appear more attractive.

Separate ever so slightly each of the dots composing the chain.

The jacket should just skim the waistline.

The back of the glove has an open panel.

Add metal shin plates to enhance the overall angular, rugged look.

The inside of the helmet is lined with soft padding.

Street Fighting: Sample Scenes

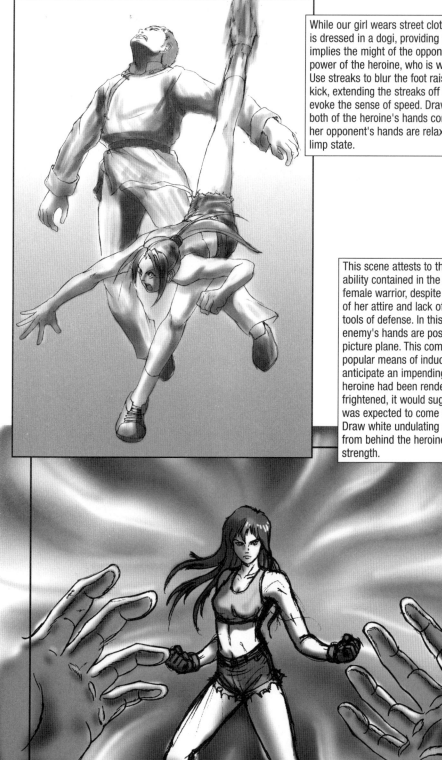

While our girl wears street clothes, her opponent is dressed in a dogi, providing contrast. The *dogi* implies the might of the opponent, attesting to the power of the heroine, who is winning the fight. Use streaks to blur the foot raised to deliver the kick, extending the streaks off the screen frame to evoke the sense of speed. Draw the hands so that both of the heroine's hands convey tension, while her opponent's hands are relaxed, expressing his limp state.

This scene attests to the immense ability contained in the hands of this female warrior, despite the plain nature of her attire and lack of weaponry or tools of defense. In this scene, the enemy's hands are positioned near the picture plane. This composition is a popular means of inducing the player to anticipate an impending force. If the heroine had been rendered to appear frightened, it would suggest that a hero was expected to come and rescue her. Draw white undulating rays emanating from behind the heroine to show her strength.

Fanciful Costumes

This popular rendition of a "demon" is sprouting horns from her head and a tail from behind and holds a whip with demonic powers-not a gal one would expect to come across in the real world. Basically garbed in fetish wear, as the quintessential representation of the abnormal, this getup becomes a symbol of the character's sadistic personality. The colors used are naturally a lustrous black and red. Use unconventional colors like green or silver in her eyes and hair to add to her "authenticity."

Here, we see an elf carrying a typically finely tapered elvish sword. The rapier is essentially used for thrusting, and silver tends to be the color of choice. Elves will rarely use another weapon. Fairytales and stories have elves favoring light clothing and shying away from metals, so strive for a design that evokes the sense of natural fibers.

This character design was inspired by the female gladiators of ancient Rome. In the world of fantasy, she plays the role of a female warrior. Her armor, which consists of a heavy breastplate following her torso, is a common addition to costumes in this world. For some inexplicable reason, the totally impractical, two-piece, bikini-type design has become recognized as the standard for this costume type. To put it plainly, this is a rather implausible fantasy. However, she does serve as a gladiator who must fight in front of an audience, so add a sheen to her armor to give it flamboyance.

Straight horns tend to be more reminiscent of Japanese demons. Twisted goat horns are the sign of a devil.

Pointy ears are the elf's trademark.

The elf's accessories are based on animal and plant forms.

Elves are consistently given willowy frames and skimpy dress.

The pointed tail is a sign of a devil and a popular ingredient to villainous characters.

The sword is in the form of a cross, making it a hallowed weapon. Whips are better suited to villains.

The widely spread arms and legs present a confident pose.

The waist is narrow and the back arced.

Fanciful Costumes: Combat Scenes

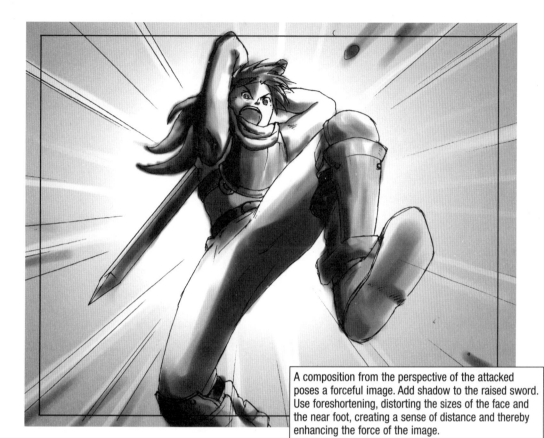

A composition from the perspective of the attacked poses a forceful image. Add shadow to the raised sword. Use foreshortening, distorting the sizes of the face and the near foot, creating a sense of distance and thereby enhancing the force of the image.

In Japan, there tends to be the impression that any "fantasy world" female character can be turned into a warrior just by dressing her in a two-piece costume. Consequently, an image of "power" can be created simply drawing a girl in a bikini-inspired outfit from a low angle. Legs wrapped in bandages are a common element.

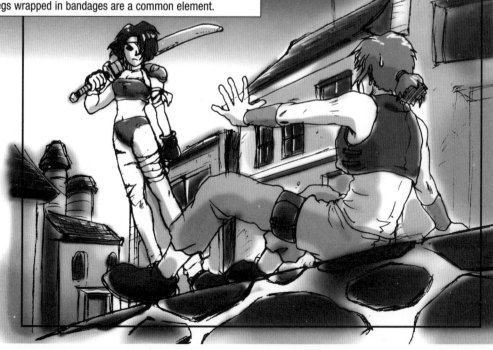

Kung fu Costumes I

Amongst combat sports, a Kung fu costume styled after a flamboyant Chinese dress is the most popular. The design shown here is actually a man's costume, but it is well-matched the "athletic girl." The bodice is roomy, making it suited to any body type. Reds and yellows are popular with Chinese dresses. This costume also works well with moderately subdued greens and browns.

Here we have a cute character wearing a reserved Chinese-style costume. Avoid making the character too thin, maintaining a bit of baby fat. Use red, blue, and other vivid colors. Add glossy highlights to compensate for the lack of patterned print.

This design originated in early combat games. Designs with a distinct waist are perfect for voluptuous characters. Bright red seems to be the color most commonly used. Add gold print motifs and embroidery. Take care in using black, as it does not stand out and will make the costume design conservative.

The left side comes over the right in Chinese dress. Simply remember that the toggles should always be to the right. Using the same colors in the toggles as in the piping makes for an attractive design.

The dual hair buns are the most important element here, as they are this character's trademark.

Here hair is braided in back in a queue.

The wide waistband accentuates the figure's chest and hips (thighs). Position the waistband just below the chest and add volume to the breasts and thighs.

The wide sash is a key design point. Add crease lines coming from both sides to suggest a tightly pulled sash.

Match the wristbands to the tunic.

The ballooning at the pant leg should be no wider than twice the ankle. Less volume presents a trim and tidy image. Wider presents a more graceful, liquid image.

Dragons are an ancient Chinese symbol. Become proficient in drawing dragon heads and tails. Their lengths will depend on the composition.

Use a curvaceous figure.

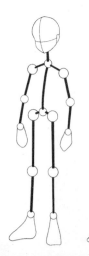

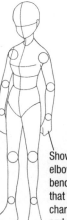

Showing the elbows slightly bend suggests that the character is alert and ready.

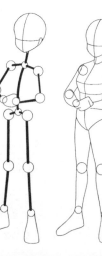

The thumb should be directed toward the opponent.

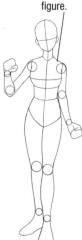

Kung fu Costumes: Sample Scenes I

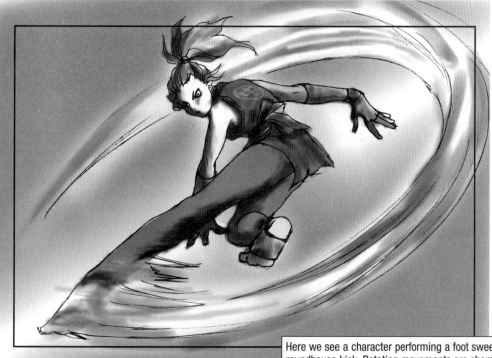

Here we see a character performing a foot sweep or roundhouse kick. Rotating movements are characteristic of kung fu. Adding whoosh marks in the direction of movement suggests a speed imperceptible to the eye. Using the frame to crop part of the whoosh marks and her hair adds expanse to the composition. Give the hair volume, making it flow from the force of her movement.

Here we see the moment that our character executes her move. The dragons looming in the background form a distinctive kung fu composition. While 1 dragon would have sufficed, the use of 2, with one rising and the other falling, balances the composition. Render the dragons' heads in clean, crisp detail have the bodies taper and fade toward the tail, using foreshortening to suggest their immense size.

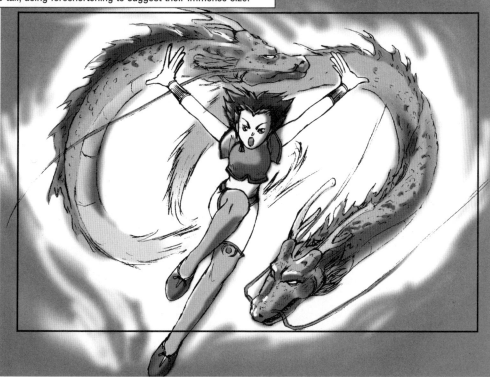

Kung fu Costumes II

This stern look where the costume minimizes any inkling of femininity paints the image of a straight-laced character. The neatly trimmed short bob combined with the jacket create a sharp, clean impression. A cool color palette should be used, based on blues and greens.

Glasses, a braid, plus Chinese-style dress constitute another popular combination. Strive to project an image of litheness rather than power. A key design point is to avoid adding a design pattern to the jacket in order to allow the toggles to stand out. A short sleeve jacket is more attractive on this character. Try for a conventional color scheme: red and vermilion.

For the haughty princess, consumers seem to prefer her to have a sexy look, so strive for a revealing design. Only this character would wear heels, despite being a kung fu fighter. Key design points are the high skirt slit and exposed cleavage. Any palette is acceptable, provided bright colors are used. Add highlights to suggest a fabric with sheen, creating a sense of luxuriance.

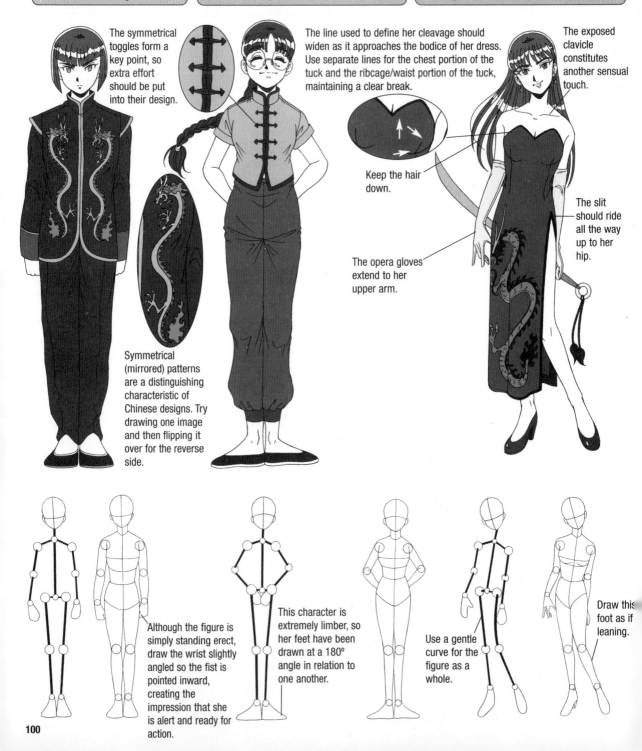

The symmetrical toggles form a key point, so extra effort should be put into their design.

Symmetrical (mirrored) patterns are a distinguishing characteristic of Chinese designs. Try drawing one image and then flipping it over for the reverse side.

The line used to define her cleavage should widen as it approaches the bodice of her dress. Use separate lines for the chest portion of the tuck and the ribcage/waist portion of the tuck, maintaining a clear break.

Keep the hair down.

The opera gloves extend to her upper arm.

The exposed clavicle constitutes another sensual touch.

The slit should ride all the way up to her hip.

Although the figure is simply standing erect, draw the wrist slightly angled so the fist is pointed inward, creating the impression that she is alert and ready for action.

This character is extremely limber, so her feet have been drawn at a 180° angle in relation to one another.

Use a gentle curve for the figure as a whole.

Draw this foot as if leaning.

Kung fu Costumes: Sample Scenes II

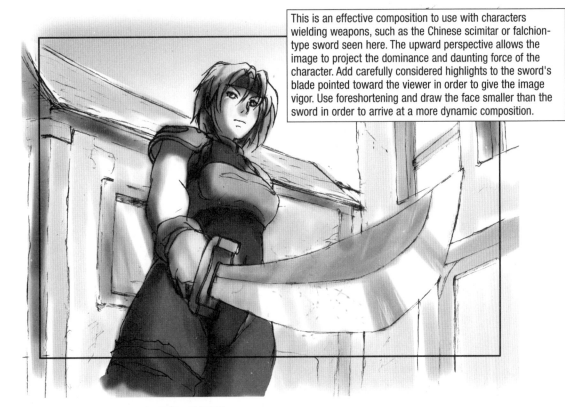

This is an effective composition to use with characters wielding weapons, such as the Chinese scimitar or falchion-type sword seen here. The upward perspective allows the image to project the dominance and daunting force of the character. Add carefully considered highlights to the sword's blade pointed toward the viewer in order to give the image vigor. Use foreshortening and draw the face smaller than the sword in order to arrive at a more dynamic composition.

Kung fu characters are often capable of using arcane arts as well as the arts of the ninja. Use roaring flames in the background to suggest emotional tension. The fundamentals in drawing impressive poses are to suggest strength by extending or bending limbs, etc. to their utmost and to suggest fluidity and grace by emphasizing curves. Here, the key design point is that the character's arms are rigidly extended all the way to her fingertips.

Japanese Costumes

Combat costumes based on traditional Japanese dress are the next popular after Chinese-influenced costumes. Ninja and kunoichi (female ninja), who non-Japanese seem to find mysterious and arcane, are often depicted wearing *hakama*. The artist should take note that the *hakama* will restrict the character to certain martial arts (e.g. aikido, etc.). The top is white and the bottom navy, black, ochre, and red. Bright colors are not often used.

The kunoichi is normally depicted like an average, everyday Japanese girl-lightly dressed and openly devoid of weapons, etc. The distinctive attribute of the kunoichi is her revealing and moderately suggestive dress. Unlike Chinese-based costumes, the kunoichi's attire bears sparse adornment, so for this example she was given a wide sash and oversized ribbon to make her appearance a bit more attractive. Use bright colors: somber colors will strip the character of her fundamental nature.

Ninja's have a silent, aloof, austere image. Ninja are often depicted with a mask covering their mouth and nose as a disguise and wearing chain mail to protect their upper bodies. Female ninja characters are typically established as natural beauties. The costume is usually rendered in dark navy and black. It should be noted that when the character is the only female amongst a group of ninjas, then her costume may be distinguished from the others by the use of white, red, or other bright colors.

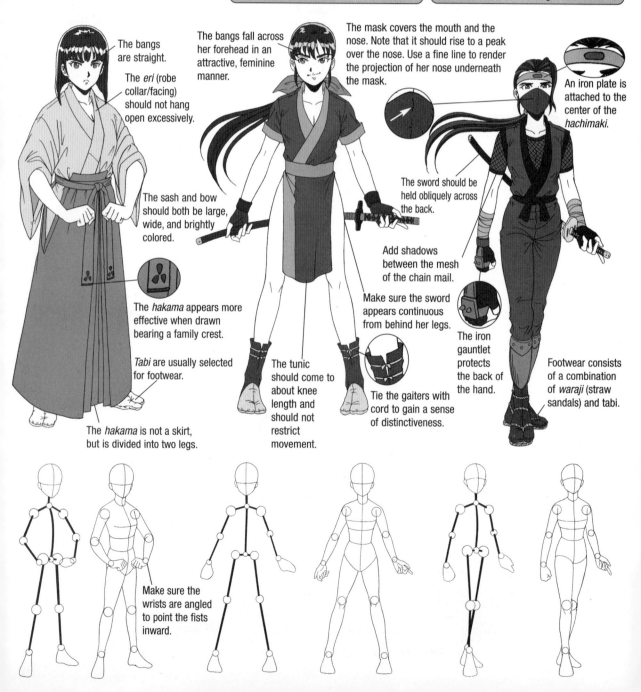

The bangs are straight.

The *eri* (robe collar/facing) should not hang open excessively.

The sash and bow should both be large, wide, and brightly colored.

The *hakama* appears more effective when drawn bearing a family crest.

Tabi are usually selected for footwear.

The *hakama* is not a skirt, but is divided into two legs.

The bangs fall across her forehead in an attractive, feminine manner.

The tunic should come to about knee length and should not restrict movement.

The mask covers the mouth and the nose. Note that it should rise to a peak over the nose. Use a fine line to render the projection of her nose underneath the mask.

The sword should be held obliquely across the back.

Add shadows between the mesh of the chain mail.

Make sure the sword appears continuous from behind her legs.

Tie the gaiters with cord to gain a sense of distinctiveness.

An iron plate is attached to the center of the *hachimaki*.

The iron gauntlet protects the back of the hand.

Footwear consists of a combination of *waraji* (straw sandals) and tabi.

Make sure the wrists are angled to point the fists inward.

Japanese Costumes: Combat Scenes

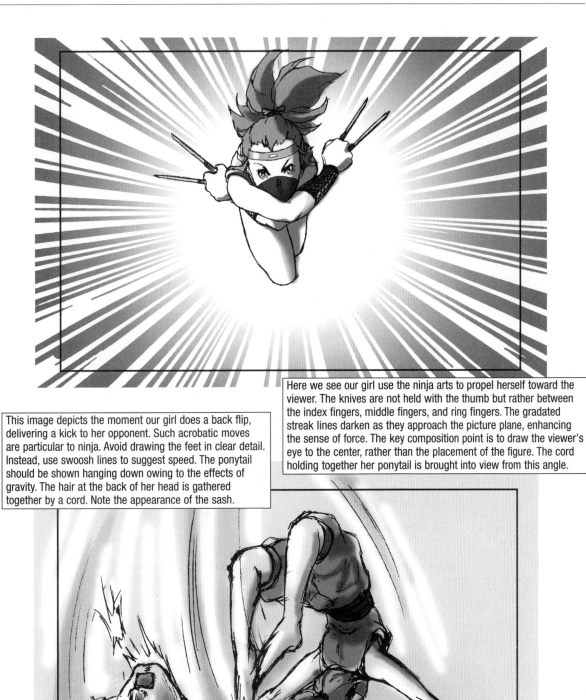

Here we see our girl use the ninja arts to propel herself toward the viewer. The knives are not held with the thumb but rather between the index fingers, middle fingers, and ring fingers. The gradated streak lines darken as they approach the picture plane, enhancing the sense of force. The key composition point is to draw the viewer's eye to the center, rather than the placement of the figure. The cord holding together her ponytail is brought into view from this angle.

This image depicts the moment our girl does a back flip, delivering a kick to her opponent. Such acrobatic moves are particular to ninja. Avoid drawing the feet in clear detail. Instead, use swoosh lines to suggest speed. The ponytail should be shown hanging down owing to the effects of gravity. The hair at the back of her head is gathered together by a cord. Note the appearance of the sash.

Magical Girl Costumes

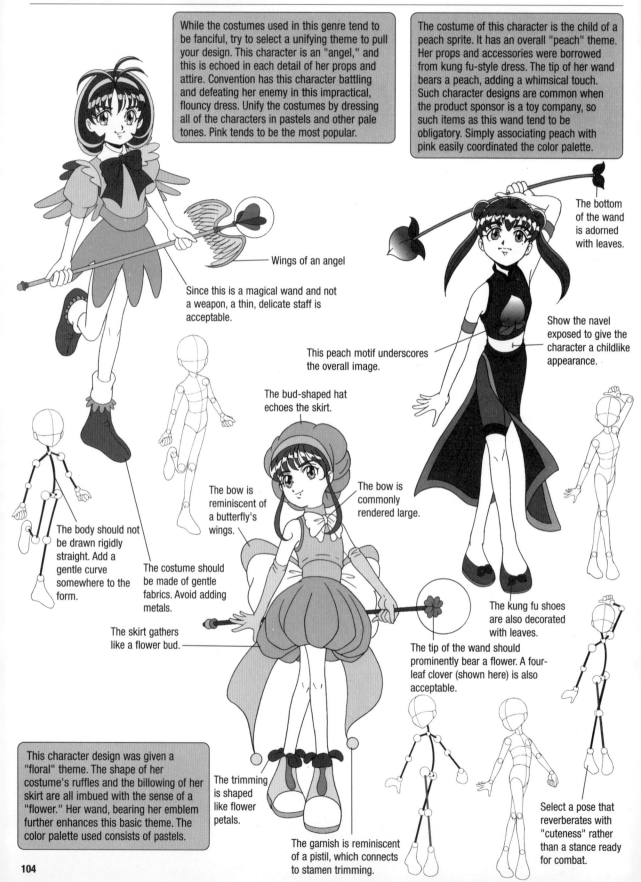

While the costumes used in this genre tend to be fanciful, try to select a unifying theme to pull your design. This character is an "angel," and this is echoed in each detail of her props and attire. Convention has this character battling and defeating her enemy in this impractical, flouncy dress. Unify the costumes by dressing all of the characters in pastels and other pale tones. Pink tends to be the most popular.

The costume of this character is the child of a peach sprite. It has an overall "peach" theme. Her props and accessories were borrowed from kung fu-style dress. The tip of her wand bears a peach, adding a whimsical touch. Such character designs are common when the product sponsor is a toy company, so such items as this wand tend to be obligatory. Simply associating peach with pink easily coordinated the color palette.

Wings of an angel

Since this is a magical wand and not a weapon, a thin, delicate staff is acceptable.

The bottom of the wand is adorned with leaves.

This peach motif underscores the overall image.

Show the navel exposed to give the character a childlike appearance.

The bud-shaped hat echoes the skirt.

The bow is reminiscent of a butterfly's wings.

The bow is commonly rendered large.

The body should not be drawn rigidly straight. Add a gentle curve somewhere to the form.

The costume should be made of gentle fabrics. Avoid adding metals.

The skirt gathers like a flower bud.

The kung fu shoes are also decorated with leaves.

The tip of the wand should prominently bear a flower. A four-leaf clover (shown here) is also acceptable.

This character design was given a "floral" theme. The shape of her costume's ruffles and the billowing of her skirt are all imbued with the sense of a "flower." Her wand, bearing her emblem further enhances this basic theme. The color palette used consists of pastels.

The trimming is shaped like flower petals.

Select a pose that reverberates with "cuteness" rather than a stance ready for combat.

The garnish is reminiscent of a pistil, which connects to stamen trimming.

Magical Beings: Combat Scenes

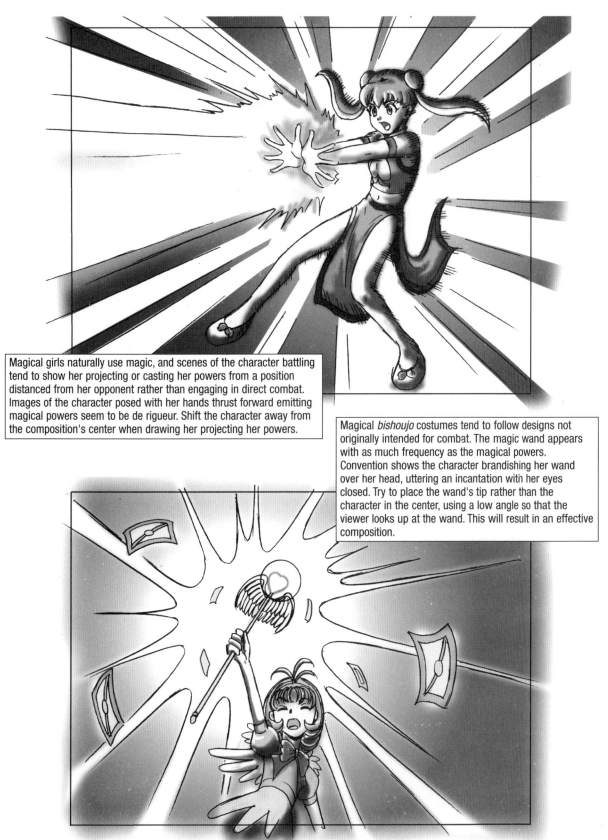

Magical girls naturally use magic, and scenes of the character battling tend to show her projecting or casting her powers from a position distanced from her opponent rather than engaging in direct combat. Images of the character posed with her hands thrust forward emitting magical powers seem to be de rigueur. Shift the character away from the composition's center when drawing her projecting her powers.

Magical *bishoujo* costumes tend to follow designs not originally intended for combat. The magic wand appears with as much frequency as the magical powers. Convention shows the character brandishing her wand over her head, uttering an incantation with her eyes closed. Try to place the wand's tip rather than the character in the center, using a low angle so that the viewer looks up at the wand. This will result in an effective composition.

While the character's physical appearance and costume are important, paying close attention to details, including her personal effects and props, brings the young artist one step closer to the professional. Learning to draw the few, basic items presented on the following pages will likely cover what you need for successful, details. Make an effort to expand your repertoire, coming up with your own designs.

School Effects I: Schoolbags

Despite that the schoolbag is always drawn with the school uniform, an unexpected number of artists are satisfied to draw a slipshod bag that they consider "passable." At the very least, practice drawing bags to ensure you can render them proficiently from multiple angles.

Schoolbag | **Day Bags**

Note the changes in appearance in the bag when viewed from an oblique angle.

The handle is attached to the bag by a metal fitting.

School Effects II: Shoes

Excluding specialized shoes for extracurricular activities, there are 3 general categories of shoes girls wear for school: 1) shoes worn to school; 2) shoes worn in the classroom (a different pair of canvas shoes are worn in the classroom); and 3) athletic shoes for gym class. Ensure that you are able to draw skillfully at least one of each category.

The most traditional school shoe is the classic penny loafer. The shoe is made of leather with a water-resistant finish. Dark brown and black tend to be the most common colors.

This tassel loafer includes a kiltie (fringed tongue) made of the same leather as the rest of the shoe. The fringe of the kiltie comes in 1 or 2 layers. Light to dark browns are the most common colors.

Mary Janes are classy are perfect for the princess-type characters. Often made of patent or high-quality leather, highlights are usually added to suggest a glossy sheen. Black is the best-suited color.

School Effects III: Purses and Tote Bags

Girls rarely leave home without a purse or bag in tow, whether it be a night on town with some friends or on a date. Bags are essential. On this page, are presented 3 general categories 1) hand and shoulder bags, 2) backpacks and courier bags, and 3) tote bags.

| Hand and Shoulder Bags | Backpacks and Courier Bags | Tote Bags |

These are the types of bags characters wear when dressing up. The top figure shows a bag perhaps better suited to the "Sexy Older Girl" or "the Heroine." Adding highlights to suggest a gloss enhances the sense of an upmarket product. The lower figure shows a small bag suited toward the more cheerful, vivacious characters. The character can be shown with the bag draped over her shoulder or, for an even cuter look, holding the bag in her hand, swinging it as she walks.

Worn slung over the shoulder or back, these bags are designed to hold hefty loads and often make their appearance at picnic and other such scenes. The backpack is more attractively worn low, toward the small of the back, rather than high. Draw your character wearing a hat to give her a look different from her norm.

Tote bags are open hand or shopping bags. Usually available in vinyl or canvas, totes are light, casual bags and perfect for when going on a short walk or shopping. Take care not to draw the bag overly large, or you will create the impression that it carries some special significance.

Uwabaki are canvas shoes worn exclusively indoors. The strap and edging are elasticized. The toe is rubber, so take extra care to distinguish the different fabrics when drawing the shoe. The rubber elastic areas appear more realistic when seams are included.

There are 2 categories of athletic shoes 1) "brand" (left figure) and 2) generic (right figure). Athletic shoes or sneakers generally appear when drawing extracurricular, sports scenes, and incorporating design elements will enhance the image. Carefully note the different ways in which the shoes are laced.

Combat I: Guns

The most common type of gun held by female characters in video games is the handgun. Next comes the machinegun, but these are still usually on the small side. Large guns carry the disadvantages of being difficult to spring and jump about while toting them as well as being difficult to conceal. Large guns are also difficult to render in an aesthetically pleasing way, whether in 2D or 3D. It should be noted that conversely, shotguns, bazookas, and other special weapons look superb when magnified to ridiculous sizes. Trace and practice drawing the 4 basic gun designs presented on the next pages.

The slide is open leaving the top of the locking block visible.

Beretta

Manufactured by the Italian corporation, Fabbrica d'Armi P. Beretta, the Beretta is a familiar gun, as the player is frequently supplied with a Beretta at the start of the game. In adventure and action games with a sense of realism, the Beretta is limited in the number of rounds it can fire. However, in action games where the player must clear stages to progress, the Beretta often becomes enabled with the capacity to fire rounds infinitely without reloading. The Beretta M92SB-F (the Beretta M9) weighs approximately 2 lbs. and measures at a length of 217 mm. The Beretta is water and dust tight. Not only is this a highly functional firearm, but also its Italian pedigree is evident in the Beretta's handsome appearance, and this attractive gun has turned up in *Die Hard* and other movies.

The magazine switch flips to the left and right according to whether the user is right-handed or left-handed.

The Beretta has a heavy grip.

The rear sight is vertically adjustable using the thumb.

The cocking handled is pulled back to fire.

The fore-grip serves to reduce recoil.

Heckler and Koch (H&K) MP5

The H&K MP5 is a high-powered, compact submachine gun developed by the West German company, Heckler & Koch GmbH. The barrel has a diameter of 9 mm, a total length of approximately 32 cm. (approx. 12 1/2"), weighs about 2 kg. (approx. 4 1/2 lbs), and has a grainy matte black finish, making it a small gun and perfect for female characters. The MP5 can easily be tucked away into an attaché case. This gun is extremely safe and comes with little risk of misfiring. Often used in reality for antiterrorist purposes by the police and public peacekeepers, the MP5 occasionally appears in street gun battles. The MP5 appears in *Lethal Weapon* and various other movies, so check it out.

Combat I: Guns

Includes a collapsible shoulder stock (shown folded up).

A silencer is attached at this point; however, silencers are banned in the United States.

The grip is lighter than that of a handgun.

Ingram M11 Heavyweight

Truly compact-measuring at 22 cm (approx. 8 5/8") in total length and weighing less than 1.5 kg (3 lbs. 5 oz.)-the Ingram M11 is the world's smallest submachine gun. The Ingram M11 was developed by the U.S. company RPB Industries in 1972, and its reasonable price and compact size met high acclaim.

Since this gun is easily concealed, many of the world's special forces and secret agencies use it. It should be noted that since the M11 is so light, it is able to fire at the astonishing speed of 1200 rounds per minute, making it difficult to control. Although movies often show this gun being fired using only one hand, such a stunt would be extremely dangerous for anyone other than a professional to execute. The M11 appears in *Total Recall*.

Grooved cylinder

Wooden stock

Shotgun

During a video game, a shotgun is often awarded to the player as a bonus. The shotgun fires a spray of many small metal pellets, enabling it to take out multiple enemies or monsters with one round. Note that a disadvantage to the shotgun is that it is limited in the number of times it can be fired, and prime opportunities can be lost if the gun is not reloaded successively. The shotgun has a long history. It was originally developed by the U.S. industrialist, Charles Parker in 1868 (later bought out by Remington Arms in 1930) and was used by stagecoach outriders for protection. Today, in the United States, a nation suffering from high crime rates, it is regularly kept on hand in police cars to offer security. The shotgun comes in black and has a wooden grip.

Holding a Mid-sized Machinegun

Combat II: Weapons

Bishoujo combat scenes include not only modern Western firearms, but also traditional Asian weapons, especially those of China and Japan, as well as weapons from medieval Europe. Protective gear makes its appearance when the characters engage in hand-to-hand combat. Scenes of our girl skillfully using these weapons to comfortably topple her opponent constitute one of the highlights of combat games. On this page are presented 5 of the most common.

Nunchaku

The nunchaku is a weapon originating in Okinawan karate passed down through tradition. The nunchaku became familiar to the general public through Bruce Lee's movies and became firmly established as a weapon used in Jeet Kune Do, the style of martial arts developed by Bruce Lee, and as a weapon used by Chinese characters.

Punching Gloves

These gloves are designed to protect the hands. Boxing gloves prevent the use of fingers in combat, so unless your character is supposed to be a boxer, have her wear these instead: they are more visually pleasing.

Morning Star

The morning star is a spiked sphere hung from the end of a chain attached to a stick. The chain can also be used to attack the enemy. The spikes on the sphere amplify the user's offensive capacity. This is an extremely cumbersome weapon.

Tonfa

The tonfa are used in pairs. One is held in each hand by the grip with the stick following the arm. One arm is then used to fend off blows, while the other is twirled and rotated to attack the opponent. While the tonfa traces its origins to karate, it is a general-purpose tool.

Double-edged Sword

This is a European medieval sword often used in fantasy-based games. While single-edged swords are also used, the double-edged sword seems fitting in the hero's hands. These swords come in various lengths with some even taller than their wielder. The weight of these swords becomes evident in scenes where they are used to hack or hew.

CHAPTER 4

Body Language

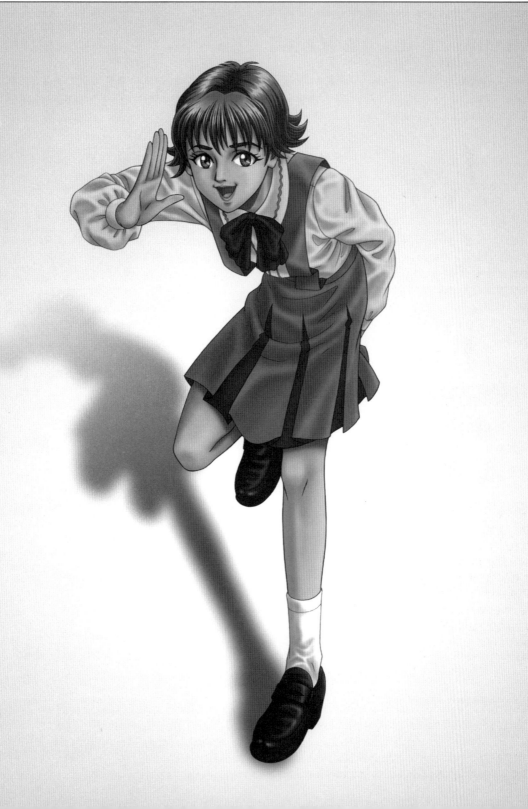

In this chapter I present some of the poses most frequently used in advertising or visuals of the game, action figures, and other areas peripheral to the game itself. (Naturally, these poses are also used within the actual game and for character design as well.) These poses are perhaps likely to appear more frequently in posters and flyers advertising the game than they do within the game itself. Since the visual aspect is emphasized in these poses, it is often unclear precisely what is taking place, making them perhaps seem difficult to approach from the artist's perspective, so keep in mind at all times the character's idiosyncrasies or the nature of the work when rendering such poses.

Preparing for the Match

Depicting the tense moment of a fighter waiting for her match shows her preparing in quiet solitude in order to gain mental focus. Rendering the character engaged in prayer or assuming a readied stance are ways for the artist to distinguish the martial arts discipline followed by the character.

Narrowing the distance between the eyebrows and having the eyebrows arch upward heightens the sense of tension.

The school of martial arts affects the choice of pose assumed before the match. For example, in karate and Shaolin kung fu the hands are positioned to express respect toward the opponent. Since these poses were originally developed by men, female characters should be given a rigid, mannish appearance when rendered in these poses.

TIP!
The fist rendered in a line finer than that used in the arm's contours represents the pose a split second earlier. Including this additional pose allows for the expression of movement.

Having the end of the headband dangle and flutter to about this extent presents a visually pleasing image.

These lines suggest a taught belly.

The fingers are spread.

The cut-off edges of the shorts are shown turned up to suggest the strength of the opponent.

The feet are spread to about the width of the shoulders. The toes should not be pointed inward.

Bare feet are standard.

Weight is shifted to the foot opposite the fist.

Firmly securing the headband allows the fighter to focus mentally. Showing the hair tied neatly in a ponytail will help evoke a sense of tension. Draw the knees widely apart and the back and hips held straight and erect in order to suggest the character is tense and not merely standing in a relaxed state.

This character is rendered with her entire body taut as she waits for her opponent's onslaught. Her gaze is focused on the opponent's eyes. Draw the character with her weight not distributed evenly on both feet but focused on one foot to allow her to shift easily into her next move.

Victory

These poses show the moment of joy after the character has defeated her opponent with a final, decisive move. Unlike scenes of the character preparing for the match, use primarily soft lines eased of tension. Remember to add feminine touches to these poses.

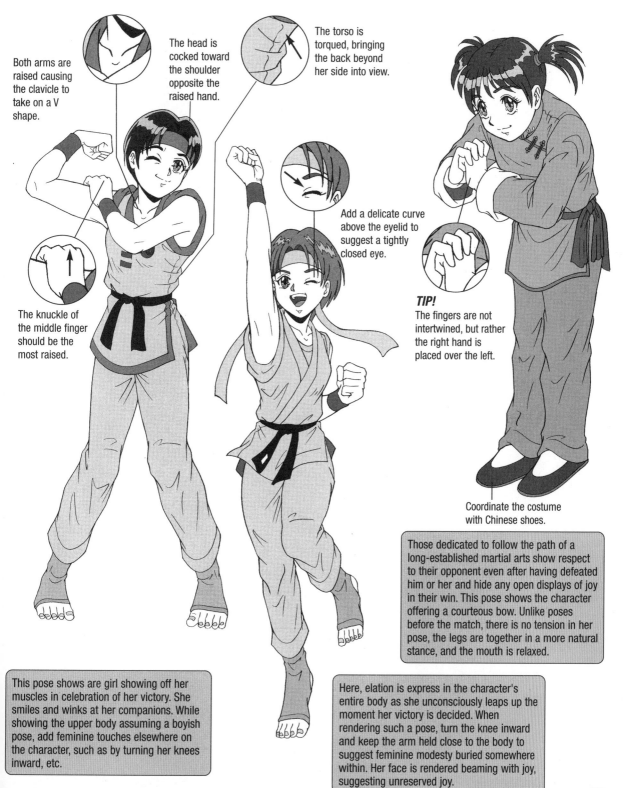

Both arms are raised causing the clavicle to take on a V shape.

The head is cocked toward the shoulder opposite the raised hand.

The torso is torqued, bringing the back beyond her side into view.

The knuckle of the middle finger should be the most raised.

Add a delicate curve above the eyelid to suggest a tightly closed eye.

TIP!
The fingers are not intertwined, but rather the right hand is placed over the left.

Coordinate the costume with Chinese shoes.

Those dedicated to follow the path of a long-established martial arts show respect to their opponent even after having defeated him or her and hide any open displays of joy in their win. This pose shows the character offering a courteous bow. Unlike poses before the match, there is no tension in her pose, the legs are together in a more natural stance, and the mouth is relaxed.

This pose shows are girl showing off her muscles in celebration of her victory. She smiles and winks at her companions. While showing the upper body assuming a boyish pose, add feminine touches elsewhere on the character, such as by turning her knees inward, etc.

Here, elation is express in the character's entire body as she unconsciously leaps up the moment her victory is decided. When rendering such a pose, turn the knee inward and keep the arm held close to the body to suggest feminine modesty buried somewhere within. Her face is rendered beaming with joy, suggesting unreserved joy.

113

Defeat

Defeat sees the character collapsed in defeat at her opponent's hands. Despite having fought valiantly up to this point, at her moment of defeat she crumples into a delicate, feminine pose. Showing emotional dismay rather than physical pain results in a more visually intense composition.

Here we see the character weeping, unable to overcome her defeat. She covers her face and wipes away her tears with a clenched fist, suggesting the profoundness of her frustration and anguish at her loss.

Here, we see the character drop to her knee in disappointment after her defeat is assured. She turns her face downward, closes her eyes and bites her lips as if trying to overcome the bitterness of her loss. Key points are that the elbows, wrists, and fingers are limply bent and that the hand rests on the ground in an enervated manner.

The face is directed down. One technique for suggesting sadness is to shroud the eyes in solid black shadow.

Rather than drawing the wrap in parallel curves, to achieve a more realistic effect, show it gathering at points to suggest that the cloth has been gathered and secured in place.

When drawing the face in profile, use vertical lines to suggest the eyelid.

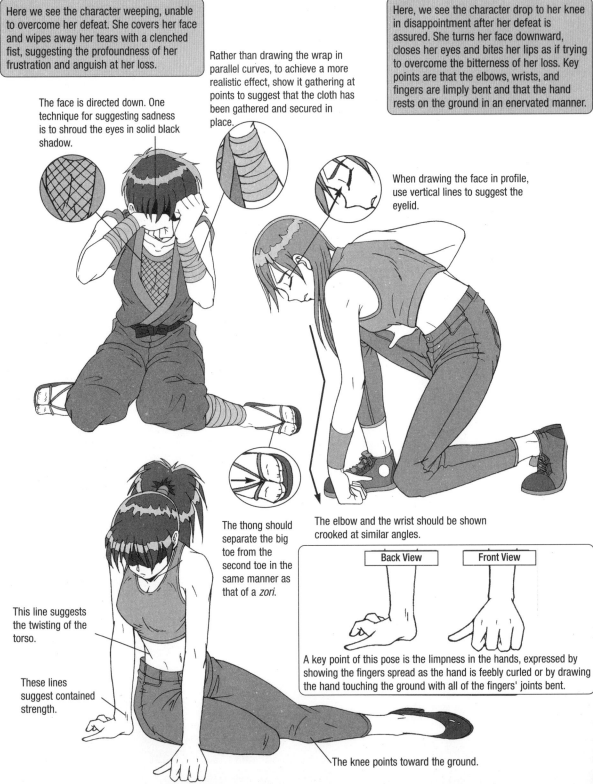

This line suggests the twisting of the torso.

These lines suggest contained strength.

The thong should separate the big toe from the second toe in the same manner as that of a *zori*.

The elbow and the wrist should be shown crooked at similar angles.

Back View	Front View

A key point of this pose is the limpness in the hands, expressed by showing the fingers spread as the hand is feebly curled or by drawing the hand touching the ground with all of the fingers' joints bent.

The knee points toward the ground.

Key Moves

The key move is the character's final grand stand-the moment when the decisive blow is spectacularly delivered. Render the figure entirely in rigid lines to suggest tautness in the body, all the way down to her fingertips. It is rather difficult to draw jumps and similar moves. However, including at least one such move will add a bit of zest to your artwork.

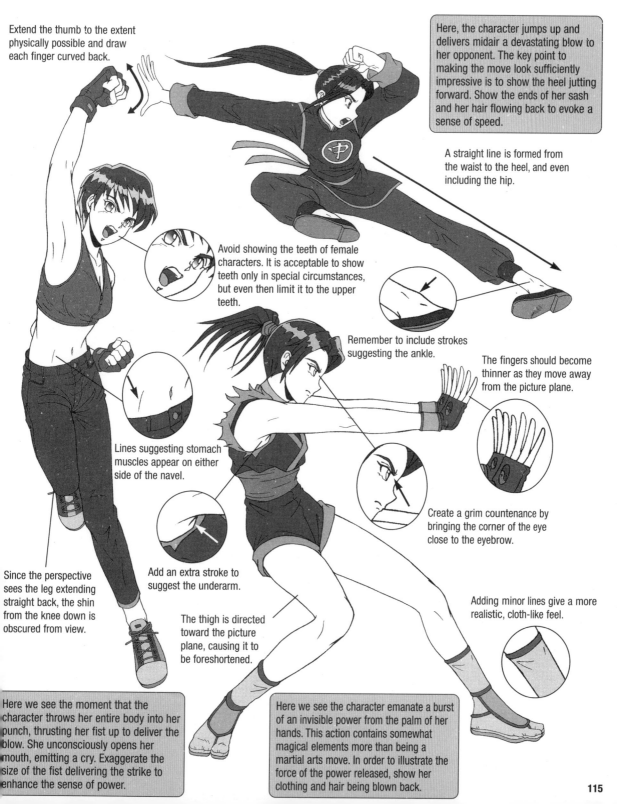

Extend the thumb to the extent physically possible and draw each finger curved back.

Here, the character jumps up and delivers midair a devastating blow to her opponent. The key point to making the move look sufficiently impressive is to show the heel jutting forward. Show the ends of her sash and her hair flowing back to evoke a sense of speed.

A straight line is formed from the waist to the heel, and even including the hip.

Avoid showing the teeth of female characters. It is acceptable to show teeth only in special circumstances, but even then limit it to the upper teeth.

Remember to include strokes suggesting the ankle.

The fingers should become thinner as they move away from the picture plane.

Lines suggesting stomach muscles appear on either side of the navel.

Create a grim countenance by bringing the corner of the eye close to the eyebrow.

Since the perspective sees the leg extending straight back, the shin from the knee down is obscured from view.

Add an extra stroke to suggest the underarm.

The thigh is directed toward the picture plane, causing it to be foreshortened.

Adding minor lines give a more realistic, cloth-like feel.

Here we see the moment that the character throws her entire body into her punch, thrusting her fist up to deliver the blow. She unconsciously opens her mouth, emitting a cry. Exaggerate the size of the fist delivering the strike to enhance the sense of power.

Here we see the character emanate a burst of an invisible power from the palm of her hands. This action contains somewhat magical elements more than being a martial arts move. In order to illustrate the force of the power released, show her clothing and hair being blown back.

Receiving Blows

This page shows those moments where the character sustains injury from a decisive blow dealt by her opponent. These scenes have her knocked off her feet or thrown to the ground in exaggerated, embellished movements. If she has enough time before the blow is delivered, she will naturally throw up her hands to try to ward off the attack. Icons or visual marks popularly used in manga may be used to suggest speed streaks or the impact of strikes.

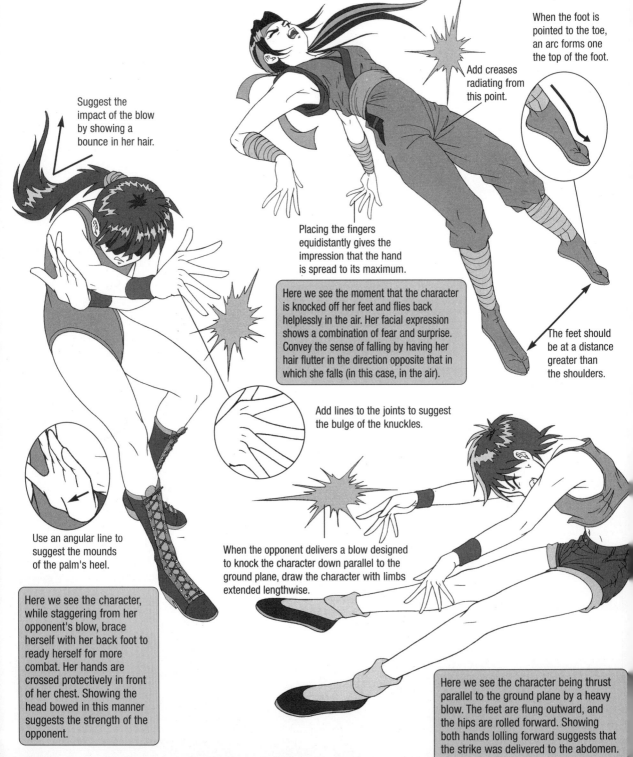

When the foot is pointed to the toe, an arc forms one the top of the foot.

Add creases radiating from this point.

Suggest the impact of the blow by showing a bounce in her hair.

Placing the fingers equidistantly gives the impression that the hand is spread to its maximum.

Here we see the moment that the character is knocked off her feet and flies back helplessly in the air. Her facial expression shows a combination of fear and surprise. Convey the sense of falling by having her hair flutter in the direction opposite that in which she falls (in this case, in the air).

The feet should be at a distance greater than the shoulders.

Add lines to the joints to suggest the bulge of the knuckles.

Use an angular line to suggest the mounds of the palm's heel.

When the opponent delivers a blow designed to knock the character down parallel to the ground plane, draw the character with limbs extended lengthwise.

Here we see the character, while staggering from her opponent's blow, brace herself with her back foot to ready herself for more combat. Her hands are crossed protectively in front of her chest. Showing the head bowed in this manner suggests the strength of the opponent.

Here we see the character being thrust parallel to the ground plane by a heavy blow. The feet are flung outward, and the hips are rolled forward. Showing both hands lolling forward suggests that the strike was delivered to the abdomen.

Challenging the Opponent

These are taunting, mocking poses designed to anger the opponent. These are primarily used when the character is psychologically superior to her opponent. Humorous elements may be added to make the scene comical. Try to apply that charming yet insufferable nature particular to girls to perturbing to her opponent.

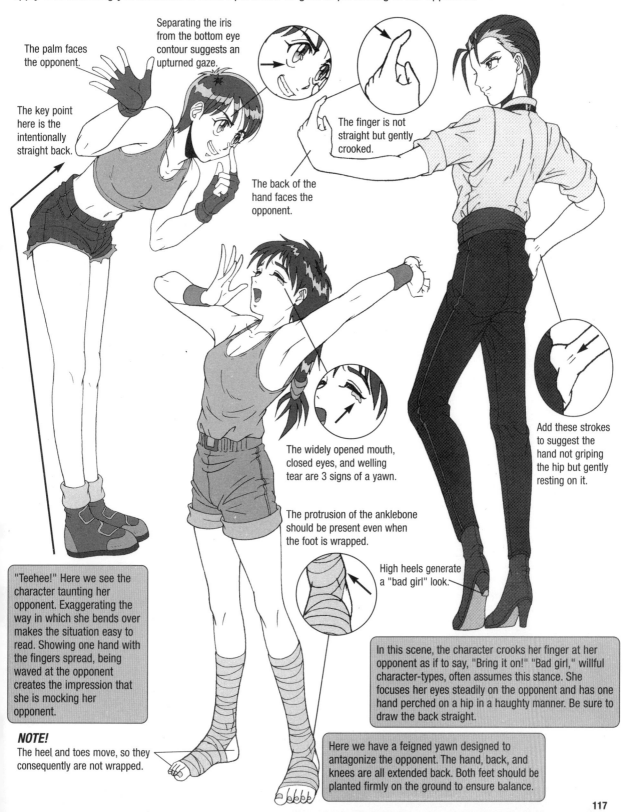

The palm faces the opponent.

Separating the iris from the bottom eye contour suggests an upturned gaze.

The key point here is the intentionally straight back.

The finger is not straight but gently crooked.

The back of the hand faces the opponent.

Add these strokes to suggest the hand not griping the hip but gently resting on it.

The widely opened mouth, closed eyes, and welling tear are 3 signs of a yawn.

The protrusion of the anklebone should be present even when the foot is wrapped.

High heels generate a "bad girl" look.

"Teehee!" Here we see the character taunting her opponent. Exaggerating the way in which she bends over makes the situation easy to read. Showing one hand with the fingers spread, being waved at the opponent creates the impression that she is mocking her opponent.

NOTE!
The heel and toes move, so they consequently are not wrapped.

In this scene, the character crooks her finger at her opponent as if to say, "Bring it on!" "Bad girl," willful character-types, often assumes this stance. She focuses her eyes steadily on the opponent and has one hand perched on a hip in a haughty manner. Be sure to draw the back straight.

Here we have a feigned yawn designed to antagonize the opponent. The hand, back, and knees are all extended back. Both feet should be planted firmly on the ground to ensure balance.

Girls exhibit extremely candid facial expressions and mannerisms when at school, perhaps because they are surrounded by their friends. Parts of the girls' world are closed to boys: girls chatting in a group or changing their clothes. However, a few of the types of gestures and mannerisms that appear most frequently in *bishoujo* games have been compiled and are presented below.

Buddy Poses

Such compositions not only appear in the game itself but are also used in posters and advertisements for the game. The dynamics of the girls' relationship may also be expressed, depending on the pose. Mix and match contrasting personalities-one who is reliable and the other reliant; one who jokes around and the other reproachful-to arrive at a balanced pair.

The hand is not gripping the shoulder but interlocked with the other hand coming up from the other side of the shoulder.

Use a difference in height to distinguish senior from junior schoolmates.

TIP!
The way a character grabs or grips something depends on her personality. The Honor Roll Student links her arm tenderly and gently. The younger girl grabs on as if she were hugging a teddy bear.

Her body is tilted, causing her shoulder to rise to this position.

| Older | Younger |

A point is made of showing the older character without her arms wrapped around the younger character to suggest that the former is in fact being hugged.

Scenes of junior and senior schoolmates draped over one another suggest the degree of closeness between the subjects. While both of the above two characters are demonstrative, the older character has opted for a composed, collected pose, while the younger character clings to her shoulder, suggesting emotional dependence.

Here we have a dependent character being embraced by a character who is normally protective of her. Decide the personalities of both characters before drawing them embracing. The positioning of the hands is a key design point.

The arc in her side suggests she is being hauled toward the other character.

When drawing a complicated composition with 2 characters embracing, draw the character being embraced first and then add the other on top. Here we see the Heroine and a honor roll character-type. This is a view of 2 friendly honor roll characters with similar personalities. Here, the Heroine for the most part retains her pose, while the honor roll enthusiastically embraces her.

Controlling Errant Skirts

These are scenes of girls stricken panic as they try to restrain an errant skirt flipped up by a sudden breeze: a sight welcomed by the schoolboys lucky enough to witness it. The character should be drawn holding the skirt firmly down with her hands, while just a bit more of her legs should be visible than usual. Consider whether you would like to make the scene comical or simply one of distress and embarrassment as appropriate to the character's personality.

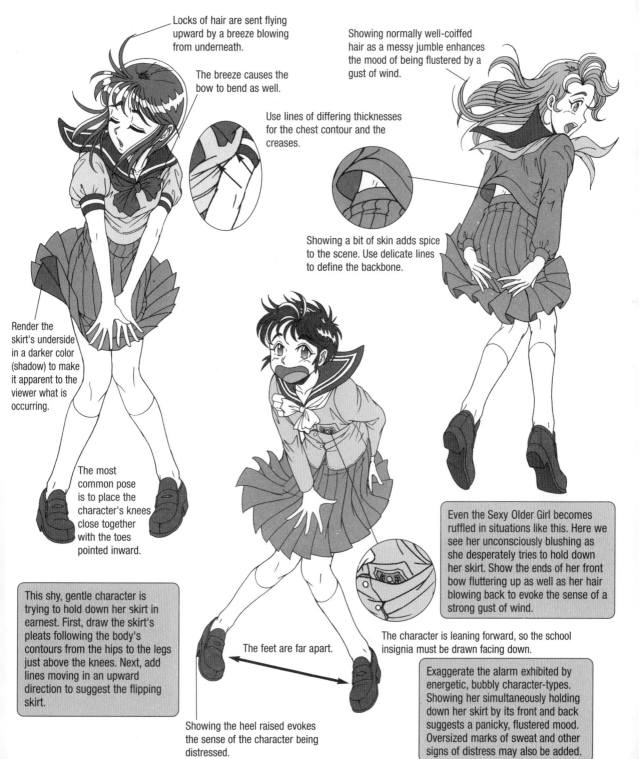

Locks of hair are sent flying upward by a breeze blowing from underneath.

The breeze causes the bow to bend as well.

Showing normally well-coiffed hair as a messy jumble enhances the mood of being flustered by a gust of wind.

Use lines of differing thicknesses for the chest contour and the creases.

Showing a bit of skin adds spice to the scene. Use delicate lines to define the backbone.

Render the skirt's underside in a darker color (shadow) to make it apparent to the viewer what is occurring.

The most common pose is to place the character's knees close together with the toes pointed inward.

This shy, gentle character is trying to hold down her skirt in earnest. First, draw the skirt's pleats following the body's contours from the hips to the legs just above the knees. Next, add lines moving in an upward direction to suggest the flipping skirt.

The feet are far apart.

Showing the heel raised evokes the sense of the character being distressed.

Even the Sexy Older Girl becomes ruffled in situations like this. Here we see her unconsciously blushing as she desperately tries to hold down her skirt. Show the ends of her front bow fluttering up as well as her hair blowing back to evoke the sense of a strong gust of wind.

The character is leaning forward, so the school insignia must be drawn facing down.

Exaggerate the alarm exhibited by energetic, bubbly character-types. Showing her simultaneously holding down her skirt by its front and back suggests a panicky, flustered mood. Oversized marks of sweat and other signs of distress may also be added.

Eating

People often say you can tell breeding and character by the way someone eats, and eating scenes tend to bring out a game character's personality. On this page I present the 3 most common meal scenes: eating breakfast, eating from a bento box (lunchbox), and eating a hot cafeteria lunch. There are also scenes of eating sandwiches in the classroom, scarfing down a lunch on the go, as well as various other settings.

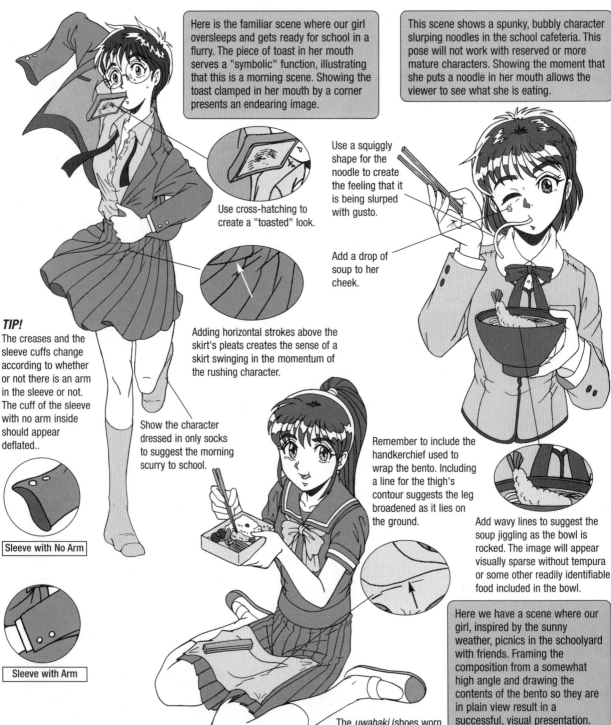

Here is the familiar scene where our girl oversleeps and gets ready for school in a flurry. The piece of toast in her mouth serves a "symbolic" function, illustrating that this is a morning scene. Showing the toast clamped in her mouth by a corner presents an endearing image.

This scene shows a spunky, bubbly character slurping noodles in the school cafeteria. This pose will not work with reserved or more mature characters. Showing the moment that she puts a noodle in her mouth allows the viewer to see what she is eating.

Use cross-hatching to create a "toasted" look.

Use a squiggly shape for the noodle to create the feeling that it is being slurped with gusto.

Add a drop of soup to her cheek.

TIP!

The creases and the sleeve cuffs change according to whether or not there is an arm in the sleeve or not. The cuff of the sleeve with no arm inside should appear deflated..

Adding horizontal strokes above the skirt's pleats creates the sense of a skirt swinging in the momentum of the rushing character.

Show the character dressed in only socks to suggest the morning scurry to school.

Remember to include the handkerchief used to wrap the bento. Including a line for the thigh's contour suggests the leg broadened as it lies on the ground.

Add wavy lines to suggest the soup jiggling as the bowl is rocked. The image will appear visually sparse without tempura or some other readily identifiable food included in the bowl.

Sleeve with No Arm

Sleeve with Arm

The *uwabaki* (shoes worn only indoors) underscore the idea of a school scene.

Here we have a scene where our girl, inspired by the sunny weather, picnics in the schoolyard with friends. Framing the composition from a somewhat high angle and drawing the contents of the bento so they are in plain view result in a successful, visual presentation. The contents of the lunch should be colorful, as would be expected of a schoolgirl.

Changing Clothes

Scenes of girls changing clothing is practically ubiquitous in *bishoujo* games or *gyaru ge* (video games featuring female heroines). It should be noted that overdoing such scenes will make them come across as indecent and offensive and could destroy the character's image. Common practice tends toward not revealing much of the undergarments; however, the difficulty lies in that completely eliminating any form of titillation from these scenes will render them boring.

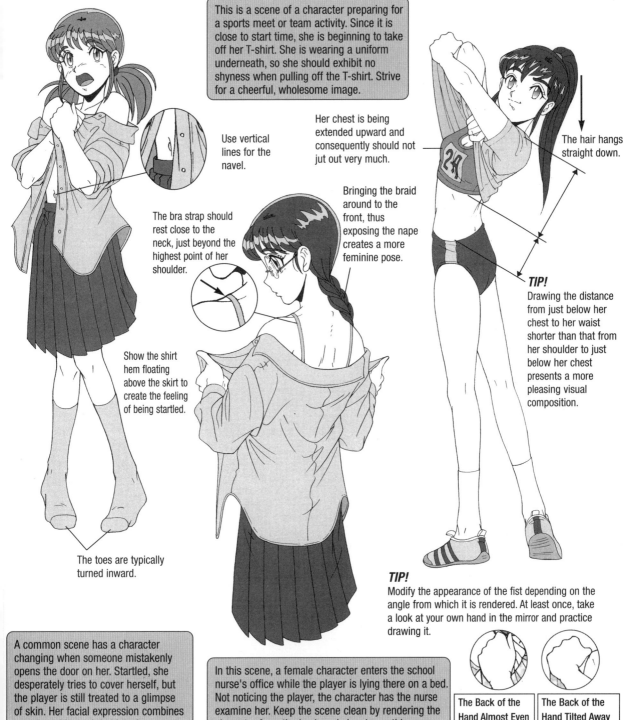

This is a scene of a character preparing for a sports meet or team activity. Since it is close to start time, she is beginning to take off her T-shirt. She is wearing a uniform underneath, so she should exhibit no shyness when pulling off the T-shirt. Strive for a cheerful, wholesome image.

Use vertical lines for the navel.

Her chest is being extended upward and consequently should not jut out very much.

The hair hangs straight down.

The bra strap should rest close to the neck, just beyond the highest point of her shoulder.

Bringing the braid around to the front, thus exposing the nape creates a more feminine pose.

Show the shirt hem floating above the skirt to create the feeling of being startled.

The toes are typically turned inward.

TIP!
Drawing the distance from just below her chest to her waist shorter than that from her shoulder to just below her chest presents a more pleasing visual composition.

TIP!
Modify the appearance of the fist depending on the angle from which it is rendered. At least once, take a look at your own hand in the mirror and practice drawing it.

A common scene has a character changing when someone mistakenly opens the door on her. Startled, she desperately tries to cover herself, but the player is still treated to a glimpse of skin. Her facial expression combines surprise with a subtle hint of indignation.

In this scene, a female character enters the school nurse's office while the player is lying there on a bed. Not noticing the player, the character has the nurse examine her. Keep the scene clean by rendering the character from the back and showing nothing more than her bra strap.

The Back of the Hand Almost Even with the Picture Plane

The Back of the Hand Tilted Away from the Picture Plane

Sitting on the Floor (Gym Class)

There are various possible seated poses a character could assume at school, but sitting on the floor, especially for gym class is essential. There are many artists who are picky about rendering this type of pose correctly, and a producer of one game even directed his art team on how to draw it. The angle may vary depending on how the game's storyline develops. However, you should practice drawing the side views first.

Sitting on the floor in this manner can be unexpectedly tiring. In addition to this basic pose, practice drawing relaxed variations as well. Here we see a babyish character. The shoulders are hunched as she grasps her ankles and gazes upward. This is a typical affected cutesy look

This sitting posture is excellent for the more active and sexually attractive characters. She has shifted from having both feet in front to laying one leg flat on the ground. While this pose bears no special significance, it does make a more visually interesting composition, and, consequently, is used frequently. While this scene is supposed to take place in gym class, this pose also appears in RPGs and action games.

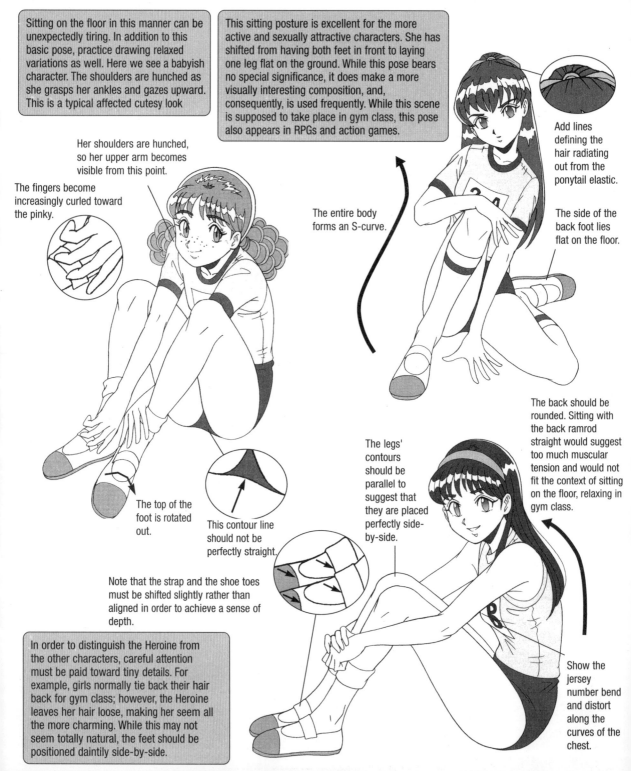

Her shoulders are hunched, so her upper arm becomes visible from this point.

The fingers become increasingly curled toward the pinky.

Add lines defining the hair radiating out from the ponytail elastic.

The entire body forms an S-curve.

The side of the back foot lies flat on the floor.

The top of the foot is rotated out.

This contour line should not be perfectly straight.

The legs' contours should be parallel to suggest that they are placed perfectly side-by-side.

The back should be rounded. Sitting with the back ramrod straight would suggest too much muscular tension and would not fit the context of sitting on the floor, relaxing in gym class.

Note that the strap and the shoe toes must be shifted slightly rather than aligned in order to achieve a sense of depth.

In order to distinguish the Heroine from the other characters, careful attention must be paid toward tiny details. For example, girls normally tie back their hair back for gym class; however, the Heroine leaves her hair loose, making her seem all the more charming. While this may not seem totally natural, the feet should be positioned daintily side-by-side.

Show the jersey number bend and distort along the curves of the chest.

Grand Entrances

Unlike the other characters, the Sexy Older Girl and Princess regularly assume affected poses indicative of their personalities and make grand entrances. This can be construed as that they constantly have their public façade in place. On the other hand, these grand entrances are easy to design. Try to add a flourish to every movement these characters make—the way they walk, the way they talk, every motion.

Here we see an austere young woman, born with a silver spoon in her mouth. The hand resting on her hip expresses her haughty, superior attitude. A key point to drawing this hand is to make sure the fingers are separated: showing the hand clenched would signify something entirely different. The fingers of the hand placed at her chest should be tautly extended.

Here we have the Princess. Her countenance is gentle, but the hand placed at her chest suggests an arrogant personality. Other key points are that she is drawn with her back straight and with her raised arm held slightly away from her body.

Here we have the conceited Sexy Older Girl. Even when walking, she assumes a distinctive pose, always conscious of her surroundings. Long hair on a tall frame alone is capable of creating a sense of presence and, consequently, is perfect for this character-type. Straight versus wavy hair project different personalities. Straight hair suggests a more austere personality.

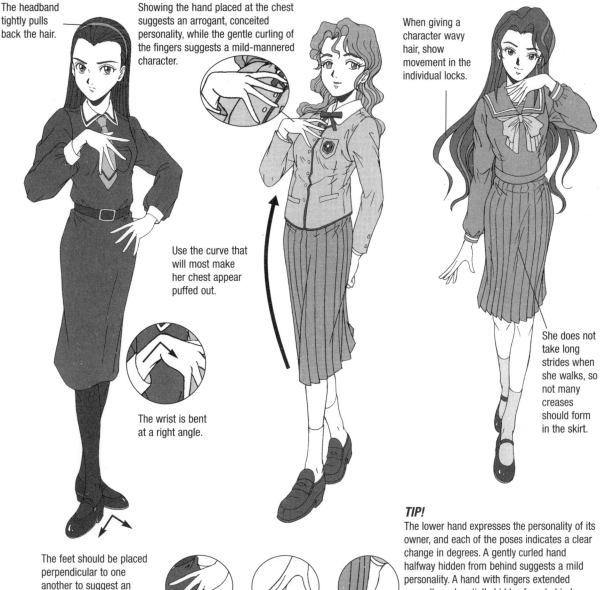

The headband tightly pulls back the hair.

Showing the hand placed at the chest suggests an arrogant, conceited personality, while the gentle curling of the fingers suggests a mild-mannered character.

When giving a character wavy hair, show movement in the individual locks.

Use the curve that will most make her chest appear puffed out.

The wrist is bent at a right angle.

She does not take long strides when she walks, so not many creases should form in the skirt.

The feet should be placed perpendicular to one another to suggest an exacting personality.

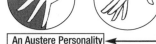

An Austere Personality

TIP!
The lower hand expresses the personality of its owner, and each of the poses indicates a clear change in degrees. A gently curled hand halfway hidden from behind suggests a mild personality. A hand with fingers extended normally and partially hidden from behind suggests a sophisticated personality. Fingers tautly extended and rested on the hip suggest an austere personality.

Waiting

Whether at the park, the movie theater, or the shopping center, all dates start with a "rendezvous." Here, below are presented 3 variations: one where our girl walks home after school with the love interest/player; one where the player is asked to stay after class by a character, and she is there; and one where she dresses up for the date. In all, add a sense of shyness, excitement, and joy.

This pose shows her with both hands held to her chest and the back straight, expressing nervousness. Such poses are frequently used in scenes where a character confesses her love or calls out a boy's name. Showing the hands partially covered by the sleeves enhances the impression of a young girl.

This pose shows her all dressed up but feeling a bit bashful. Such poses are frequently used in weekend or holiday rendezvous scenes. The key points here are the torsion in the elbows and the inward pointed toes.

This is a standard pretty pose used for female characters. In this scene, the player is asked to stay after class by the teacher. This shows the moment that the player arrives in the classroom, finds her there, and she glances back. Adding sunlight in the background will make her seem to sparkle all the more.

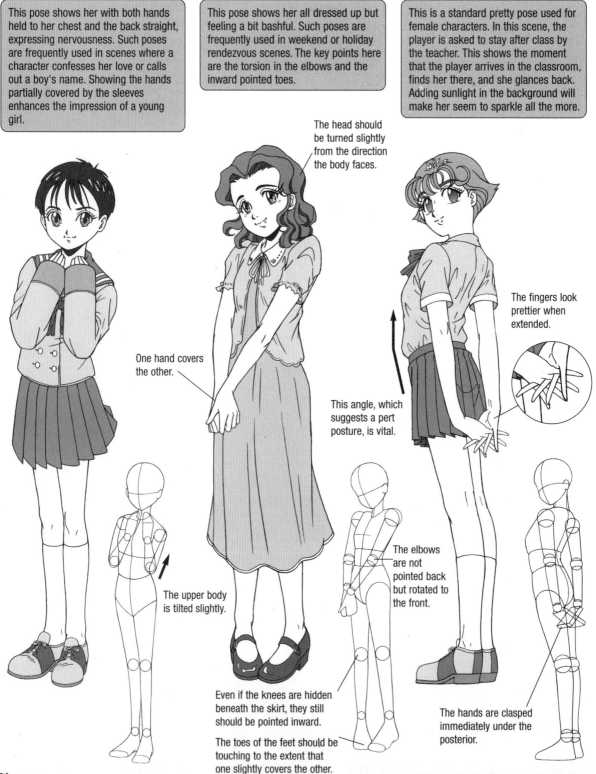

The head should be turned slightly from the direction the body faces.

One hand covers the other.

The fingers look prettier when extended.

This angle, which suggests a pert posture, is vital.

The upper body is tilted slightly.

The elbows are not pointed back but rotated to the front.

Even if the knees are hidden beneath the skirt, they still should be pointed inward.

The toes of the feet should be touching to the extent that one slightly covers the other.

The hands are clasped immediately under the posterior.

Relaxing

There are countless poses where a character is plopped on the floor: sitting with legs splayed out in front or first sitting with the legs tucked politely underneath, but then moving the legs out, sitting kerplunk on the floor. Try to imbue the scene with an air of vulnerability: she may be tired, feeling bashful, or needing attention/trying to look coquettish. The Athletic Girl may be shown sitting cross-legged.

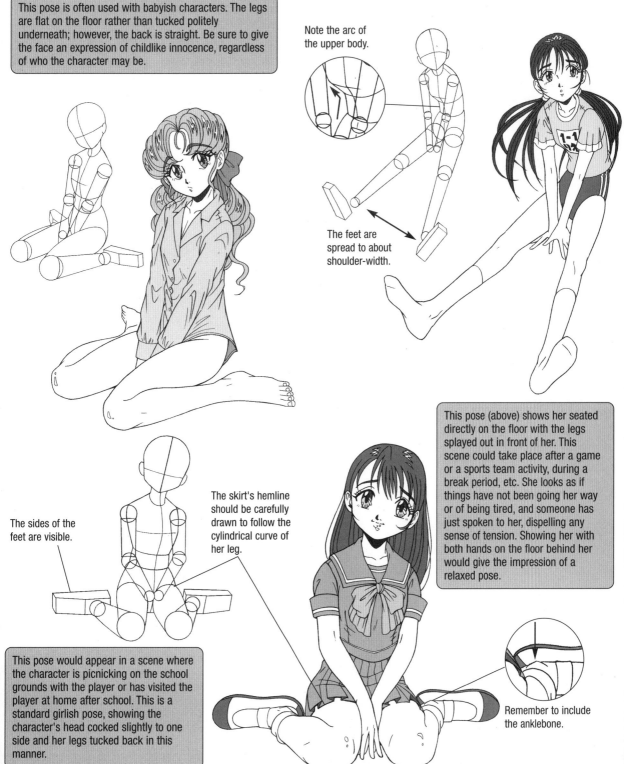

This pose is often used with babyish characters. The legs are flat on the floor rather than tucked politely underneath; however, the back is straight. Be sure to give the face an expression of childlike innocence, regardless of who the character may be.

Note the arc of the upper body.

The feet are spread to about shoulder-width.

This pose (above) shows her seated directly on the floor with the legs splayed out in front of her. This scene could take place after a game or a sports team activity, during a break period, etc. She looks as if things have not been going her way or of being tired, and someone has just spoken to her, dispelling any sense of tension. Showing her with both hands on the floor behind her would give the impression of a relaxed pose.

The sides of the feet are visible.

The skirt's hemline should be carefully drawn to follow the cylindrical curve of her leg.

This pose would appear in a scene where the character is picnicking on the school grounds with the player or has visited the player at home after school. This is a standard girlish pose, showing the character's head cocked slightly to one side and her legs tucked back in this manner.

Remember to include the anklebone.

Flirtatious Poses

When a character has allowed the player to enter her bedroom, she assumes a pose that indicates she is opening herself completely. An oversized or extra-long T-shirt offers more a sense of "girlish allure" than would skimpy lingerie. Imagine the movements of a kitten when drawing the character, showing her stretching extravagantly or her with her head tilted to the side.

This pose, with the head cocked slightly to the side, indicates indecision. A key point is that her eyes should gaze into the direction opposite the one her body faces. The finger is not pressed directly on the lips but a little to the side. Be sure that the fingertip is extended.

This is a "relaxed" pose, where the character has stretched and is arching back. Take note that the knees should not be together as this would throw the figure off balance. The shirt is most attractive when its hemline comes just past the posterior. Take note that exposing her panties would be in bad taste.

Show the body turning just slightly in the direction opposite that of the character's gaze and draw the entire figure from head to feet in an S-curve. This pose projects a sense of bashfulness. This pose is a viable option for active, tomboyish and athletic characters. Despite feeling embarrassed, she still adopts this flirtatious posture. This pose is also acceptable for the Heroine or the more mature characters.

This shoulder is only slightly visible.

Rotate the right hand behind the figure and show it gently curled.

The key point here is to show the thumbs interlocked.

Use wide curves for the overall form.

The stomach is thrust out.

Use a gentle slope for the figure overall.

Relaxing

Once the player has achieved a certain degree of friendship with a female character, the game will likely develop, and she may visit the player's home or may ask the player to visit her. On this page are presented seated poses the character may assume that indicate she is feeling totally open to the player. The more relaxed she feels, the more unguarded she will become, allowing the player to get a clear glimpse of her true self.

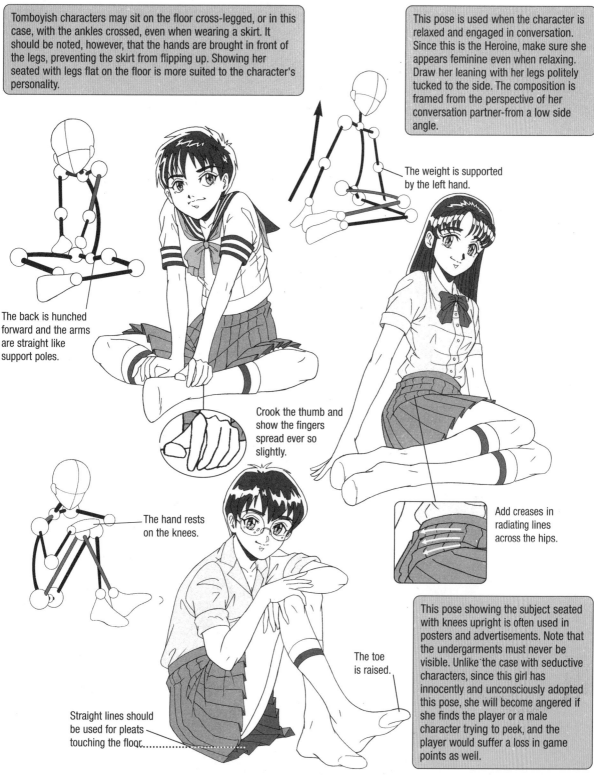

Tomboyish characters may sit on the floor cross-legged, or in this case, with the ankles crossed, even when wearing a skirt. It should be noted, however, that the hands are brought in front of the legs, preventing the skirt from flipping up. Showing her seated with legs flat on the floor is more suited to the character's personality.

This pose is used when the character is relaxed and engaged in conversation. Since this is the Heroine, make sure she appears feminine even when relaxing. Draw her leaning with her legs politely tucked to the side. The composition is framed from the perspective of her conversation partner-from a low side angle.

The weight is supported by the left hand.

The back is hunched forward and the arms are straight like support poles.

Crook the thumb and show the fingers spread ever so slightly.

The hand rests on the knees.

Add creases in radiating lines across the hips.

The toe is raised.

Straight lines should be used for pleats touching the floor.

This pose showing the subject seated with knees upright is often used in posters and advertisements. Note that the undergarments must never be visible. Unlike the case with seductive characters, since this girl has innocently and unconsciously adopted this pose, she will become angered if she finds the player or a male character trying to peek, and the player would suffer a loss in game points as well.

Temptation

As it is in line with their characters, the Sexy Older Girl and the Princess may inevitably require a "sexy scene," depending on how the story develops. If developments take the game to the beach or a swimming pool, then a sexy pose of the character in a swimsuit becomes essential. Since these poses can be used in illustrations for posters and the like as well as are popular poses for plastic and vinyl figures, make sure you master them.

Draw the figure arcing back at an angle and have her gaze up at her companion/the player. Arc the torso back to emphasize the chest. The positioning of the hands is popular for creating a beguiling pose. Another key point is to show one heel raised.

The Sexy Older Girl is sufficiently sexy, even without using an exaggeratedly provocative pose. This pose, where the character modestly covers her chest, is, to the contrary, sexy. Show both arms wrapped around the torso to give the impression of the character hugging herself with both arms.

Showing the waist twisting in this manner gives the figure an attractive sweep. Even if it is not clear what exactly she is doing, this character's personality permits the use of such a pose, provided it is flattering to the character.

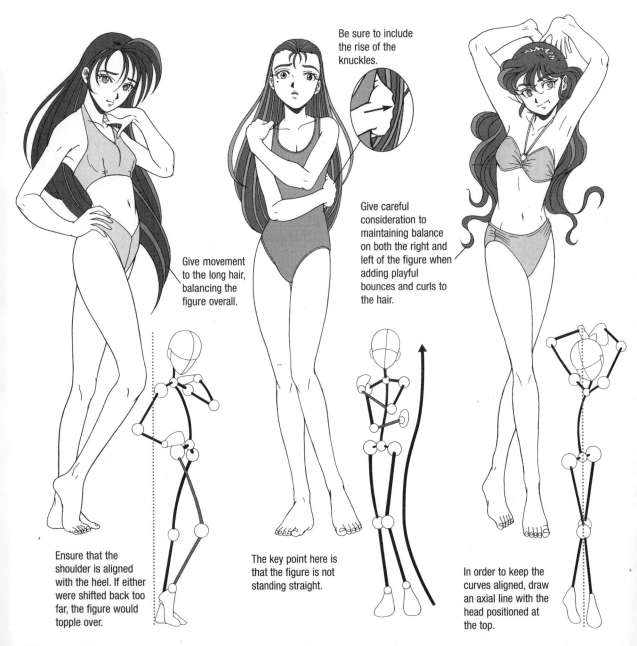

Be sure to include the rise of the knuckles.

Give movement to the long hair, balancing the figure overall.

Give careful consideration to maintaining balance on both the right and left of the figure when adding playful bounces and curls to the hair.

Ensure that the shoulder is aligned with the heel. If either were shifted back too far, the figure would topple over.

The key point here is that the figure is not standing straight.

In order to keep the curves aligned, draw an axial line with the head positioned at the top.

Relaxing

Views only from the waist up often appear in conversation scenes taking place in cafés and restaurants while on dates. Since the composition is only from the waist up, the face automatically takes up more of the screen, making the player feel as if he (or she) is truly conversing with the character. Yet, showing the character sitting with her hands politely on her lap would be interesting neither visually nor in terms of the game. On this page are presented how to position the hands, cock the head, and other poses suited to the different characters' personalities.

Here we see a pose used for either the Sexy Older Girl or the Athletic Girl. She is more absorbed in thought about herself than she is focused on her conversation partner. This pose, which shows the head tilted to the side and resting on the hand, is popular for showing a character lost in thought. Draw the eyes as if gazing distantly.

The shoulders rise as the elbows are brought close together.

The chin is rested on the palms of the hands, and space is left between the face and the fingers.

The elbow should be shown protruding.

The edge of the table should be placed just below the chest.

The Cute, Younger Girl is totally absorbed in her conversation partner. Both elbows are resting on the table, and her hands cup her face. She leans forward, gazing into her date's eyes. Draw her cute to the point of appearing calculated.

Only the eyelashes of the opposite eye \are visible.

Add highlights to the lips, indicating she is wearing cosmetics, as would be natural for a girl on a date.

The swell of the hand's heel hides part of the chin.

This character is sitting straight up in her seat, so the table should be positioned somewhat distanced from the chest.

The Bad Girl sits at an angle, superficially projecting a disinterested air. However, her eyes are closely fixed on her conversation partner. Draw the fingers of the hand resting on the table as if drumming or fidgeting in some manner.

The Honor Roll Student is even serious when on a date. Although her hands are interlocked beneath her chin, she is sitting erect in her seat, so no weight is actually being placed on the hands. The elbows should not be brought too far apart- about to shoulder-width.

Sleeping/Reclining

Showing the character sleeping soundly while tucked into her futon (a thin mattress placed directly on the floor and used for sleeping) is neither visually interesting, nor does it add to the game's development. Consequently, the artist must resort to using poses, which seem extremely artificial or at first glance seem used for the sole function of making the character look cute. Use your ingenuity when rendering the motions of the hands, positioning of the legs, or twisting of the waist. Be careful to avoid using an overly risqué pose. Sleeping poses can also be used in scenes where the player is tempted, or poster and other game-related artwork.

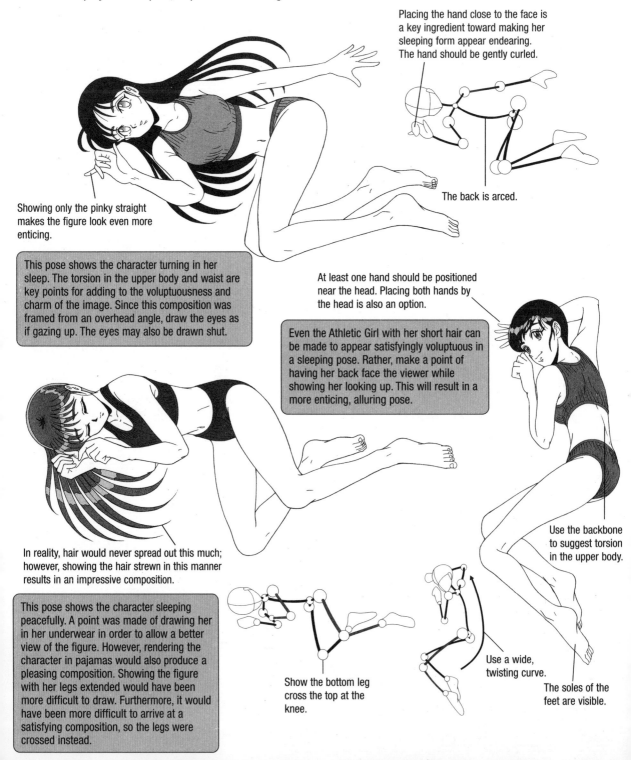

Placing the hand close to the face is a key ingredient toward making her sleeping form appear endearing. The hand should be gently curled.

The back is arced.

Showing only the pinky straight makes the figure look even more enticing.

This pose shows the character turning in her sleep. The torsion in the upper body and waist are key points for adding to the voluptuousness and charm of the image. Since this composition was framed from an overhead angle, draw the eyes as if gazing up. The eyes may also be drawn shut.

At least one hand should be positioned near the head. Placing both hands by the head is also an option.

Even the Athletic Girl with her short hair can be made to appear satisfyingly voluptuous in a sleeping pose. Rather, make a point of having her back face the viewer while showing her looking up. This will result in a more enticing, alluring pose.

In reality, hair would never spread out this much; however, showing the hair strewn in this manner results in an impressive composition.

This pose shows the character sleeping peacefully. A point was made of drawing her in her underwear in order to allow a better view of the figure. However, rendering the character in pajamas would also produce a pleasing composition. Showing the figure with her legs extended would have been more difficult to draw. Furthermore, it would have been more difficult to arrive at a satisfying composition, so the legs were crossed instead.

Show the bottom leg cross the top at the knee.

Use the backbone to suggest torsion in the upper body.

Use a wide, twisting curve.

The soles of the feet are visible.

Injured

Scenes of a character meeting with an accident or sustaining an injury serve as accents in the game's development. Give careful consideration to how the character became injured when drawing the scene. Do not limit expression of pain to the face. Reflect pain through the character's entire body.

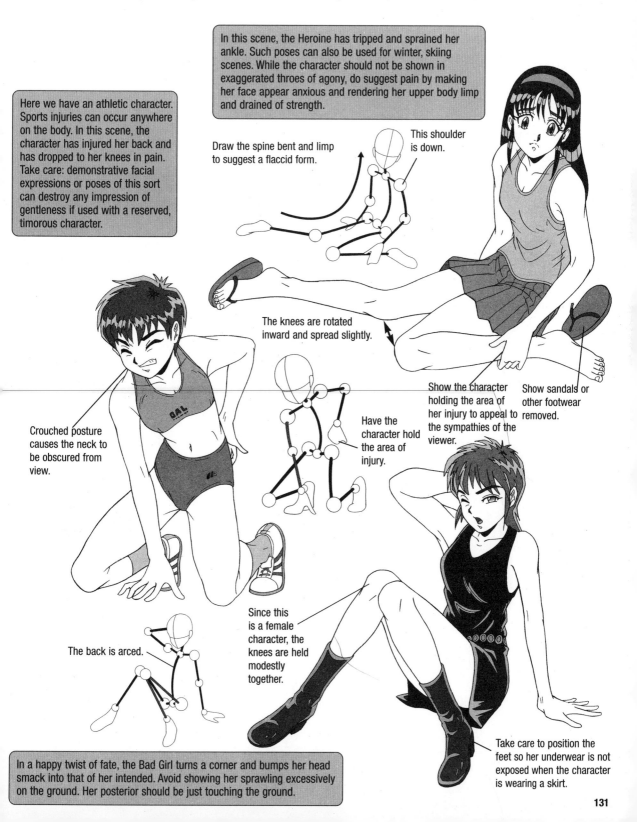

In this scene, the Heroine has tripped and sprained her ankle. Such poses can also be used for winter, skiing scenes. While the character should not be shown in exaggerated throes of agony, do suggest pain by making her face appear anxious and rendering her upper body limp and drained of strength.

Here we have an athletic character. Sports injuries can occur anywhere on the body. In this scene, the character has injured her back and has dropped to her knees in pain. Take care: demonstrative facial expressions or poses of this sort can destroy any impression of gentleness if used with a reserved, timorous character.

Draw the spine bent and limp to suggest a flaccid form.

This shoulder is down.

The knees are rotated inward and spread slightly.

Crouched posture causes the neck to be obscured from view.

Have the character hold the area of injury.

Show the character holding the area of her injury to appeal to the sympathies of the viewer.

Show sandals or other footwear removed.

The back is arced.

Since this is a female character, the knees are held modestly together.

Take care to position the feet so her underwear is not exposed when the character is wearing a skirt.

In a happy twist of fate, the Bad Girl turns a corner and bumps her head smack into that of her intended. Avoid showing her sprawling excessively on the ground. Her posterior should be just touching the ground.

Cheering/Motivational Poses

One of the factors in making a character appealing is how to give her a touch of humanness in order to make her engaging to the players. An example would be the warm words of encouragement offered by a character when she comes to see the player participate in an athletic event. The "cheering" poses below can carry completely different meanings depending on the game context or character, but let us take a look at a few basic poses.

Here we see a "Hang in there!" pose. The Heroine adopts more of a pretty, girlish pose than one that is rousing. Maintaining the arm at a moderate height-about eye level-will present a more feminine image.

"Go get 'em, tiger!" Here we see a motivational pose. Always render athletic characters with the same vigorous air. Show her with both hands forward and bunched into fists to give her a more robust appearance than the other characters.

Even if no spoken lines accompany the pose, ensure that the intent to motivate is expressed throughout the entire figure. If this pose were used with a combat game character, it would simply be a "muscle flexing" sort of pose intended to intimidate the opponent. However, with a romance simulation game character, the same pose is transformed into a motivational pose.

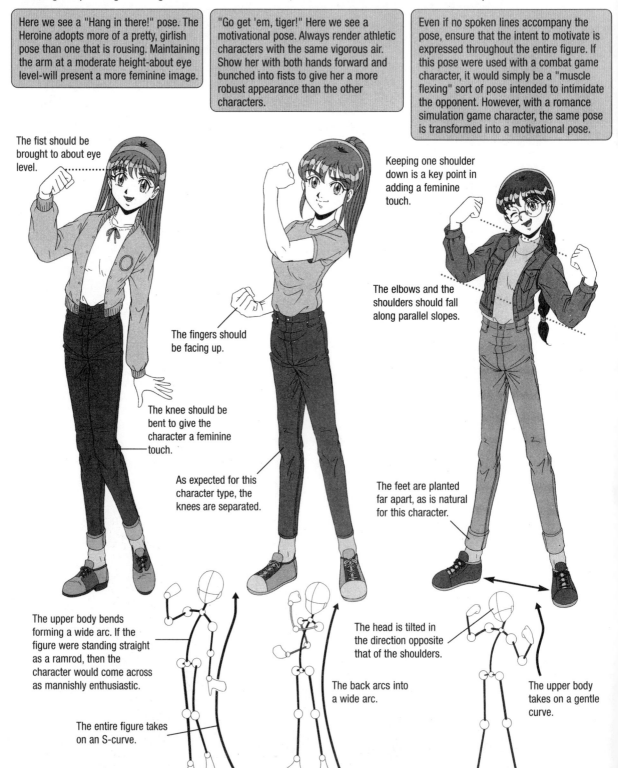

The fist should be brought to about eye level.

The fingers should be facing up.

The knee should be bent to give the character a feminine touch.

As expected for this character type, the knees are separated.

Keeping one shoulder down is a key point in adding a feminine touch.

The elbows and the shoulders should fall along parallel slopes.

The feet are planted far apart, as is natural for this character.

The upper body bends forming a wide arc. If the figure were standing straight as a ramrod, then the character would come across as mannishly enthusiastic.

The entire figure takes on an S-curve.

The head is tilted in the direction opposite that of the shoulders.

The back arcs into a wide arc.

The upper body takes on a gentle curve.

Positioning of the Hand and Feet and Design Considerations

Various poses have been presented in this book. However, we have yet to discuss specifically how to pose a character to make her look feminine and pretty, no matter what she is doing. We will also discuss what types of positioning of the hands and feet can be used effectively in multiple contexts. Specifically the positioning of the hands and feet is to a certain extent predetermined and independent of the character-type or gender. Let us take a look at a few basic positions.

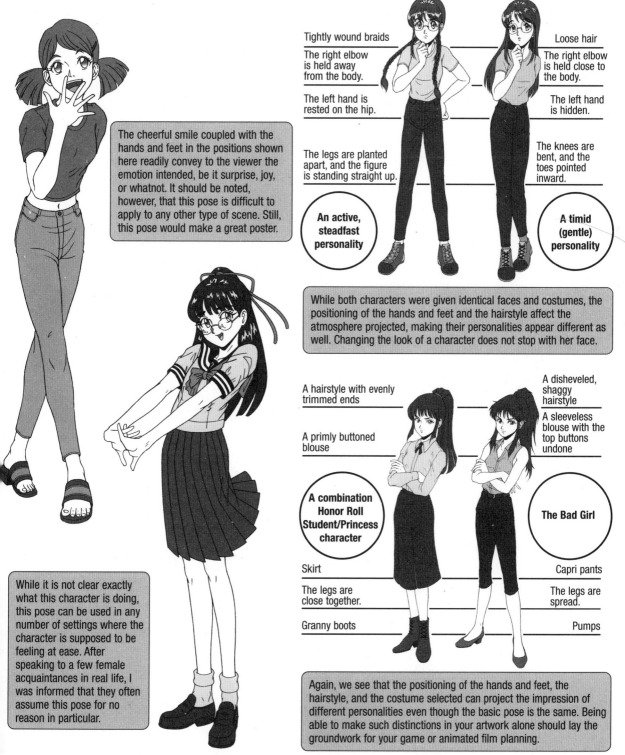

The cheerful smile coupled with the hands and feet in the positions shown here readily convey to the viewer the emotion intended, be it surprise, joy, or whatnot. It should be noted, however, that this pose is difficult to apply to any other type of scene. Still, this pose would make a great poster.

Tightly wound braids

The right elbow is held away from the body.

The left hand is rested on the hip.

The legs are planted apart, and the figure is standing straight up.

An active, steadfast personality

Loose hair

The right elbow is held close to the body.

The left hand is hidden.

The knees are bent, and the toes pointed inward.

A timid (gentle) personality

While both characters were given identical faces and costumes, the positioning of the hands and feet and the hairstyle affect the atmosphere projected, making their personalities appear different as well. Changing the look of a character does not stop with her face.

While it is not clear exactly what this character is doing, this pose can be used in any number of settings where the character is supposed to be feeling at ease. After speaking to a few female acquaintances in real life, I was informed that they often assume this pose for no reason in particular.

A hairstyle with evenly trimmed ends

A primly buttoned blouse

A combination Honor Roll Student/Princess character

Skirt

The legs are close together.

Granny boots

A disheveled, shaggy hairstyle

A sleeveless blouse with the top buttons undone

The Bad Girl

Capri pants

The legs are spread.

Pumps

Again, we see that the positioning of the hands and feet, the hairstyle, and the costume selected can project the impression of different personalities even though the basic pose is the same. Being able to make such distinctions in your artwork alone should lay the groundwork for your game or animated film planning.

Was yesteryear's look better?

Things connected to *bishoujo* seem to embody a unique interpretation of the world. Looking at fashions, hairstyles, etc., everyone seems to have a different conception of beauty. Yet, a character designer is not at liberty to push his or her preferences. Rather, the character designer must strive to produce artwork that will appeal to a wide spectrum of people. So then, what sort of artwork has general appeal?

The answer is the cute look of the girl next door, and it is the latest poster girl that seems to fulfill these conditions and has the capacity to appeal to both men and women, young and old alike.

To boot, the character designer must also act as his or her own character producer. You may have arrived at what is considered a satisfactory character design for the year, but if it is immediately incorporated in a game, and then the next year or whenever the game goes on sale, the character's look will have already become obsolete. Consequently, it is safer to select a classic or conventional design for your character.

Trend of the Day
Occasionally, a trendy character like this may be just what the artist requires. However, such a faddish look cannot be used with the Heroine. In fact, this look, recently the rage in Tokyo, is already a bit passé.

The hair is more bleached blond than brown.

Black roots peak through.

The eyes are blank.

She is dripping in cheap accessories.

The bag is slung over the shoulder.

The blouse's neck is unbuttoned and the bowtie loose.

The sweater (or vest) is baggy.

Miniskirt

Oversized, loose socks

Maintaining the same pose, but turning the face toward the viewer and adding a smile would make the character 10 times cuter.

The Classic Heroine
While this character wears a number of fashion elements no longer scene on the street, she still has a charming appeal.

The gaze is always directed at the viewer.

The headband is positioned neatly on the head.

The hair is straight and long.

The sweater's sleeves puff around the cuff's gathers.

The hands holding the schoolbag are primly placed side by side.

The skirt falls to just above the knees.

The knee-highs are folded over twice.

Leather loafers

The Old-fashioned Style
While this is supposed to be the Bad Girl, someone has overdone the old-fashioned elements. With this costume, she has become more of a "retro Bad Girl."

The bow has been omitted.

Even though she may be bad, characters absolutely cannot be shown smoking cigarettes in home video games.

The middy blouse is short enough to reveal her navel.

The blouse is low cut.

The sleeves are rolled.

Duct tape has been wrapped around the book bag handle.

The hand is permanently shoved into the pocket.

The skirt is long.

The back of the shoe has been mashed down.

No socks.

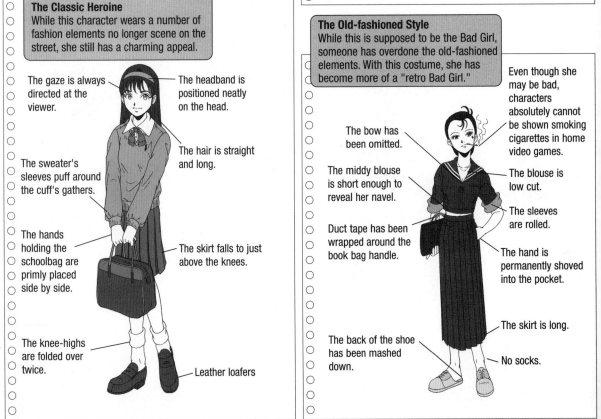

CHAPTER 5

Designing Posters

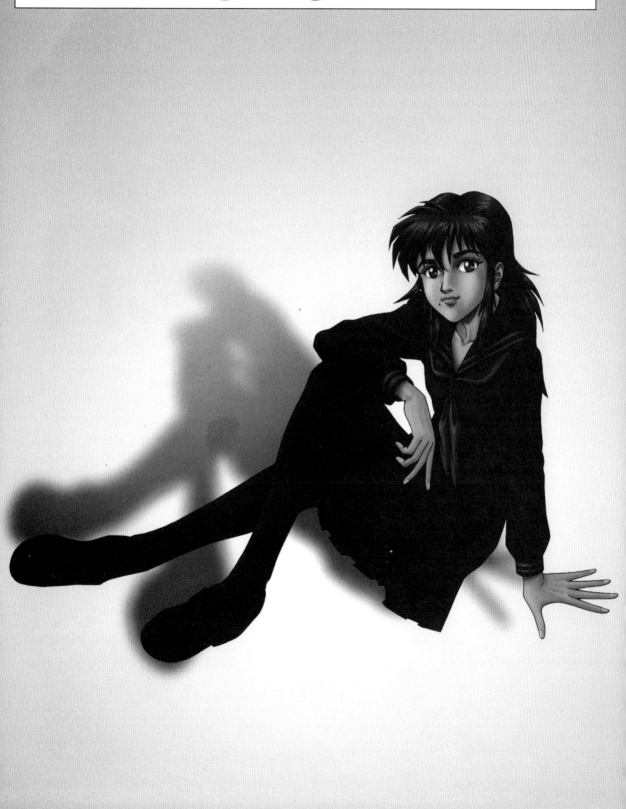

It is difficult to convey a game or animated film's appeal through a poster featuring just one character. However, combining multiple characters is also difficult and requires that the artist use his or her head. In particular, consideration must be given to interrelationships between the heroine and minor characters as well as to the positioning of characters in a way that communicates the essence of the story, etc. On the following pages are presented a few basic composition patterns that afford the viewer with a sense of visual balance.

Triangular Compositions

The triangle is the most popular composition for posters and advertisements. Triangular compositions come across to the viewer as the most visually balanced and are relatively difficult to bungle. I selected and arranged 3 characters for the figure below: the Heroine, the Honor Roll Student, and a vivacious, bubbly character. Such groupings of 3 are common to anime.

Upside-down and right-side-up patterns

Variant triangle patterns

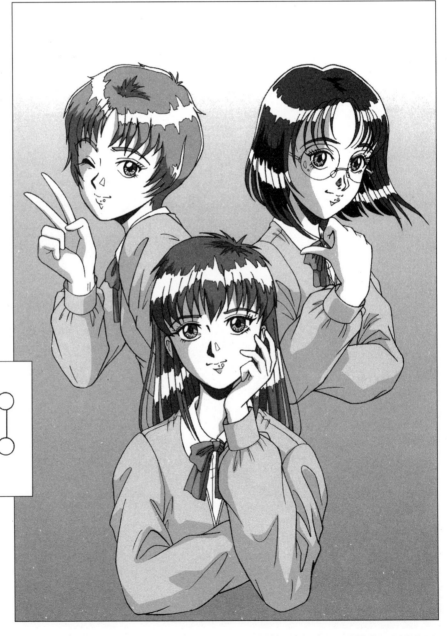

5-Character grouping

Variant Triangle Patterns

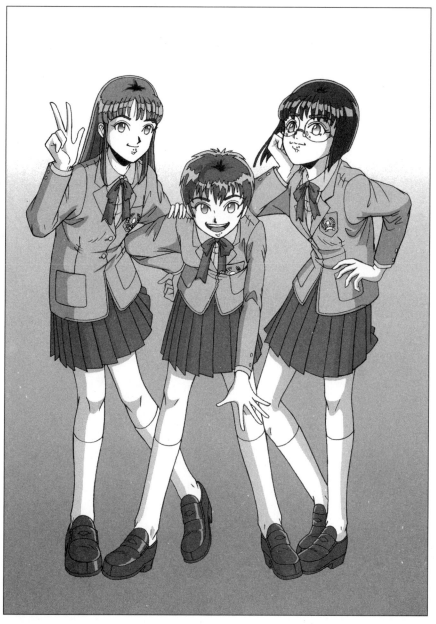

Positioning the character's heads to form a triangle

This could also be considered a 5-point pattern. The combined placement of the 3-characters, including the entire figures, forms a triangle. The heads and feet form key points in the composition. Rendering the characters with feet apart and aligned along the same plane creates a balanced composition.

The central character may be shown sitting in a chair.

Divided Composition

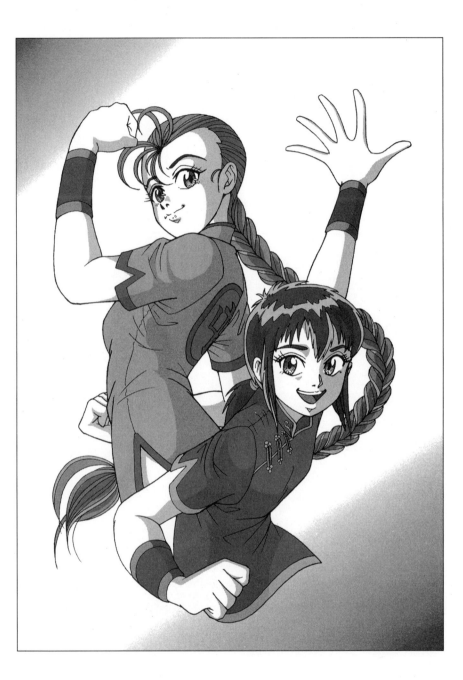

 This type of composition is frequently used with a character duo intertwining or a character and her nemesis counterposed.

 Showing one character in full and the other from the waist up conveys to the viewer which of the duo is stronger and mentally superior.

 Showing both characters at the same size and the same distance from the picture plane is used to suggest 2 rival characters equal in ability.

Positioning Characters in a Row

 Compositions showing 3 to 5 characters positioned in a row suggest that no single character is the heroine, but rather that all form a single group with each character fulfilling a different role. Needless to say, these characters must all be friends or allies. No adversaries can appear in such compositions.

Composition with 1 character in front

 Composition with 2 characters in front and a scatterbrained character running from the rear, trying to catch up

Combination Divided + Triangular Composition

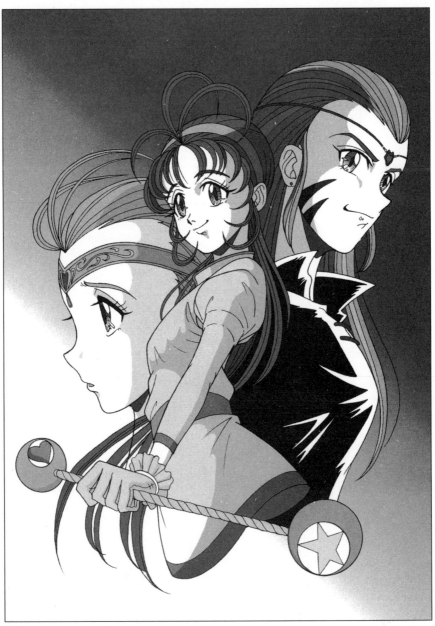

The hero or heroine is placed in the center. The direction each character faces indicates whether he or she is an ally or foe.

 + →

A composition like the one to the left is still unbalanced. Use wands, swords, and other props to draw the eye and balance the lower portion of the composition.

Groupings of 5 Characters I

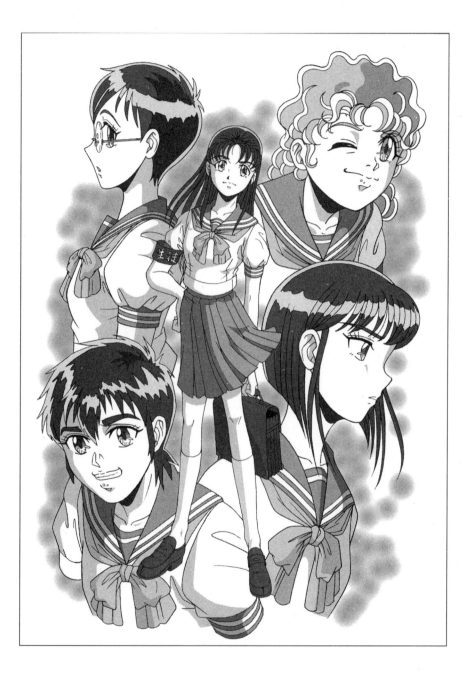

 This is a divided composition using 5 characters. The lower half of the composition is nicely balanced, making swords, wands and other props unnecessary.

 To highlight the heroine in the center, render her in a frontal view. Show each of the remaining 4 characters facing different directions. Even though these characters are friends, showing all of them facing the same direction would make it appear as if the heroine was the leader and would destroy any sense of individuality in the other characters.

Groupings of 5 Characters II

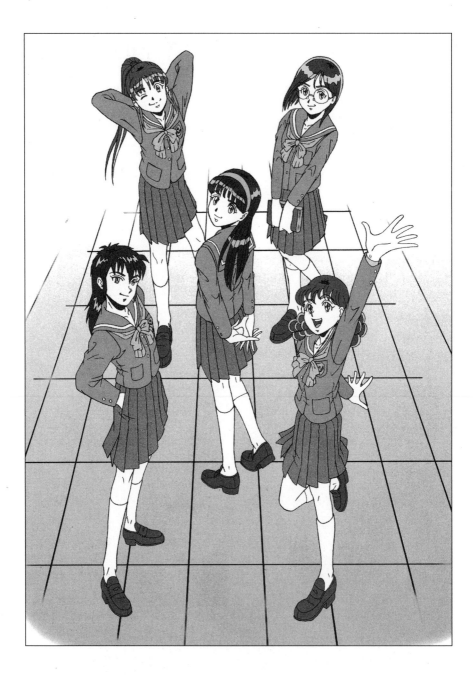

 Here we have a balanced placement of all 5 characters rendered at the same size in a baseball-diamond format. Such compositions are frequently used in romance simulation games or works with 5 main characters.

 The concept was that the characters are having their photo taken from overhead by a camera, so each character is facing the viewer. Since perspective and depth have been given to this image, an overall trapezoidal form has been adopted, balancing the composition. It should be noted that foreshortening is difficult to execute successfully, so this sort of composition should only be attempted after having become proficient with the technique.

Once you have become competent at figure placement, next try your hand at backgrounds. While the background is necessary for establishing the world in which the story takes place, many artists find it troublesome. With that in mind, on the following pages are presented a few basic backgrounds that you can use over and over again, once you master them.

Practical Backgrounds

First are introduced a few multipurpose backgrounds that can be used not only for specific settings, but various types of scenes.

An Apartment House

This building could be where someone lives, it could simply appear as the backdrop while a character is taking a stroll, or it could function as a rendezvous spot. Match it to a suitable scene in a story you have created.

A Restaurant

This could be the setting for a date, a lunch or dinner with friends or parents, an interview, or seeking advice from a friend, and easily adapted to any number of other situations simply by varying the characters used. Changing the curtains and switching to a rectangular ceiling will transform this backdrop into a wholly new restaurant.

Date Settings

Seasonal settings will expand possible character costume options and are effective for date scenes. An amusement park backdrop, which can be used for any season.

Shrine Festival

The Beach

Date Settings

An Amusement Park

Hatsumode **(The Year's First Visit to a Shinto Shrine)**

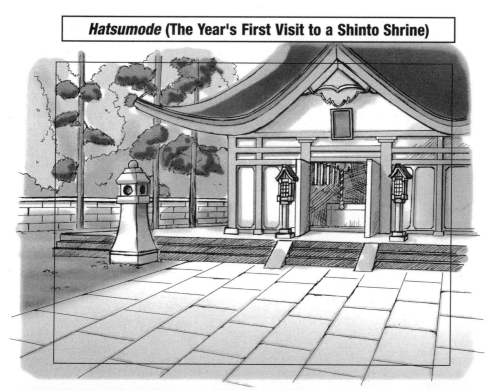

School

Of all the possible backgrounds, school settings are indispensable. While scenes in the classroom are the most common, story developments usually occur outside of class. On the next 2 pages are 4 common school settings.

The Classroom

The Hall

School

The Schoolyard

The Front Gate

To and From School

After school scenes, the next most important scenes take place after school and other common settings. Such scenes establish the character's world within the story and form the foundation for the game. When drawing such scenes, determine first what sort of home life the character has, what sort of neighborhood the character lives in, and other setting elements.

A Train Station Platform

In Front of the Station

To and From School

The Player's Room

Her House

Character Names: All Girl High School

All artists agonize over what sort of appealing names to give to the anime and game characters they have poured their efforts into designing. In the world of games, names are also important for hinting at the personality of their bearer. Below is a list of cute albeit improbable names I came up with using actual school rosters as reference.

Sophomore Class, Group A

Aina Amami
Sayaka Isa
Kyoko Utsugi
Tomomi Okumura
Miyuki Onodera
Mitsuki Kamiya
Mizuho Kawabata
Kayoko Kiriyama
Aya Koshimizu
Ayumi Gojo
Kanae Sakuma
Akemi Shibuya
Yuki Sudo
Makoto Seto
Miho Takeda
Serina Tanzawa
Mayumi Toyoshima
Eriko Nagata
Shima Naruse
Tokiko Nishioka
Risa Hashiratani
Ai Hibikino
Shiho Higuchi
Mina Hirose
Moe Fujio
Manami Furuoka
Masami Honnami
Riyo Mochida
Kaoru Yasuko'uchi
Reimi Yoshikawa

Sophomore Class, Group B

Hiromi Ikawa
Tomoko Ichijo
Tatsuko Iwanami
Momiji Iwamoto
Motoko Usami
Tomoko Endo
Akiko Oshima
Mika Okuyama
Yoshiko Kasai
Aki Katsura
Tomoe Kamata
Toyoko Kambashi
Yukari Shinohara
Kiyomi Shudo
Yuki Sonoda
Mariko Fujisawa
Chizuru Horie
Haruna Matsu'ura
Manami Myojin

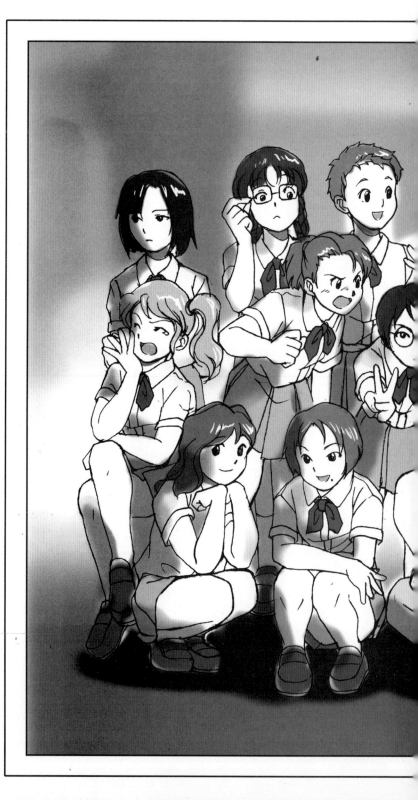

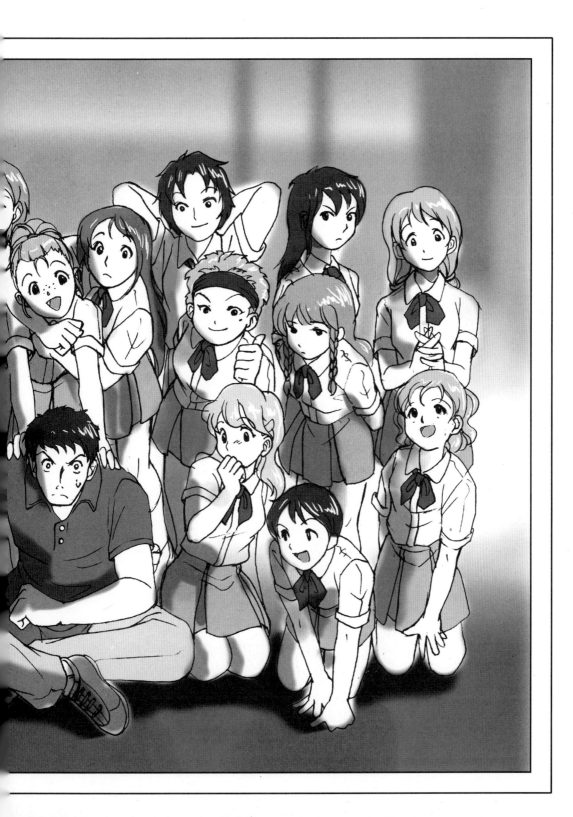

Character Names: Coed High School

Do not stop at just the heroine and her friends. Expand the world within the game and give names to peripheral characters as well. Boy names with "ichi," "kazu," "ji," etc. indicate the character's order of birth, so careful consideration should be taken when using such names.

Boys

Junichi Azuma
Soichiro Ikeda
Makoto Inaba
Shuhei Enoki
Kazunari Oda
Takuya Kusunoki
Kazuya Koga
Yuji Kokubo
Akira Terada
Masanori Togashi
Toshihiko Nagahara
Katsutoshi Hayashi
Shin'ichi Mimura
Nobuya Yuki
Nobuo Yoshioka

Girls

Sawako Igarashi
Murasaki Utsumiya
Yoko Kakizaki
Yumiko Kitagawa
Mai Kurosaki
Yurie Kenmochi
Saiko Jinguji
Kaori Shindo
Shinobu Tsujimoto
Madoka Nagatani
Miyuki Nonomura
Kotomi Fuchu
Naomi Honjo
Mikoto Minazuki
Hime Yanagi

It is obvious that the artist put plenty of effort into the details of this design. The artist has stated that she looked to tropical fish for her inspiration, but she has to an incredible degree managed to create a unique, distinctive design. Still, I think this character would look considerably better without the socks. Also, I would like to suggest that Misako Yoshikawa take a look at other artists' designs to gain a few hairstyles ideas and sketch these down at least once: this will undoubtedly help her arrive at her own, satisfying hairstyles.

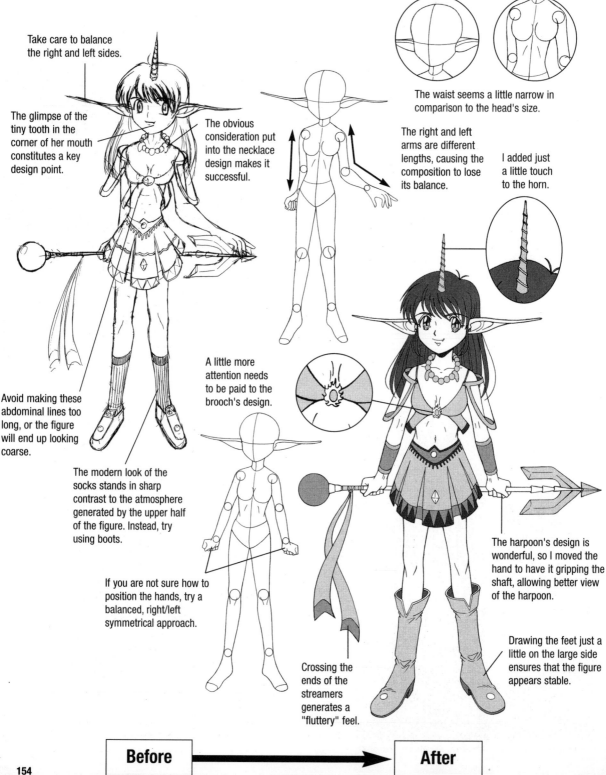

Take care to balance the right and left sides.

The glimpse of the tiny tooth in the corner of her mouth constitutes a key design point.

The obvious consideration put into the necklace design makes it successful.

The waist seems a little narrow in comparison to the head's size.

The right and left arms are different lengths, causing the composition to lose its balance.

I added just a little touch to the horn.

Avoid making these abdominal lines too long, or the figure will end up looking coarse.

A little more attention needs to be paid to the brooch's design.

The modern look of the socks stands in sharp contrast to the atmosphere generated by the upper half of the figure. Instead, try using boots.

If you are not sure how to position the hands, try a balanced, right/left symmetrical approach.

Crossing the ends of the streamers generates a "fluttery" feel.

The harpoon's design is wonderful, so I moved the hand to have it gripping the shaft, allowing better view of the harpoon.

Drawing the feet just a little on the large side ensures that the figure appears stable.

Before ➡ **After**

Advice from a Young Creator

YUKI ICHIMIYA

Yuki Ichimiya studies game graphics at an art academy, learning illustration, while simultaneously working at a certain game company. Today, Ichimiya continues her illustration studies while producing games.

I feel sort of embarrassed that someone like myself, who is still at just the apprentice stage, could be allowed an entire page like this, and my humblest wish is that at least one of the readers might find what I have to say useful. There are a number of factors critical to drawing, but if I were to choose one from a technical perspective, I would have to name sketching. Someone in my past taught me that just selecting someone on a train and observing that person from any number of angles can be instructive practice. Observing people is something you can do anywhere, even without a pencil or paper. However, staring at people is rude, so you do have to maintain a little moderation.

To all of my fellow young artists, I would like to say hang in there! We'll make it some day.

YOUR ORIGINAL STORY

TAROT CARD

Credits

Page 6
*1 © CAPCOM CO., LTD.
*2 © CAPCOM CO., LTD.

Page 7
*3 © 2001 SQUARE CO., LTD. Character Design: Tetsuya Nomura
*4 © KONAMI & KONAMI COMPUTER ENTERTAINMENT TOKYO
*5 © 1996, 1999, 2001 ENTERBRAIN, INC./Game CRAB
*6 © KOEI Co., Ltd.
*7 © SEGA/OVERWORKS 2001, © RED 2001
*8 © 1986 NAMCO LTD.